First published in the United States of America in 2009 by
Universe Publishing
A Division of Rizzoli International Publications, Inc.
300 Park Avenue South
New York, NY 10010
www.rizzoliusa.com

Originally published in the United Kingdom in 2008 by
Carlton Publishing Group
20 Mortimer Street
London W1T 3JW

Text and design © Carlton Books Limited

ISBN: 978-0-7893-1824-4

Library of Congress Control Number: 2008932288

Fourth printing 2011
2011 2012 / 10 9 8 7 6 5 4

Printed in Dubai

CAROL CLERK

VINTAGE TATTOOS

The Book of Old-School Skin Art

UNIVERSE

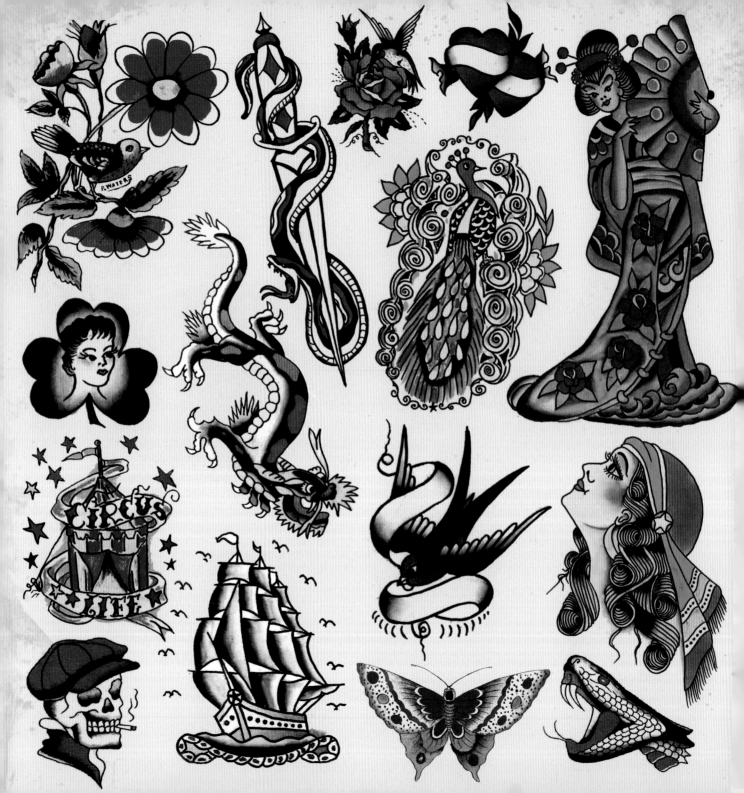

CONTENTS

INTRODUCTION 6

1 THE GREATEST SHOW ON EARTH 16

2 NAUTICAL & PATRIOTIC TRADITIONS 54

3 GIRLS, HEARTS & BANNERS 108

4 THE GOOD, THE BAD & THE SUPERSTITIOUS 150

5 THE NATURAL WORLD 180

6 THE DECLINE OF A GOLDEN ERA 232

7 THE VINTAGE REVIVAL 238

INDEX 250

READING & RESOURCES 252

ACKNOWLEDGEMENTS 254

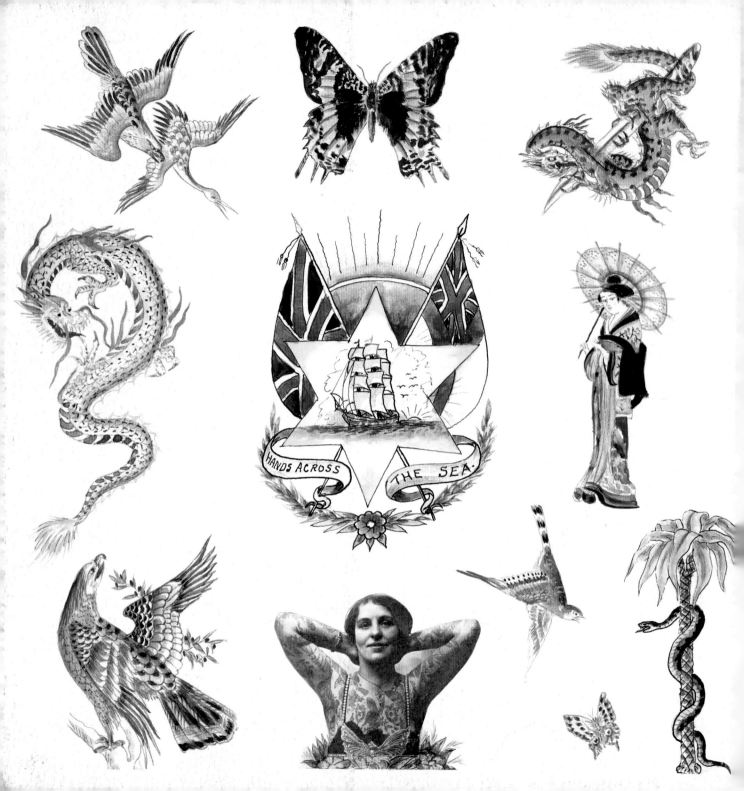

HANDS ACROSS THE SEA.

INTRODUCTION

After many years of disapproval and prohibition, the tattoo has become an accepted and often creative form of self-expression. Body art, no longer a badge of rebellion and outsider status, has become fully absorbed into mainstream culture, shown off with pride by bankers, celebrities and ordinary working people alike.

With this has come a fascinating phenomenon: the rise and rise of the vintage tattoo, developed across two World Wars by seamen and circus artists. And merchandizers have been quick to cater for the demand, emblazoning everything from T-shirts to umbrellas, and baby clothes to pencil cases, with the classic, vivid images of sailing ships, skulls, roses and hula girls. If tattoo art is cool, the vintage variety is doubly so. But where did it all begin?

The history of the tattoo is impossible to trace: it trails way back in the mists of time, far beyond the reach of archaeologists. The first apparent evidence dates back a mere 12,000 years. It is believed that in the Old Stone Age, somewhere around 10,000 BC, people were inking their skin using grooved needles crafted from bones. For colour, it would seem that they mixed a primitive paste made from coloured iron oxide deposits (ochre), clay and water. This hypothesis arises from the findings of French husband-and-wife team Saint-Just and Marthe Péquart, who excavated a cave called the Grotte du Mas d'Azil in the Pyrenees, southern France, at the start of the 1940s. The Péquarts unearthed a collection of tools, utensils and pieces of ochre that they felt could well point to a tattoo culture among prehistoric Europeans.

However, the earliest undeniable example of tattooing was discovered quite recently in the dramatic form of Ötzi the Iceman. This unfortunate fellow had been frozen since 3,300 BC in an Alpine glacier, close to the border of Italy and Austria. In 1991, his upper half was spotted emerging from melting ice by a couple of passing tourists – and a well-preserved Ötzi was later found to sport 57 carbon tattoos, none pictorial. They were simply lines and dots. But for whatever reason they existed, they guaranteed this Copper Age corpse – Europe's oldest natural mummy – a place in history.

It has been shown that, in the ensuing centuries, tattooing flourished in ancient Egypt as far back as 2,000 BC, and among the Russian Pazyryk community, who lived in mountainous terrain near the Chinese border around 400 BC. In the absence of any evidence, it is nevertheless likely that permanent body markings were a fact of life for many other tribes and cultures around the world, up to and including this particular era.

Historically, tattoos have been applied to princes and prisoners, kings and criminals, the abject and the aristocracy, for reasons as varied as the experiences of

the wearers. Tattoos could denote high social standing, slavery or membership of a family, tribe, gang or secret organization. They could represent skills, fine achievements and wrongdoings. They could invite luck, or hope to ward off misfortune. Used for simple decoration, for inspiration or identification, they could also act as a memorial or a loving tribute. They could serve as a request for the bearers to be endowed with the great qualities of the gods or animals illustrated on their skin, or symbolize hopes, fears, joys, warnings or religious convictions. They could be given as part of a tradition or ritual, or as a punishment.

In the West, the tattoo existed for hundreds of years before the invention of the first electric tattoo machine, in 1891, by the leading New York artist Samuel O'Reilly. With subsequent advances in colour, equipment and health and safety, the scene was set for the golden age of vintage tattoo.

By this time, the tradition was travelling quickly by sea via sailors and by land via circuses and fairgrounds, and tattoo artists were able to discover, admire and assimilate the techniques of other nations. The following pages explore the bold and colourful old-school designs that were perfected in the first half of the twentieth century, and which are now much copied by enthusiasts today.

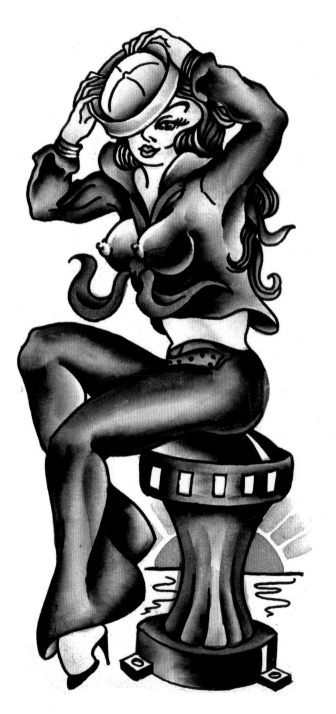

LEFT: A skull tattoo design by the legendary Bert Grimm.

RIGHT: A Don Nolan sailor girl, circa 1969.

A TATTOO TIMELINE

10,000 BC
Archaeological findings suggest that Stone Age folks inked their skin using primitive equipment and natural dyes.

3300 BC
Ötzi the Iceman was frozen in an Italian glacier, where he remained until 1991. His body, patterned with lines and dots, was proof of early tattooing.

2000 BC
Tattoo culture was alive and well in ancient Egypt.

400 BC
Russian tribes are known to have been tattooed.

1691
The world's first exhibition of a human being for entertainment found tattooed slave Giolo, the famous Painted Prince, being shown at English carnivals.

1768
Captain Cook set sail for the first of three great voyages in which he discovered and chronicled native tattooing, stimulating great interest in body art back in Britain.

1772
The world's first circus was held in Vauxhall Pleasure Gardens, London. American circuses, which would start touring in the 1800s, became centres of tattoo culture, as in Europe.

1774
Omai, a tattooed Polynesian and a discovery of Captain Cook's, thrilled London's elite.

LATE 1820s
John Rutherford, England's first homegrown tattoo attraction, went on the road. Circus attractions including illustrated people, fat ladies, fire-eaters and other showmen and oddities were exhibited away from the big top, in sideshows.

1841
James F O'Connell became the first tattooed man to be exhibited in the United States.

MID 1800s
New York and Chicago became the United States' first major tattoo centres. At the same time, the coming of the railway enabled circuses to reach more towns. Circus attractions and tattooists therefore met more easily and frequently, and gradually formed a network.

1870s
The elaborately decorated Prince Constantine joined Barnum's Great Traveling Exposition, inspiring many young men to take up tattoo art, including New York's Charles Wagner.

1882
America's first tattooed lady, Nora Hildebrandt, made her first professional appearance.

1891
New York tattooer Samuel O'Reilly patented the first electric machine, making tattooing quicker, less painful and, unsurprisingly, more popular.

LATE 1890s
Lewis "Lew the Jew" Alberts embarked on a campaign to raise the standards of tattoo flash in New York.

1904
O'Reilly's apprentice Charlie Wagner patented a new, improved version of his mentor's tattoo machine. In the same year, Londoner Tom Riley tattooed the body of a buffalo in a three-week exhibition in Paris.

1911
Norman "Sailor Jerry" Collins, the legendary tattooer, was born. He expanded the range of colours available.

1927
The Great Omi, an ex-Army major, visited London tattooer George Burchett to arrange his transformation into the wildest circus attraction ever seen.

1939–45
Business was booming for tattooists in the Second World War, with soldiers and sailors queueing up to be inked with the emblems central to the vintage craft.

1950s
American authorities targeted tattooing by either banning it or insisting on such strict conditions that many owners moved on, or retired. At the same time, moral opposition to circus sideshows was building.

1970
Texas singer Janis Joplin started a craze for rock 'n' roll tattoos, bringing the curtain down on the old-school era.

1979
Long Beach Nu-Pike closed down. The amusement park, once filled with eminent tattooists such as Bert Grimm, had deteriorated, with the renowned Owen Jensen dying in 1976 after being stabbed and robbed in his own shop.

2000
Retailers, advertisers and promotions companies set the scene for a resurgence of vintage tattoo art.

ARTISTS' GALLERY

A sample of the artists featured in this book

GEORGE BURCHETT (1872–1953)

Trained by English tattooists Tom Riley and Sutherland MacDonald, Burchett's designs were influenced by his international travel.

JOE DARPEL

With head-to-toe body art by Bert Grimm, Joe Darpel worked a a circus attraction and tattoo artist. He and his wife Mabel, a knife-thrower in the circus, tattooed together from about 1927.

AMUND DIETZEL (1890–1973)

Born in Denmark, Dietzel was a sailor before settling in the United States. Known as the "Master in Milwaukee", his designs were charming and confidently drawn.

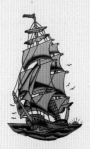

JACK DRACULA

Born Jack Baker, he started working as a tattooist in Brooklyn's Coney Island in the late 1950s. Heavily tattooed, with eagle and eye mask designs on his face, he operated shops in Camden, New Jersey, and Philadelphia. He was famously photographed by Diane Arbus.

DOC FORBES

A Vancouver-based tattooist, Doc Forbes got his name from the medical magazines he kept in his studio and the white coat he wore.

BERT GRIMM (1900–85)

A Chicago-, then St Louis-based tattooist who moved to Long Beach, California, and set up shop at the Nu-Pike. The parlour was claimed to be the oldest continually running in the continental US and the place for sailors to get inked before shipping out. He sold the shop to Bob Shaw in 1970.

TREVOR HODGE

From Bristol, England, tattooist Hodge was immortalized in the song "Mermaid and the Swallow" by Ian Bell.

HERBERT HOFFMAN (1919–)

Beginning tattooing in 1930s Germany, Hoffman went on to become one of the stars of European tattooing in the 1950s. Along with fellow tattooists Karlmann Richter and Albert Cornelissen, he featured in the 2004 film *Blue Skin* (*Flammend' Herz*).

OWEN JENSEN (1891–1976)

Born in Utah and a serviceman in World War One, Jensen tattooed across many US cities in his lifetime, working last at Nu-Pike with Lee Roy Minugh.

CAPTAIN DON LESLIE (1938-2007):

Sword-swallower, fire-eater and tattooed circus attraction, Captain Don Leslie made numerous television appearances and is pictured in the *Smithsonian Photographic Historian*.

LEE ROY MINUGH (1911–94)

After learning the trade via the circus, Lee Roy settled in Los Angeles, later working at Nu-Pike. His work dates to the 1950s, when hearts, eagles, snakes and insects were drawn in dark, heavy lines and filled in with the simple colours.

DON NOLAN

First learning the art of tattooing in 1955, he opened a studio in New London, Connecticut, and had many other shops across the US before his current one, Acme Tattoo Company, in Minnesota.

PAUL ROGERS (1905–90)

A carnival worker, tattoo artist and inventor of tattoo machines, he worked with Cap Coleman in Norfolk, Virginia, for five years from 1945.

FLOYD SAMPSON

A carnival tattooist, working in the 1920s and 1930s.

BOB SHAW (1926–93)

Having learnt tattooing from Bert Grimm (Grimm tattooed his sleeves) in St Louis, Missouri, he worked with many other artists, such as Jack Tyron, before joining Grimm again at Nu-Pike. He was president of the National Tattoo Association from 1983–88.

LES SKUSE (1912–73)

Hailing from Bristol, England, Skuse was a fan of the Coleman school of tattooing, rather than the single-needle technique of English tattooists. After working at the tattoo shop of Joseph Hartley, he joined the RAF during the Second World War before setting up his own business. He formed the British Guild of Tattooing and the Bristol Tattoo Club.

PERCY WATERS (1888–1952)

Waters built a successful tattooing business in Detroit, Michigan, during the 1920s and 1930s, receiving a patent for his tattoo machines in 1929. In 1939 he returned to his birthplace of Anniston, Alabama, where he ran a tattoo supplies business.

MILTON ZEIS (1901–72)

From the mid 1930s, Zeis set up a tattoo studio business supplying supplies and flash. He publishing *Tattooing the World Over* from 1947 and set up his mail-order Zeis School of Tattooing in 1951.

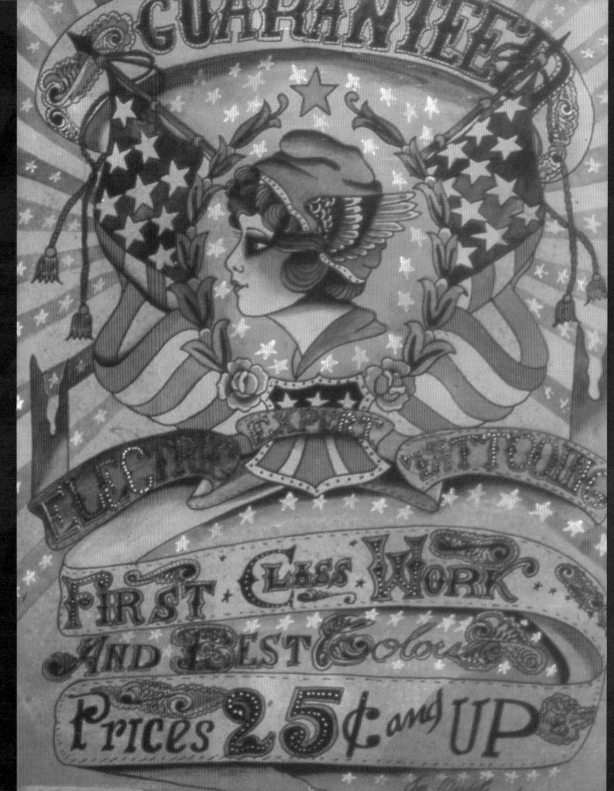

THE GREATEST SHOW ON EARTH

The tattooed lady and the illustrated man, long immortalized in songs and films, were staple "freak" attractions at the circus and fairground sideshows that began touring their native lands in the 1800s. This took extreme tattoo culture into virgin territory. The coming of the railways was a huge advantage, especially in the vastness of America during the second half of the nineteenth century. It opened up many new opportunities for the travelling shows and the tattooed people who found work with them.

The artists responsible for decorating the star exhibits were usually themselves inked from head to toe. They stood to gain a great deal from the staring crowds, since the acts served as a living advertisement for their work. It was hoped that at least some of the spectators would be impressed enough to splash out on a tattoo.

The freaks, for their part, were generally happy with the day job. Some had grown up in the circus; others joined as runaways or out-of-work sailors, or simply as individuals seeking the freedom and community of an itinerant lifestyle. Many hoped to become tattooists themselves, and often succeeded. For whatever reasons they ended up displaying themselves to the public, the performers all appear to have viewed exhibition work as an easy way to earn a good living, and they submitted to endless hours under the needle to make the grade. The arrival of the electric tattoo machine towards the end of the nineteenth century caused flurries of excitement. Dozens of prospective human exhibits flocked to the craftsmen who owned such equipment, seizing the opportunity of a fast track into showbusiness.

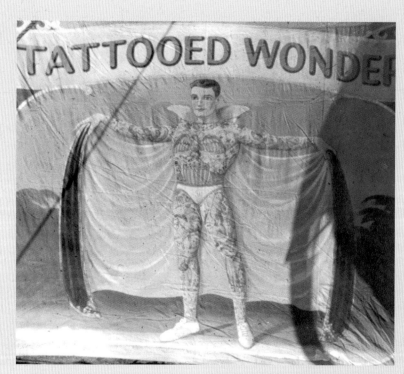

ABOVE: Circus tattoo banner advertising a tattooed man – the Tattoo Wonder – with a whole-body tattoo, undated.

RIGHT: Circus sideshow stalls depicting the various attractions on offer, with a tattoo stand front and centre, undated.

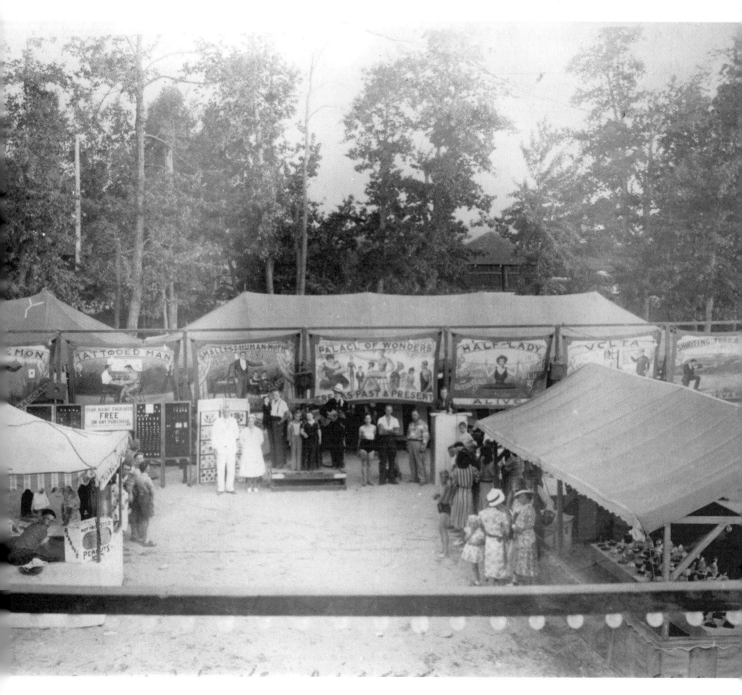

STORYTELLERS AND CIRCUS STUNTMEN

In order to be able to persuade the crowds to "Roll up! Roll up!", the performers had to be elaborately tattooed over every inch of flesh. Spectacle was everything. Accordingly, the tradition of tall tales grew up around the circus acts, who invented sensational stories about their lives and body art so as to become larger than life. Many claimed to have been captured by hostile tribes in far-off places and tattooed against their will. Few, however, could compete with the legend of James F O'Connell, the first tattooed oddity ever to be exhibited in America, in the early 1840s. O'Connell professed to have been taken prisoner by natives on the North Pacific island of Pohnpei (formerly known as Ponape), where he claimed he was then subjected to extensive tattooing by a succession of beautiful young virgins, the last of whom he was made to marry. O'Connell wowed the crowds as he told and retold his remarkable story through a 20-year circus and vaudeville career.

Tattooists, too, saw the benefit of reinventing themselves. The more colourful and self-aggrandizing their stories, the more punters flocked to their parlours, intrigued. The legendary Bert Grimm was a master of this, regaling customers in his St Louis shop with vivid anecdotes about tattooing Bonnie and Clyde, Pretty Boy Floyd and other notorious outlaws in the early 1930s. Grimm's reputation soon spread across many states,

RIGHT: An illustration of Irishman James F O'Connell showing his chest tattoo, acquired while travelling in Micronesia in the 1820s and 1830s.

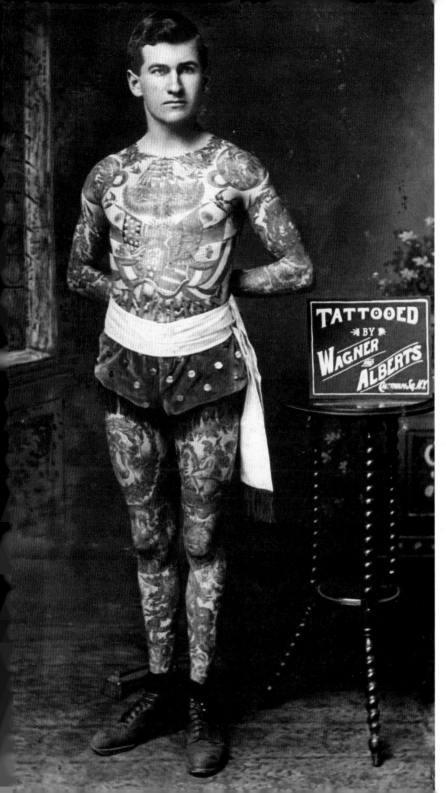

LEFT: "Painless" Jack Tryon with his full-body tattoo by Lew "Lew the Jew" Alberts and Charlie Wagner.

BELOW: Paul Rogers balancing a handstand on chairs in March 1928. A tattoo artist and performer with the JJ Page and the John T Rea Happyland shows in the 1930s, he worked the carnival circuits before joining Cap Coleman's tattoo practice in Norfolk, Virginia, in the mid-1940s.

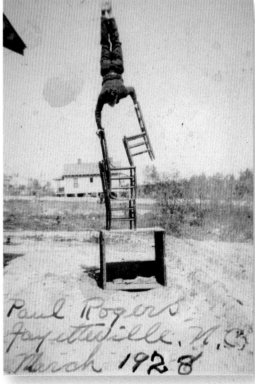

where he was hailed as the world's greatest tattooist – largely because that's what he told everyone, and they believed him. Still, he remains a revered artist and one of the numerous tattoo personalities whose fact has become inseparable from his fiction.

Many of the tattooed attractions developed spectacular circus skills to further enthrall their audiences. "Painless" Jack Tryon, a favourite on the American circuit at the beginning of the 1900s, would eat flames, perform magic tricks, walk a tightrope, balance on one hand and banter with his snake-brandishing wife when he wasn't simply flaunting his illustrated body. Paul Rogers, who took to the road in the 1930s, performed daring handstands high above the ground, supported only by a couple of wobbly chairs. And the inimitable Captain Don Leslie, a circus sideshow sensation from the mid 1900s who spent a number of years with the King Brothers Circus, was a fire-eater and a prodigious sword-swallower. He didn't stop at swords, though; knives, bayonets, screwdrivers – nothing was too much trouble for Captain Don.

Joe Darpel and his knife-throwing wife Mabel also started out in the circus life in the 1920s before teaming up as tattoo artists and plying their trade throughout the states, including Virginia, Kansas and Texas. Decorated head to toe in Bert Grimm tats, Joe worked for the Greater Alamo Show and the Wortham Show in the 1920s.

RIGHT TOP: Samuel O'Reilly tattooing a customer in the late 1880s or '90s.

RIGHT BOTTOM: The Darpels' business card after they moved from Norfolk, Virginia, to Fort Worth, Texas.

BELOW: Rea's Museum of Oddities hosted many attractions in the 1930s, including Paul Rogers and his wife Helen.

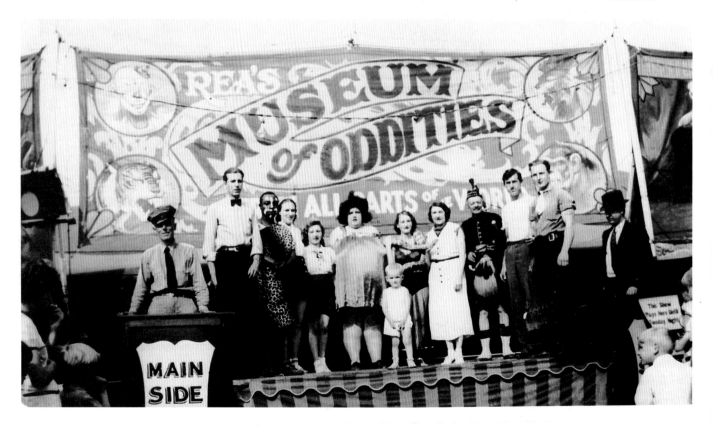

THE TATTOOING FAD HAS REACHED NEW YORK VIA LONDON

Chinese Dragon

His Sweetheart

"South West Wind"

Fond Fathers Dead Children

The Bathing Girl

The Ballet Girl.

TOM RILEY AND THE TATTOOED WATER BUFFALO

One person who took the premise of showmanship to extraordinary lengths was Britain's Tom Riley, who developed his skills as a tattooist during army service in the late 1800s. Thanks to Riley, countless numbers of his fellow soldiers returned home from tours of duty in South Africa and the Sudan with regimental or military emblems etched indelibly into their skin.

Riley also happened to be the cousin of the noted New York tattoo artist Samuel O'Reilly, who, in 1891, invented and patented the first electric needle machine. This revolutionized the whole tattoo scene, and in Britain, Tom Riley was the first to benefit. Quitting the army, Riley set up a parlour in London and, using his cousin's invention, he soared to prominence in England and Europe. Rich and titled people demanded his services for many years to come, although it is fair to speculate that even with the new machine, he would not have held his own for as long as he did without his innate flair for drawing, spectacle – and public relations.

In 1904, Riley performed a stunt so breathtakingly audacious that it now seems almost impossible to believe. Over the course of three weeks at the Paris Hippodrome, he tattooed the entire body of an Indian water buffalo in front of an incredulous audience consisting of the press and public. Some awestruck observers decided that they must immediately celebrate and worship the hapless animal, and did, amid billowing clouds of incense.

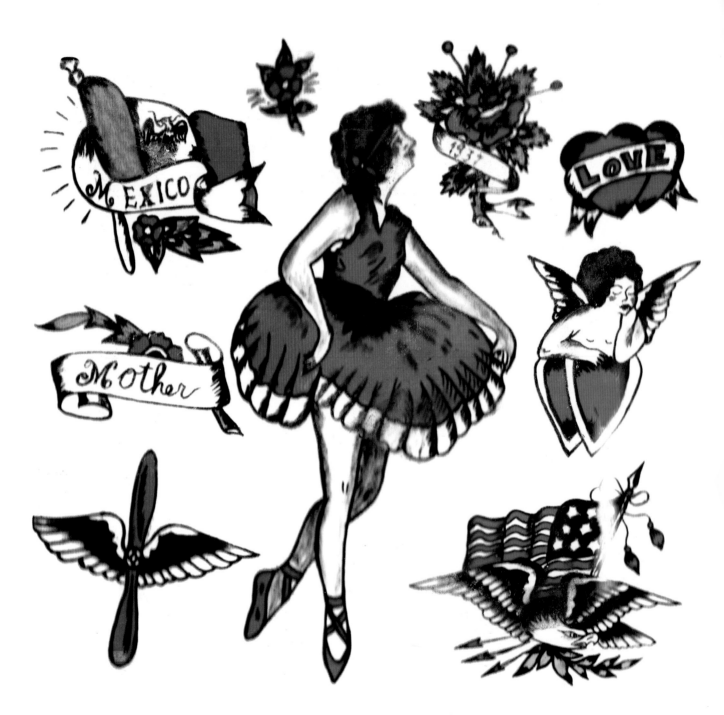

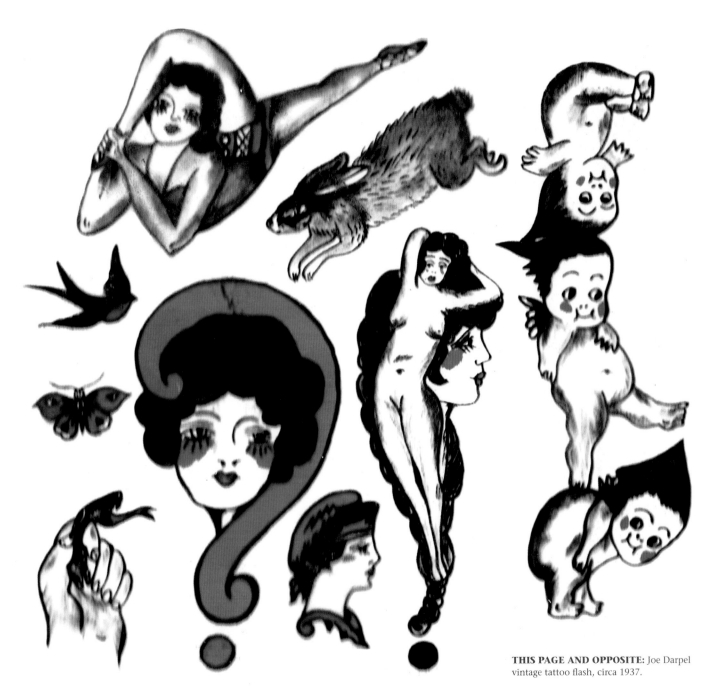

THIS PAGE AND OPPOSITE: Joe Darpel vintage tattoo flash, circa 1937.

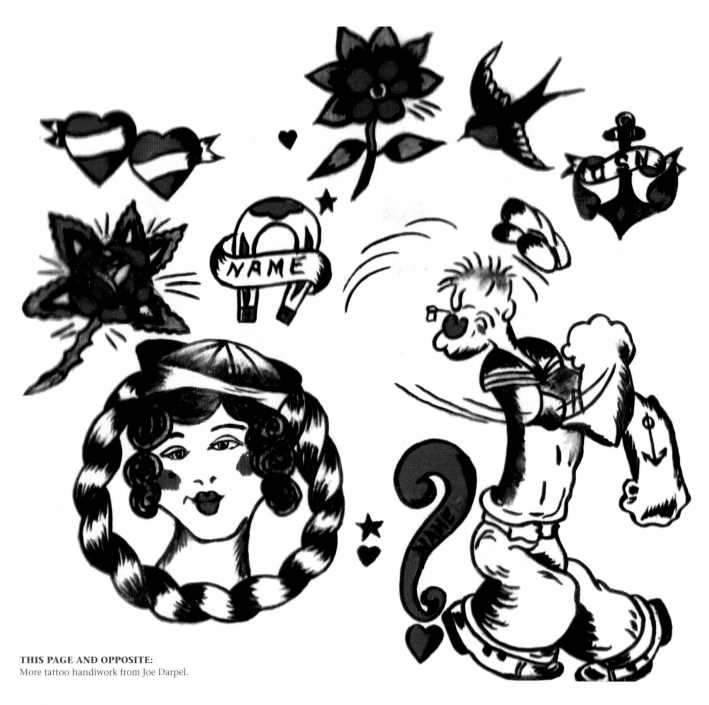

THIS PAGE AND OPPOSITE:
More tattoo handiwork from Joe Darpel.

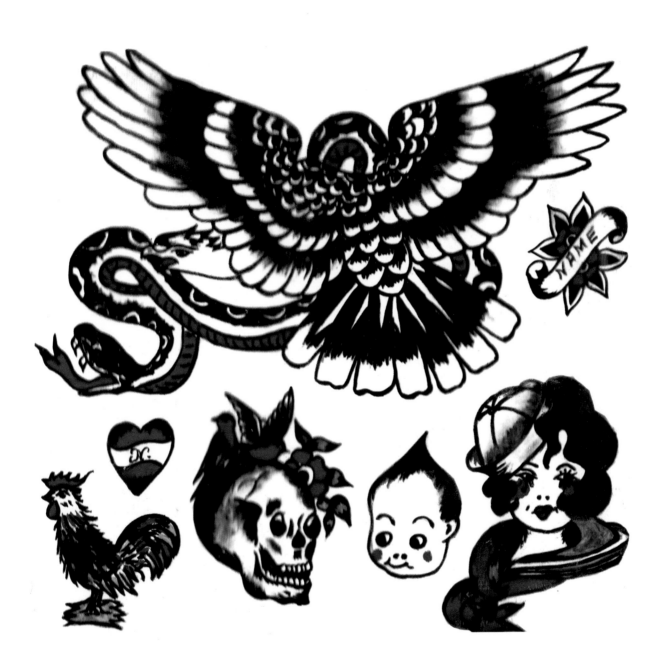

CAPTAIN DON P LESLIE

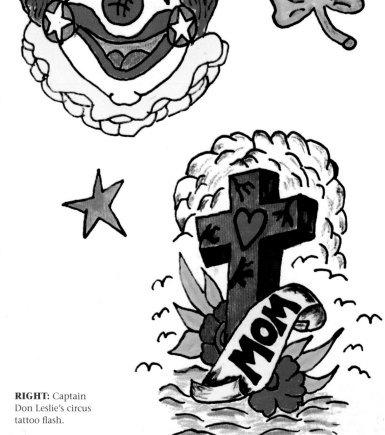

Born in the state of Massachusetts in 1937, Captain Don P Leslie became a legend of the circus sideshow, regularly appearing in mainstream magazines, newspapers, films and TV shows. He was an all-round performer, comprehensively tattooed but also famous for his spectacular feats of knife-throwing, sword-swallowing and fire-eating. In one especially dramatic trick – the "human volcano" – he would blow a massive ball of fire from his mouth.

Captain Don, it's said, ran away to join Ringling Brothers circus aged fourteen, starting at the bottom by selling confectionery to the audiences. Determinedly, he applied himself to learning a host of circus skills until he became an accomplished entertainer, although he was never too proud to busk the streets out of season, wintering in warm states such as Florida and California. A true itinerant, he worked with all of the big touring circuses and lived where he landed. Almost inevitably, the irrepressible Leslie started painting circus signs, and tattooing on the road. He wasn't naturally gifted, and his designs were rudimentary. They were, however, packed with personality. His friend Lyle Tuttle explains: "He didn't tattoo that much. He had a style, but he wasn't a Rembrandt. If you look at his flash, it's not sensational, but there was a call for it because of his renown as a showman."

Tuttle first met Captain Don in 1955 at the Long Beach Nu-Pike amusement pier, and soon added extensively to his

RIGHT: Captain Don Leslie's circus tattoo flash.

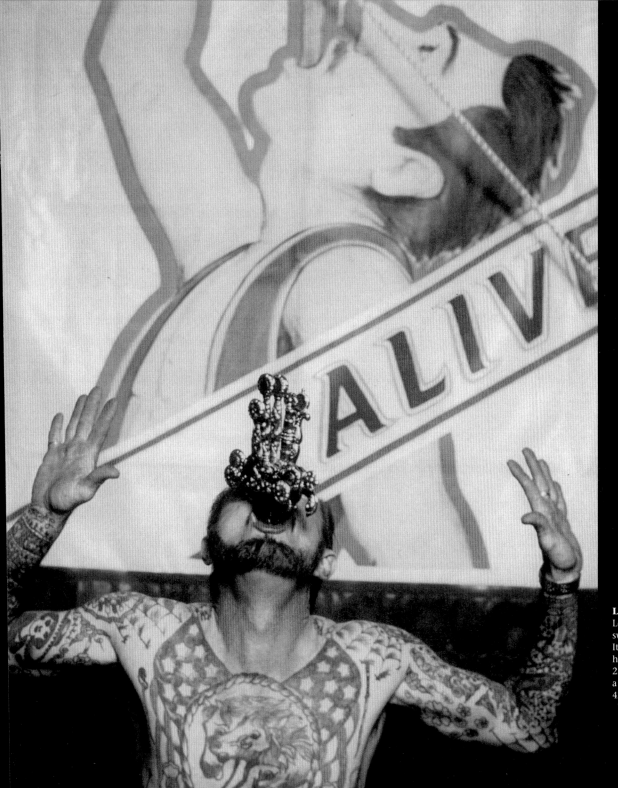

LEFT: Captain Don Leslie in sword-swallowing mode. It is reputed that he would do up to 22 performances a day during his 42-year career.

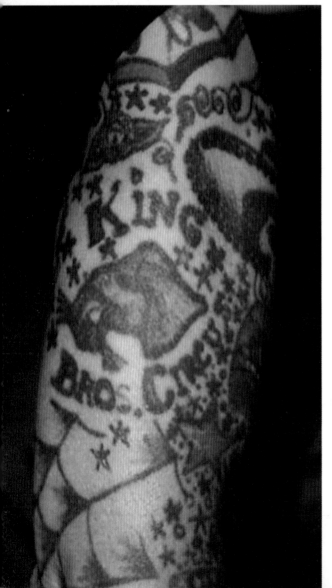

LEFT: Captain Don's homage to his years with the King Brothers circus. The photograph was taken in 1994.

existing tattoos, helping along Leslie's career. Twenty years later, he walked into Tuttle's San Francisco shop and the pair rekindled a lasting friendship.

"Married twice and two sets of kids by each wife," says Tuttle of Leslie. "He was an alcoholic for about 25 years. They don't eat and stuff like that, and he let his teeth deteriorate and he didn't have any teeth. He got a sore spot on his gum, went and got it checked – it was malignant. To remove it, they would've had to remove half his jaw and really disfigure him. He didn't opt for that. He just went ahead and let his cancer run its course. The doctors found out it was caused by a petroleum product. It was in the fuel that he used for eating fire."

In more than thirty years of using the fuel, Captain Don had never read the warning on the container: "If taken orally, can be a carcinogenic." And he had been forcing petroleum through his salivary glands up to ten times a day just to perform the "human volcano".

Tuttle reveals that he spent the last three months with him and during this time Captain Don poignantly signed a photograph to his friend: "Last photo taken before my final curtain. This one is for you Lyle. To: Lyle Tuttle, my friend for over 50 years." The Captain's final curtain fell on 4 June 2007, and Tuttle remembers him this way: "He was the pied piper of indigents, 'cos the people that were around that were indigents. He always had time for them. He was a hell of a good guy."

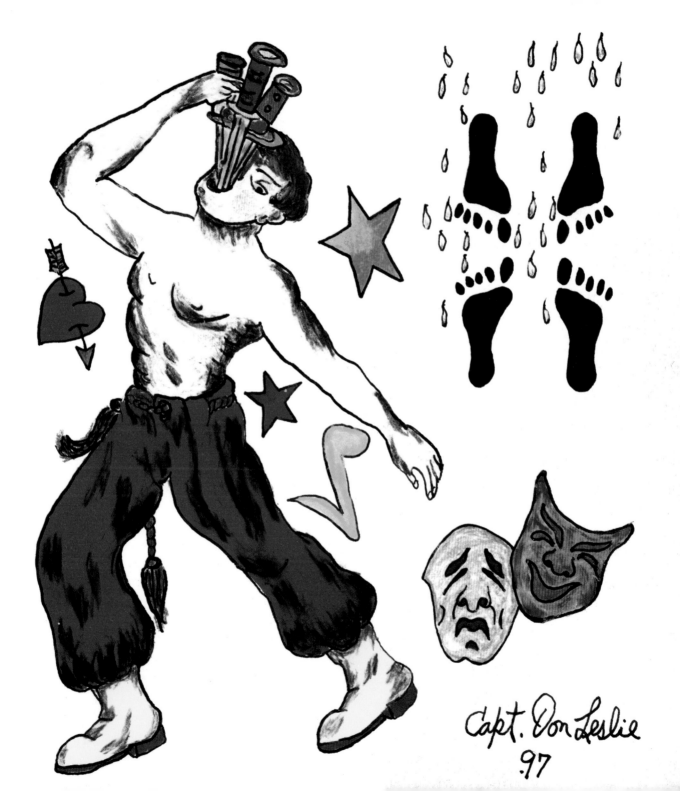

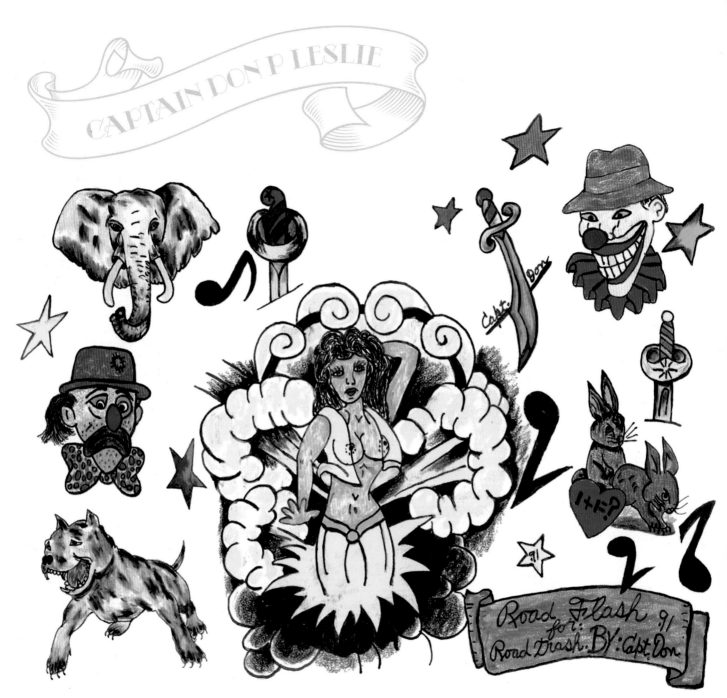

Road Flash '91
for:
Road Trash. BY: Capt. Don

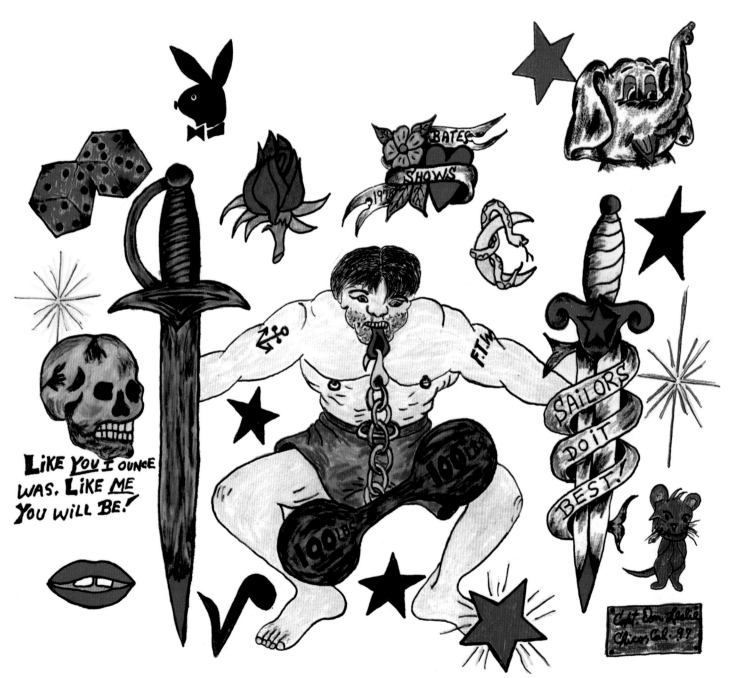

THE GREATEST SHOW ON EARTH

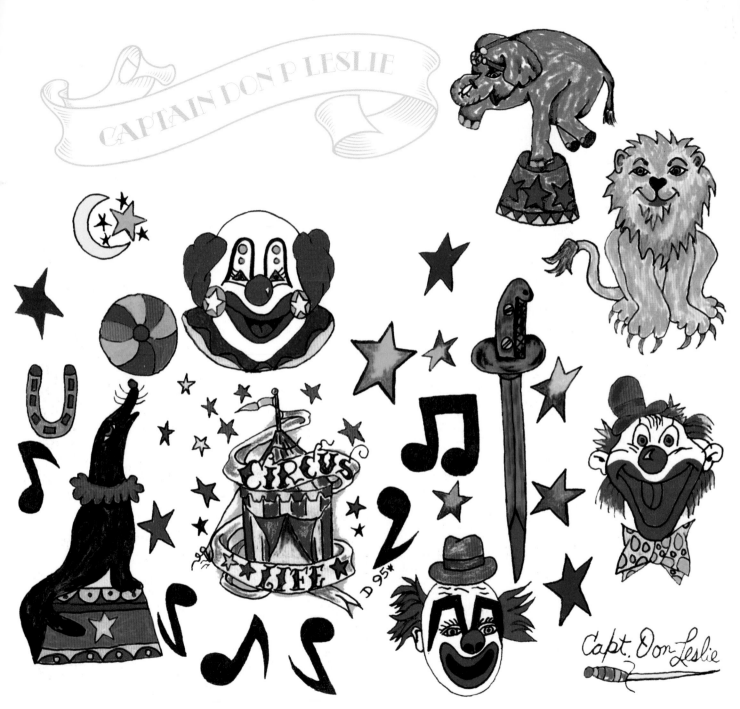

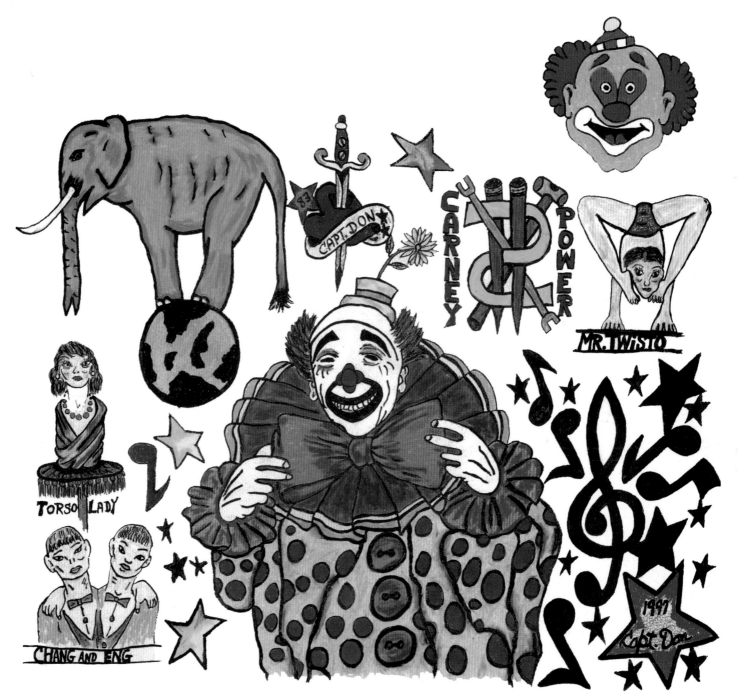

CARNEY POWER

MR. TWISTO

CAPT. DON

TORSO LADY

CHANG AND ENG

1997
Capt. Don

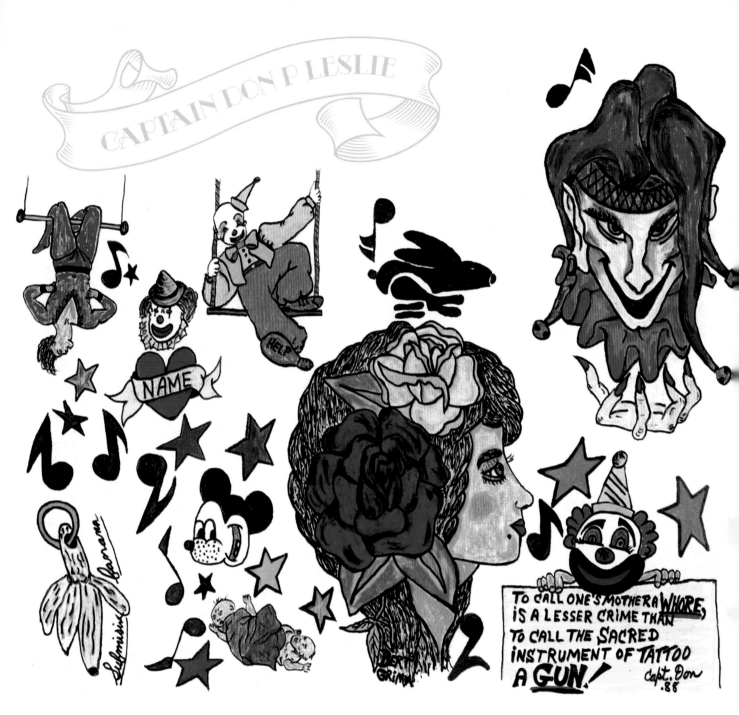

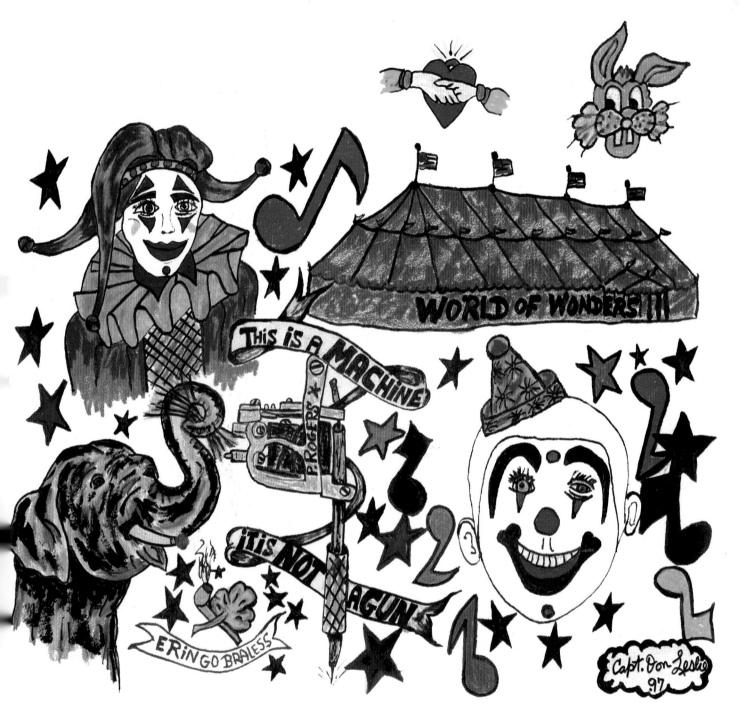

TATTOOED MEN FROM EXOTIC LANDS

Tattooed attractions certainly predated the circus in England. The concept of tattooed people as entertainment began long before the nineteenth century, with the first known exhibition of a human being taking place in 1691. Body-marking – viewed as a "pagan" activity – had been banned by the Church since 787 AD. But as pirates and adventurers started taking to the seas in great numbers, they returned with fantastic tales of exotic lands where the inhabitants decorated their bodies. And the living proof of this materialized in 1691, when the sailor, pirate and explorer William Dampier brought back to England a fully tattooed slave he had bought in the Philippines. Billed as Giolo, the Famous Painted Prince, and also known as Prince Jeoly, the islander was paraded around English carnivals as a curiosity, drawing gawping and frequently horrified crowds from far and wide.

Dampier had guaranteed his reportedly reluctant protégé a life of fame and riches and an eventual return to the Philippines. Unfortunately, the Painted Prince died from smallpox only three months after arriving in England, before he could take advantage of any of these promises.

Much happier was the experience of a Polynesian native called Omai, who was brought to British shores in 1774 on the orders of the renowned explorer Captain James Cook, towards the end of his second great voyage. Omai, from the island of Huaheine, near Tahiti, was groomed in social etiquette before being exhibited around England by Joseph Banks, one of Cook's adventuring colleagues, who was a leading naturalist and a future

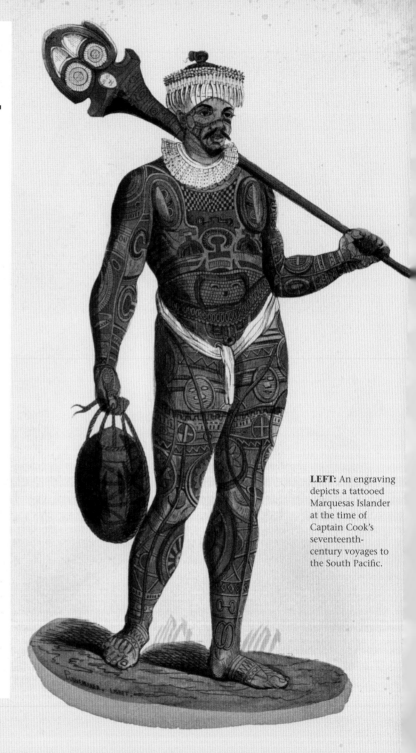

LEFT: An engraving depicts a tattooed Marquesas Islander at the time of Captain Cook's seventeenth-century voyages to the South Pacific.

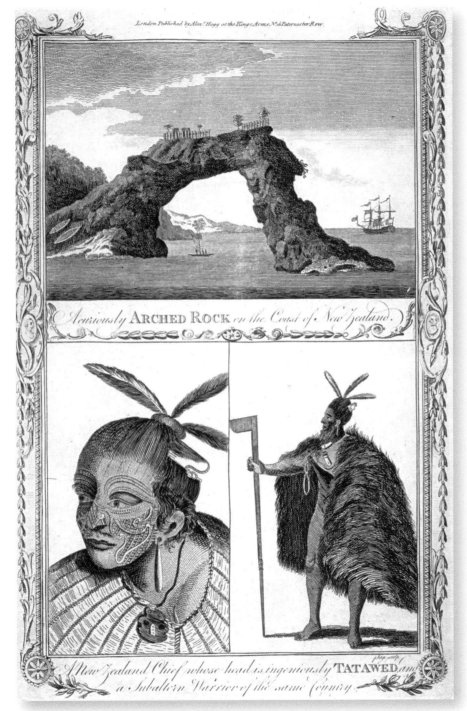

A curiously ARCHED ROCK on the Coast of New Zealand.

A New Zealand Chief whose head is ingeniously TATAWED, and a Subaltern Warrior of the same Country.

London Published by Alex.r Hogg at the Kings Arms, N.o 16 Paternoster Row.

LEFT: Etchings of various sights seen by Captain James Cook in New Zealand during his second voyage and illustrated in his journals, including a curiously arched rock along the coast, a tattooed chief and a subaltern warrior.

knight. The charismatic Omai wore robes that revealed only his tattooed hands and arms, and he responded naturally to his tutoring. He quickly charmed his way into the highest echelons of London society where, it is said, he triggered a brief craze for tattoos among the glitterati. Omai was presented to King George III and Queen Charlotte, and he accepted invitations to the theatre and exclusive events where his novelty was found both romantic and amusing.

Before long, all of Europe was hearing about the "noble savage" who moved among London's most fashionable circles. Omai was painted by many of the day's foremost artists – his portrait by Sir Joshua Reynolds sold at auction for more than £10 million ($19 million) in 2001 – and he made a great deal of money during his visit, which lasted a mere two years. In 1776, laden with expensive gifts, Omai sailed off over the horizon with Captain Cook, who was setting out on his third voyage, and disembarked the following year, back home in Huaheine.

Captain Cook was arguably the most important figure in Western tattoo history in this era. During the epic voyages he commanded, he and various colleagues made detailed notes about the body art they observed – and the tools used to create it – in territories such as Tahiti, New Zealand and the Hawaiian Islands (where Cook was murdered by natives in 1779). Their graphic descriptions, and the tattoos brought back by the deckhands, ignited a huge interest, especially among English sailors, who revived the practice after the centuries-long church ban. And it was the interaction of sailors with carnival and circus folk in Europe and America over the next century that eventually resulted in the artistic tradition we know today.

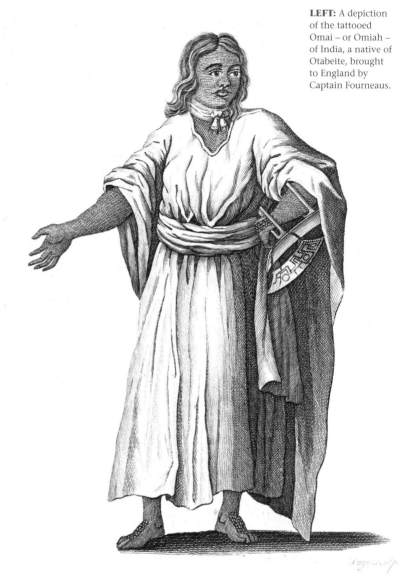

LEFT: A depiction of the tattooed Omai – or Omiah – of India, a native of Otabeite, brought to England by Captain Fourneaus.

OMIAH.

A Native of Otabeite, brought to England by Cap. Fourneaus.

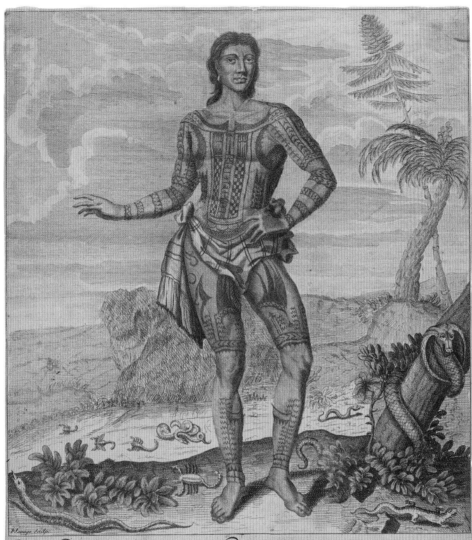

Prince Giolo Son to ye King of Moangis or Gilolo: lying under the Equator in the Long. of 152 Deg. 30 Min. a fruitful Island abounding with rich Spices and other valuable Commodities. This famous Painted Prince is the just Wonder of ye Age, his whole Body (except Face Hands and Feet) is curiously and most exquisitely Painted or stained full of Variety and Invention with prodigious Art and Skill perform'd In so much ye ancient and noble Mistery of Painting or Staining upon Humane Bodies seems to be comprised in this one stately Piece. The Pictures & those other engraven Figures copied from him & now dispersed abroad serve only to describe as much as they can ye Fore-parts of this inimitable Piece of Workmanship: The more admirable Back-parts afford us a Representation of one quarter part of the Sphere upon & betwixt his shoulders where ye Arctick & Tropick Circles center in ye North Pole of his Neck. And all ye other Lines Circles & Characters are done in such exact Symmetry & Proportion, that it is astonishing & surmounts all ye hither to been seen of this kind The Paint it self is so durable, & nothing can wash it off or deface ye beauty of it: It is prepared from ye Juice of a certaine Herb or Plant, peculiar to that Country, which they esteem infallible to preserve humane Bodies from ye deadly poison or hurt of any venomous Creature whatsoever: & none but those of Royal Family are permitted to be thus painted with it. This excellent Piece has been lately seen by many persons of high Quality & accurately survey'd by severall learned Virtuosi & ingenious Travellers who have expres'd very great satisfaction in seeing of it. This admirable Person is about ye Age of 30 graceful and well proportioned in all his Limbs, extreamly modest & civil, neat & cleanly; but his Language is not understood, neither can he speak English.

Sold by Iosseph Madley

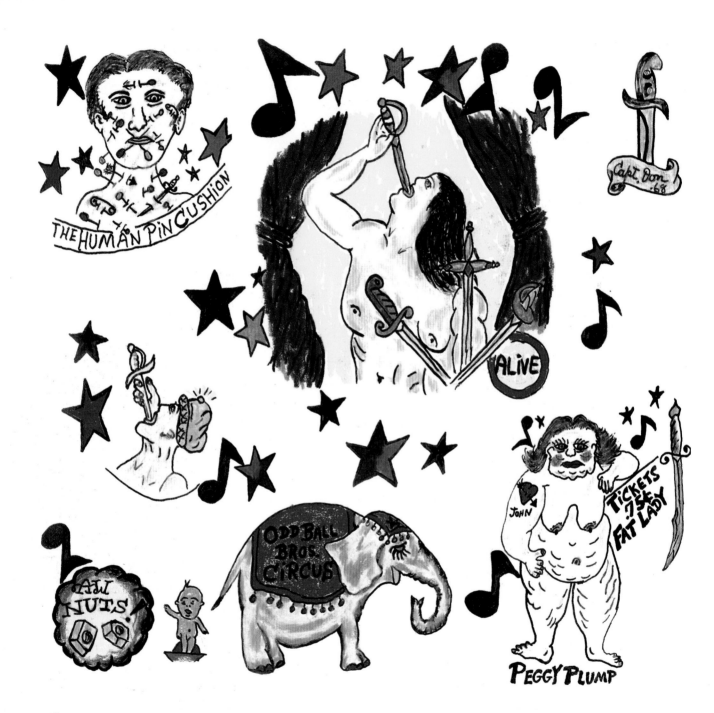

EUROPEAN ATTRACTIONS

Come the 1800s, Europe was starting to exhibit its own tattooed men. The first was Jean Baptiste Cabri, a French gentleman who, admittedly, had spent time living in Nuka Hiva, one of the remote Marquesas Islands in French Polynesia. There are differing accounts of how he got there. According to some sources, he was a deserter. According to others, he'd been shipwrecked. Cabri clearly initiated the tall tale, later spinning epic adventure stories about the "savages" who seized and tattooed him before finally accepting him so warmly that he was permitted to marry a chieftain's daughter. What is certain is that Cabri acquired his striking body art in the Marquesas Islands (the tradition subsequently exerted great influence on Western tattoo culture), and that on his return to so-called civilization, Cabri showed himself in Russia and then in fairgrounds across Europe.

More outrageous was England's first home-grown attraction, John Rutherford. He was fully adorned with Maori markings from New Zealand that he proudly showed off in sideshows in the late 1820s, after making his debut in Bristol. Of course, he too claimed to have been overpowered by natives, aggressively tattooed and then welcomed into the bosom of the community. He also, allegedly, joined in tribal battles and headhunting expeditions, and took not one but several wives before setting sail for home.

Fast forward 100 years, and England produced an extraordinary showman: Horace Ridler, also known as Zebra Man and, more famously, as the Great Omi. He was illustrated all over his body by London artist George Burchett, one of the world's most respected old-school tattooists. The gifted Burchett was once apprenticed to England's renowned Tom Riley and Sutherland MacDonald, though he was more used to inking his customers with nautical emblems such as ships, girls, hearts and flags. The Great Omi, a former British Army major, posed a different challenge when he visited Burchett in 1927. He wanted to have his existing, rather clumsily administered tattoos covered over with new and spectacular designs. And in his ambition to become a circus superstar, he insisted on having amazing black stripes tattooed onto his face. Burchett insured himself by demanding written permissions from Omi and his wife and stage partner, Gladys (the "Omette"), before beginning untold hours of work on the transformation.

Omi went further still, taking body modification to wild extremes. He had his teeth filed down to scary points and a tusk planted through his nose. He was an instant smash hit, courted on both sides of the Atlantic by the greatest travelling shows of the day – in Britain, Bertram Mills Circus, and in the United States, Ringling Brothers and Barnum & Bailey Circus. He became, as he had intended, one of the most popular and famous showmen of all time.

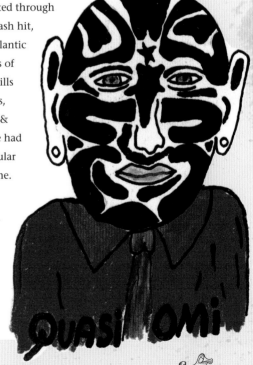

OPPOSITE: Captain Don Leslie's circus flash from 1968.

RIGHT: The Great Omi, who was tattooed by George Burchett, is pictured here in tattoo flash by Captain Don Leslie.

AMERICAN TALENTS

Following Europe's lead with Jean Baptiste Cabri and John Rutherford, America produced its first tattooed attraction with the exhibition of James F O'Connell in Barnum's American Museum, New York. Phineas T Barnum took over the museum in 1841, filling it with a mixture of educational and bizarre attractions so as to draw in a wide range of visitors. O'Connell, an Irishman with full-body tattoos, was among the original group of "peculiar people" gathered for the amusement of the public. Certainly, he was a sight to behold in the streets of Manhattan, with women and children running for cover when they saw him coming and preachers darkly warning their congregations not to look at him.

Not that it worried O'Connell. In 1846, setting a precedent followed by many circus freaks, he sold copies of a book about his "life and adventures" to supplement his income, and he went on to enjoy a long career. As for PT Barnum, he gave up on the American Museum in 1868 after seeing it ravaged by fire twice, and instead launched his own touring entertainment troupe. To this day, he remains one of the biggest names in circus.

A Greek man called Alexandrinos Constentenus, aka Prince Constantine, joined Barnum's Great Traveling Exposition in the 1870s. Constantine was more intricately tattooed over every imaginable part of his body than anyone had ever been, his skin a mass of intertwining images of real and mythical animals, human figures, flowers and leaves. Constantine is thought to have been the first person to undergo such major body work with the express intention of becoming an exhibit,

even though he peddled the usual yarns about being ambushed abroad and forced to submit to tattoo torture. His earnings were real enough: he raked in a fortune for many years to come. But his lasting legacy was his influence. He directly inspired a new generation of attractions, including soon-to-be tattooed ladies, as well as tattooists. New York's Charles Wagner is said to have set his heart on becoming a tattoo artist the moment he saw Constantine; he immediately set the wheels in motion for a 50-year career in which he became celebrated for decorating sideshow acts.

Wagner's good fortune was to become an apprentice and then a colleague of Sam O'Reilly, an Irishman whose clientele included numerous circus hopefuls as well as sailors seeking early versions of what would later become classic old-time tattoo images. The Rock of Ages was one of O'Reilly's popular designs.

Wagner learnt his trade in O'Reilly's "shoebox" shops – like many New York tattooists of the late nineteenth century, hidden away in all sorts of strange nooks and crannies, O'Reilly required minimum work space. Some practitioners were mobile, operating from wagons hitched to horses. O'Reilly's most convenient place of business was a spot at the back of a barber's shop in Chatham Square; it had an endless stream of male customers, many of them quickly attracted to the idea of a tattoo.

When O'Reilly invented the electric machine in 1891, his workload increased dramatically. He and Wagner inked elaborate full-body designs onto men and

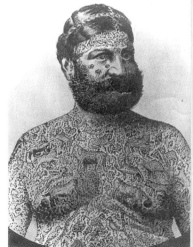

BELOW: The Great Captain Costentenus, one of the first tattooed men to be exhibited in the United States after James F O'Connell. The Greek Albanian was tattooed over every part of his body bar the soles of his feet.

women who hoped to join the circus. Four years before O'Reilly's death in 1908, Wagner perfected and patented a new, improved version of his mentor's machine with vertical coils, thus boosting business even more. He then developed a sideline selling his machines and other equipment, but, for his work during the first half of the twentieth century, Wagner was first and foremost hailed as the city's favourite artist, truly "the Michelangelo of tattooing".

ABOVE: Charlie Wagner's orignal tattoo machine, in pristine condition at the Triangle Tattoo Museum, Fort Bragg, California.

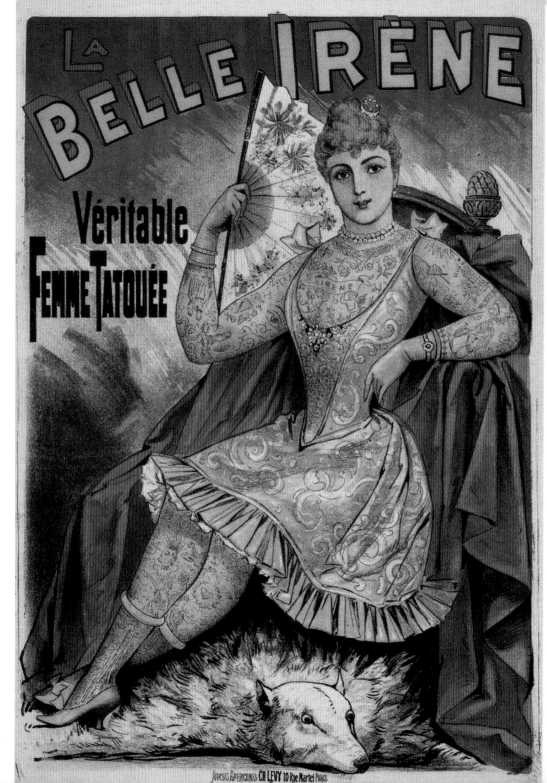

RIGHT: Irene Woodward, known as Le Belle Irene, pictured here on a postcard from the 1890s. Her tattoos were supposedly done by Samuel O'Reilly and Charles Wagner.

THE TATTOOED LADIES

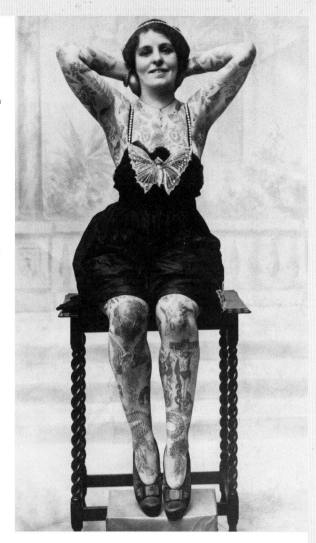

It was also in New York that America's first professional tattooed lady made her debut, in 1882. Nora Hildebrandt was the daughter of tattooist Martin Hildebrandt, a German who had set up shop in the Big Apple in the 1840s. When Martin was not applying his trademark freehand designs to soldiers, sailors and sideshow exhibits, he was working on Nora's skin. With a different tattoo for every day of the year, Nora stepped into the public gaze for the first time at Bunnell's Museum, a gallery of oddities set up by George B Bunnell in the style of Barnum's American Museum.

In the 1890s, Nora took to the road with the Barnum & Bailey Circus and showed off as much pictorial flesh as was decent, aiming for glamour in a corset top and matching bloomers, with strings of pearls wound round her neck and a feathery hat coquettishly tilted on her head. Nora talked the talk, breathlessly explaining to spectators that she and her father had been seized by Native Americans and forcibly tattooed. In other renditions, Martin had been ordered to tattoo his daughter by no less than Chief Sitting Bull; Nora was tied to a tree; and she was tattooed every day for a year. Then suddenly, for no apparent reason, she began confessing the rather more mundane reality to her audiences.

Within months of her debut, Nora must have been disappointed to be upstaged by Irene Woodward. Irene had been comprehensively tattooed by Sam O'Reilly and his apprentice Charles Wagner, although, naturally, she didn't admit it. According to some sources, Irene announced, rather blandly, that she'd voluntarily been inked by her father. Other stories say she claimed to have been tattooed in Texas as some sort of protection against, yes, those bad old Native Americans. Graduating from Bunnell's Museum, Irene went on to tour Europe, performing in London in 1890.

Tattooed women would soon earn much higher performance wages than their male counterparts.

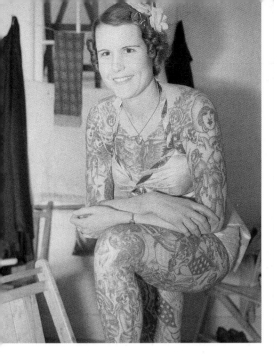

ABOVE: A tattoo attraction in the late 1920s and 1930s, Betty Broadbent had tattoos by Charlie Wagner and Joe Van Hart. Here Betty is shown in her dressing room as she prepares to appear in the John Hix "Strange As It Seems" freak house at the New York World's Fair in 1939.

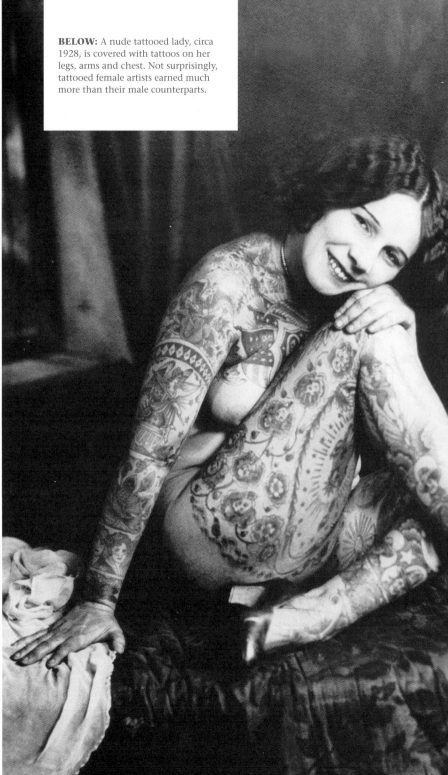

BELOW: A nude tattooed lady, circa 1928, is covered with tattoos on her legs, arms and chest. Not surprisingly, tattooed female artists earned much more than their male counterparts.

They became enormously popular. Not only were the women displaying extreme body art, a rarity in itself, but they were also permitting men to ogle parts of the female anatomy that were never willingly exposed in polite society.

Annie Howard and her husband, Frank, came to prominence in 1885 as one of the first examples of another sideshow phenomenon, the tattooed couple. Complete with extensive markings by Sam O'Reilly, they joined the Barnum & Bailey Circus – "The Greatest Show On Earth". Later, the Ringling Brothers were to buy this legendary circus, merging it with their own in 1919.

O'Reilly was also responsible for the artwork adorning an especially successful celebrity couple called Frank and Emma de Burgh. While O'Reilly was busy with his new electric tattoo machine in New York City, the de Burghs were in Europe showing off his creations to astonished audiences. Emma's backpiece – an extraordinarily detailed recreation of Leonardo da Vinci's painting *The Last Supper* (see page 176) – is regarded as one of O'Reilly's first masterpieces. This would soon become a staple in the better tattoo parlours. Frank de Burgh, for his part, sported a Mount Calvary scene across his back, and both he and his wife were liberally inscribed with many other religious images and declarations of love for one another.

Charles Wagner, meanwhile, was turning out some exceptional work. One of his most admired accomplishments was the body art he provided with colleague Lew Alberts, known as "Lew the Jew", for "Painless" Jack Tryon (see also page 21). In a great compliment to Wagner and Alberts, Tryon was lauded as "the world's most handsomely tattooed man" by virtue of his carefully designed and beautifully realized full-body suit. Tryon later became a reputed tattoo artist himself.

In another satisfying collaborative effort, Wagner worked alongside Joe Van Hart in the decoration of tattooed lady Betty Broadbent. Formerly a nanny in Atlantic City, New Jersey, Betty allegedly collected more than 350 tattoos before taking to the road in 1927 with a succession of leading shows, beginning with the Ringling Brothers and Barnum & Bailey Circus. She was exhibited at the New World's Fair in 1939 as part of the John Hix "Strange As It Seems" sideshow, and also appeared with Cole Brothers, King Brothers, Sells-Floto and Harry Carey's Wild West Show. Betty thoroughly enjoyed her 40-year career. She spent her winters tattooing other people in San Francisco, and two years before her death in 1983, she was the first person to be inducted into the Tattoo Hall of Fame.

Mildred Hull, like Betty, was an all-over tattooed lady inked by Charles Wagner, and she, too, became a tattooist, working out of a barber's shop in the Bowery, New York City. Mildred, known as Millie or Mary, was memorable for belonging to the Butterfly Club, being the proud owner of a butterfly tattoo across the most intimate part of her body. Sadly, she died by suicide in 1947.

In the earliest days of exhibition, the tattoos themselves could be rudimentary – a riot of lines, linking patterns and images, including many beloved of sailors. Other body suits, such as those of Painless Jack Tryon and Emma de Burgh, were works of art. The craft of vintage tattoo was developing steadily as artists focused on the quality, detail, character and impact of the illustrations they designed, as independent pieces or as intrinsic parts of an ensemble. The sideshow freaks, however, were doomed to extinction. By the end of the Second World War, the public had lost interest. They'd been there, seen that – and, today, they can even buy the T-shirt.

PERCY WATERS

A foundry worker from Alabama, Percy Waters was born in 1888 and began tattooing locals in his hometown of Anniston. After settling in Detroit around 1918, he built up a successful tattoo supply business, often cited as the largest in the world in the 1920s and 1930s, and went on to design and manufacture tattoo equipment, inscribed with his name. In 1929 he gained a patent for what was considered the first modern electric tattoo machine, and which is still in use. Today his machines are highly prized collector's items and on offer for thousands of dollars. Back then, however, for as little as one dollar, Waters would offer an instruction manual on tattooing, billing himself as Professor Percy Waters and "Just a Good Tattooer". He also advertised to help new artists find work in the circus circuit or to gain an apprenticeship with an established artist.

Reportedly trained by Charlie Wagner, Percy tattooed many famous circus acts, such as Pearl Hamilton, Detroit Dutch, Clyde Williams and Shelly Kemp, and in his alternative career as a photographer immortalized many of these entertainers on tattoo pitchcards, which were sold at circuses.

OPPOSITE AND THIS PAGE: Percy Waters' flash shows the classic "Mother" tattoo and a patriotic sailor girl, among others. He is considered among the best of the old-school artists.

RIGHT: An instruction booklet on professional tattooing, published by Percy Waters in 1932.

PROFESSIONAL
Tattoo Artists Guide
Full Intructions On
TATTOOING
PUBLISHED 1932

Prof. Percy Waters
25 Years Experience in
Decorating the Human Body
Detroit's Tattooing Artist

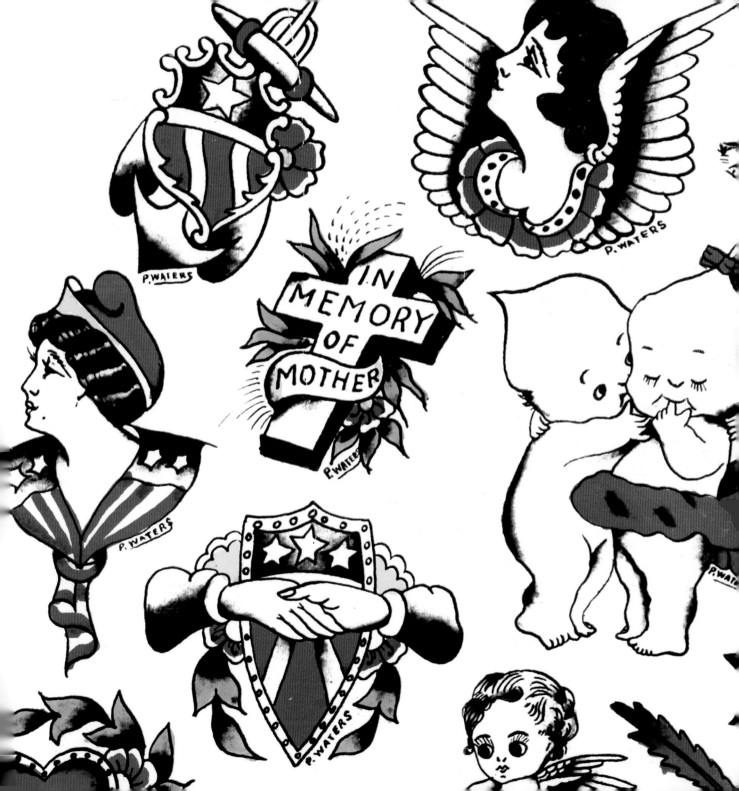

PERCY WATERS

Real Photo Postcards bearing Waters imprint are generally high quality and photographed in a distinctive and dramatic style. They are reproduced by developing the photograph directly onto photographic paper with a postcard backing and are thus made up of solid colour, not dots. These cards were sold by the performers, as well as by Waters himself through his Detroit company catalogues, and bear the mark Waters Detroit.

BELOW: A catalogue illustration advertising one of Percy Waters' tattoo machines, from 1928.

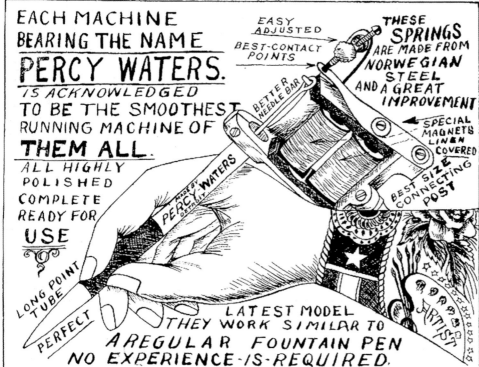

EACH MACHINE BEARING THE NAME **PERCY WATERS**. *IS ACKNOWLEDGED* TO BE THE SMOOTHEST RUNNING MACHINE OF **THEM ALL**. ALL HIGHLY POLISHED COMPLETE READY FOR USE

EASY ADJUSTED BEST-CONTACT POINTS

BETTER NEEDLE BAR

MADE BY PERCY WATERS DETROIT

THESE **SPRINGS** ARE MADE FROM NORWEGIAN STEEL AND A GREAT IMPROVEMENT

SPECIAL MAGNETS LINEN COVERED

BEST SIZE CONNECTING POST

LONG POINT TUBE

PERFECT

LATEST MODEL THEY WORK SIMILAR TO A REGULAR FOUNTAIN PEN NO EXPERIENCE IS REQUIRED.

ARTIST

ABOVE: Examples of Percy Waters' tattoo flash from 1928. Flowers and hearts were a prevailing theme, as shown in the emblems and bracelets here.

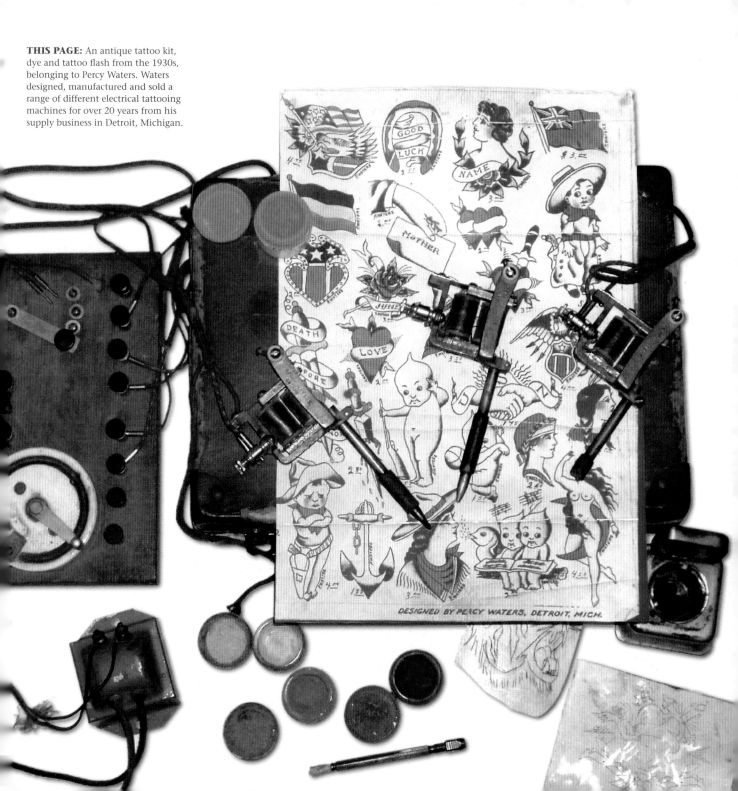

THIS PAGE: An antique tattoo kit, dye and tattoo flash from the 1930s, belonging to Percy Waters. Waters designed, manufactured and sold a range of different electrical tattooing machines for over 20 years from his supply business in Detroit, Michigan.

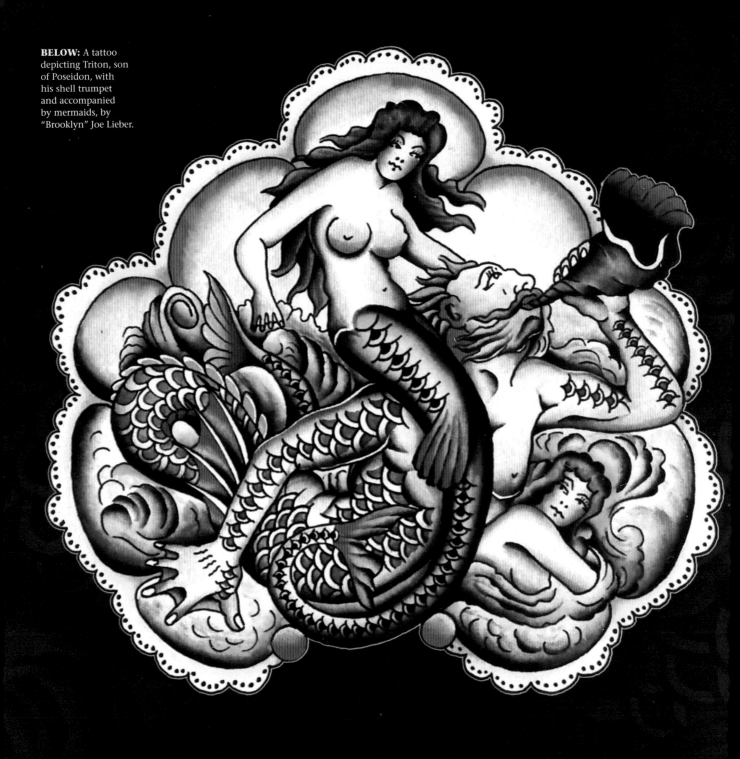

NAUTICAL & PATRIOTIC TRADITIONS

From the first days of maritime tattooing, sailors flaunted emblems that encompassed the entire experience of being at sea – their vessels and everyday duties, military purpose and patriotism, shore leave, faraway loved ones as well as their enemies, achievements and comradeship, superstitions and religious beliefs, hopes and fears, and their acknowledgement of those who perished beneath the waves.

Between the late 1800s and the 1950s, these nautical images developed a distinct style and personality that placed them at the heart of what we now know as vintage tattoo. People often use the expression "sailor tattoos" to refer generally to this old-school art form, whose simplicity was key to everything. The designs – single images and combinations – were boldly drawn and solidly, often vividly, coloured. At the same time, they could be remarkably detailed and shaded, and their inimitable Western character carried some stylistic influences from Europe and Asia.

While many tattoos were straight-forwardly pictorial, others caught something of a feeling or an atmosphere – for instance, a sombre reflection or a pin-up girl's naughty wink, a glimpse of beauty or a bawdy joke, a surge of pride or a sense of purpose.

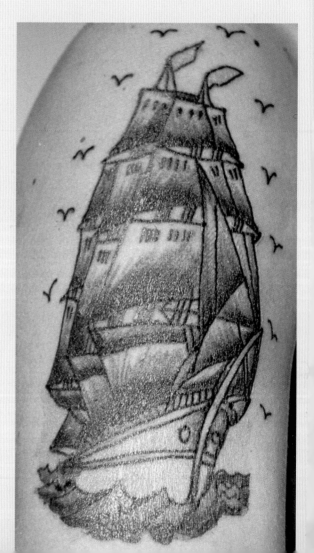

ABOVE AND OPPOSITE: A sailor cat, from the sheet of tattoo flash on the facing page by Bristol-based artist Trevor Hodge, which depicts further nautical images and memorials.

RIGHT: A full-rigged sailing ship, splitting the waves with sea-birds in the background, is one of the most well-known nautical tattoos. This one is displayed on arm of a US sailor, circa 1940.

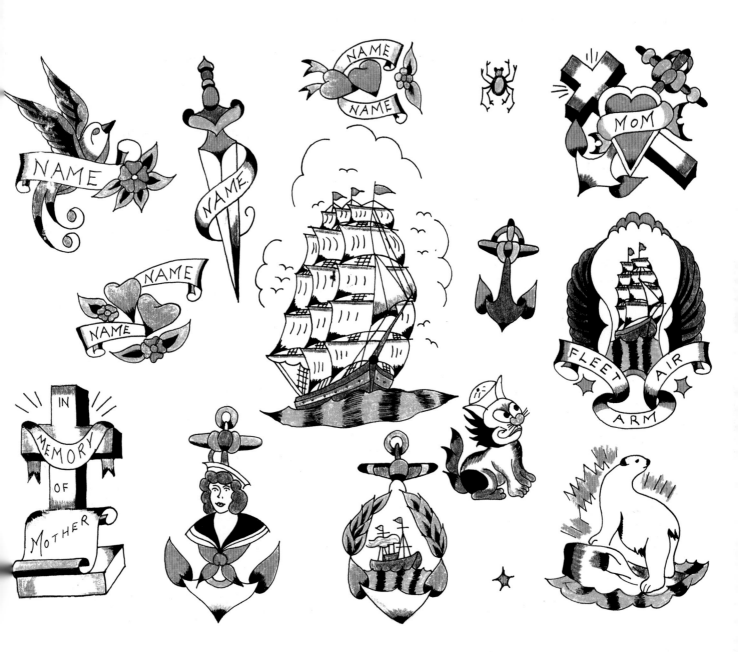

SAILING SHIPS, SLOGANS AND SUPERSTITIONS

The most dramatic and intricate designs were those of the clipper or full-rigged ship, complete with billowing sails, which often appeared grandly in the centre of the wearer's back. Early seafarers in the South Pacific were entitled to a sailing-ship tattoo if they completed the perilous voyage around Cape Horn. According to other traditions, the same journey gave a sailor the right to a small, blue, five-pointed star on the left ear. Five trips around the Cape would enable him to match it on his right ear. Ten trips and he earned red forehead markings. But as ocean travel became safer, the clipper came to represent a wider tribute to the sailing tradition.

One variation of the ship tattoo saw the vessel sinking, accompanied by the words "Sailor's Grave" and a combination of nautical illustrations, commonly anchors, spread eagles and flowers. This expressed an acceptance of danger while also remembering ships and men lost at sea, as did the Davey Jones skull-and-crossbones design, usually appearing with an anchor, and the Davey Jones' Locker, which is a direct reference to the seabed where many an unfortunate sailor ended his life. The pirates' Jolly Roger flag, in contrast, speaks only of hazard on the high seas. In wartime, clipper tattoos in America

RIGHT: A classic Bert Grimm lighthouse design incorporates an anchor, rope, star and other nautical themes, as well as the United States Navy initials at the top.

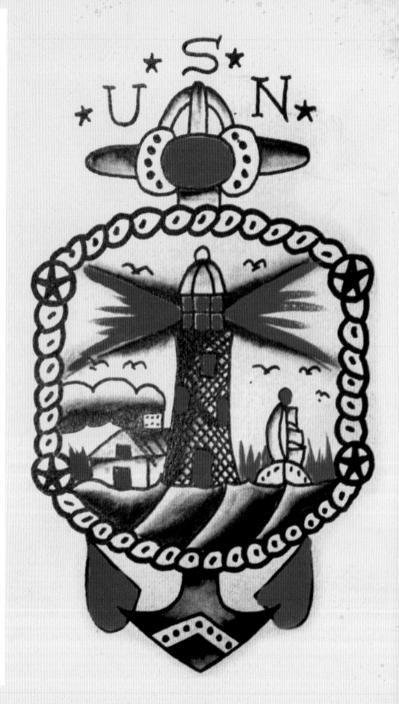

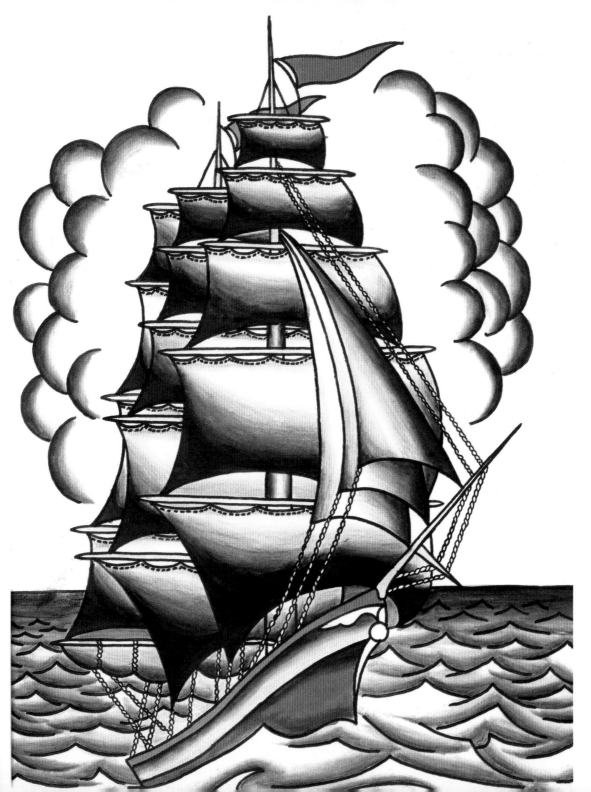

LEFT: A clipper ship tattoo by Danny Danzl of Seattle, from the 1950s with detailed rigging and a background of clouds. The image is not just worn by sailors however: many view a sailing ship as a metaphor for life, as sometimes there is smooth sailing and other times storms and rough seas.

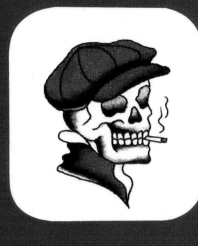
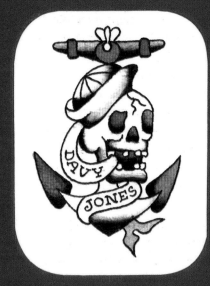

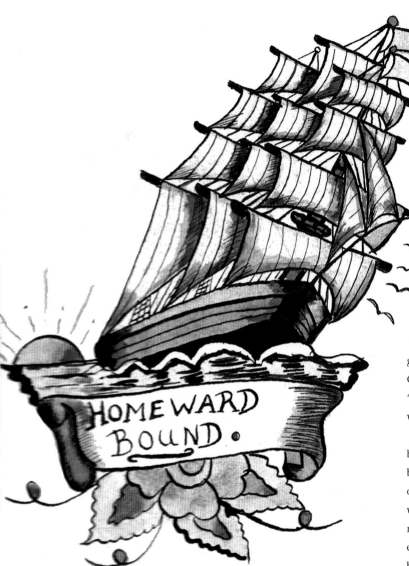

were often connected specifically to the US Navy with flags, initials, eagles and morale-boosting slogans. Optimistically, tattoos would show banners proclaiming "Homeward Bound" decorating ships headed proudly through the waters with a sunset or a warm sun behind them, sometimes followed by the bluebirds or swallows, whose presence alerted sailors to the fact that they were nearing land. Symbols of good luck, the birds also once signified extensive travel: a sailor who notched up 5,000 miles would have a bluebird inked on his chest, and when he doubled that distance, he would add a second one.

Nautical stars, particularly the Southern Cross, became hugely popular tattoos, not only as a tribute to ancient navigational methods but as an appeal for guidance and protection. The Rock of Ages or the Sailor's Cross similarly functioned as a talisman, as did the words "Hold" and "Fast" across the fingers: riggers hoped this would save them from losing their grip.

They may have been a tough, rowdy, hard-living bunch by and large, but seamen were a superstitious breed, with many claiming to have seen mermaids. One of the world's most irresistible mythological characters, with her propensity to lure sailors to their death on the rocks, the mermaid was feared, adored and tattooed as enthusiastically as the safer port names, hula girls and banners that proclaimed love for sweethearts and family members. (Although, having said that, the hula girl occasionally showed up in mermaid form, or as a pirate.) Similarly, the rooster and pig, tattooed on the feet, were believed to guard a sailor from drowning. A pig was tattooed on the left foot and a rooster on the right. Since

ABOVE: A Homeward Bound ship by Les Skuse, circa 1950s. The image leans extremely forward, suggesting an urgency for home.

LEFT: Various classic designs by Chicago artist Tatts Thomas, including the Davy Jones skull-and-anchor, which refers to the final resting place of sailors – the bottom of the sea.

neither of these animals can swim, they would want to get the seaman back to shore quickly.

The nuts and bolts of daily life on the sea were immortalized in images such as the rope and the anchor. The anchor image has multiple interpretations. In ancient days, it symbolized ocean gods, but later indicated that the bearer had crossed the Atlantic. It also acted as a secret observation of Christianity. Always, though, it meant stability in life and faith in whatever came afterwards.

Many sailors wore tattoos as souvenirs of the places and sights they'd seen, collecting them as cheerfully and casually as holidaymakers picking up postcards and souvenirs. Others were more serious or more selective about what they chose to make permanent on their skin. One thing was clear, though. As New York tattooist Sam O'Reilly once memorably remarked, "A sailor without a tattoo is like a ship without grog: not seaworthy." Even Popeye, the popular cartoon sailor, sports anchor tattoos. Another anchor-wearer was Sir Winston Churchill, Britain's great wartime leader, who reputedly had the image tattooed on his right arm, even though he'd been a soldier and not a sailor.

Some seamen, on leaving the forces, decided to add to their existing tattoos and seek exhibition work with circuses and carnivals. Some instead focused on becoming tattooists, having admired and understood the tattoo culture of the lands they had visited as well as those they came from.

RIGHT: Tattoo legends Charlie Barr and Bert Grimm, photographed in the 1950s. Grimm's Nu-Pike tattoo parlour was, for generations, the place where sailors would go to get inked.

OPPOSITE: A selection of historic nautical Bert Grimm designs, including the swallow, nautical star, anchor and Sailor's Grave, which has a sinking ship as its central motif.

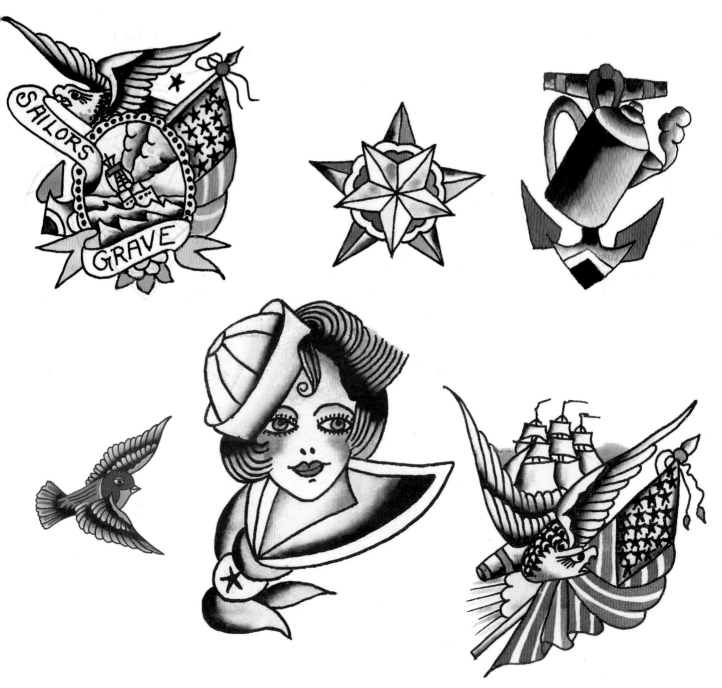

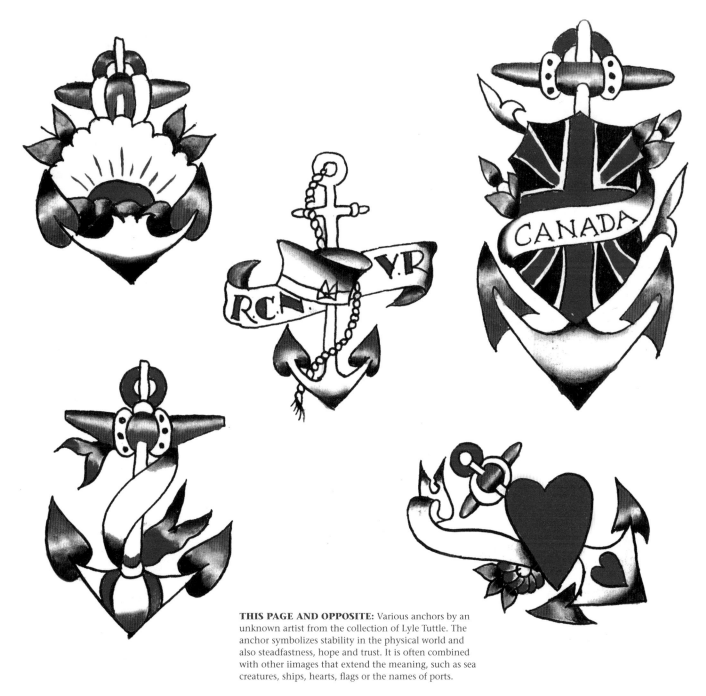

THIS PAGE AND OPPOSITE: Various anchors by an unknown artist from the collection of Lyle Tuttle. The anchor symbolizes stability in the physical world and also steadfastness, hope and trust. It is often combined with other iimages that extend the meaning, such as sea creatures, ships, hearts, flags or the names of ports.

CAPTAIN COOK INTRODUCES THE ART OF TATTOO

While many of the great personalities in classic Western tattoo art were American, Europe too had its heroes and pioneers. In the United Kingdom, the names of Tom Riley, Sutherland MacDonald and George Burchett are held in the highest esteem, and it is in English history that vintage tattoo has its origins (see also pages 38–41).

It was triggered, unwittingly, by Captain Cook when he made his first voyage in 1769 to the South Pacific island of Tahiti, and continued to New Zealand. Included in his crew were two artists, Alexander Buchan and Sydney Parkinson, whose job was to paint and sketch the sights they saw on their travels. Parkinson, in particular, made many detailed drawings and notes about the tattooed Polynesian natives and Maoris they encountered during the expedition – and the same drawings are now on display at the British Museum in London. Joseph Banks was on board, too, keeping journals, and on this trip he was presented with the preserved head, complete with tattoos, of a decapitated Maori.

It was on his second Pacific voyage that Cook instructed one of his captains to transport the native Omai back to England as a living specimen, in 1774, and it was Joseph Banks who successfully groomed the Polynesian in the niceties of social etiquette. The Captain's third and final South Seas expedition took the voyagers to Hawaii, then called Sandwich Island. Cook himself wrote descriptions in his log of the particular characteristics of Hawaiian tattooing.

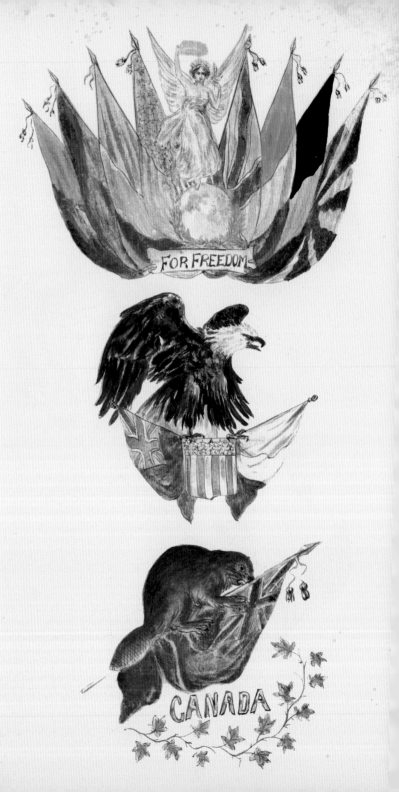

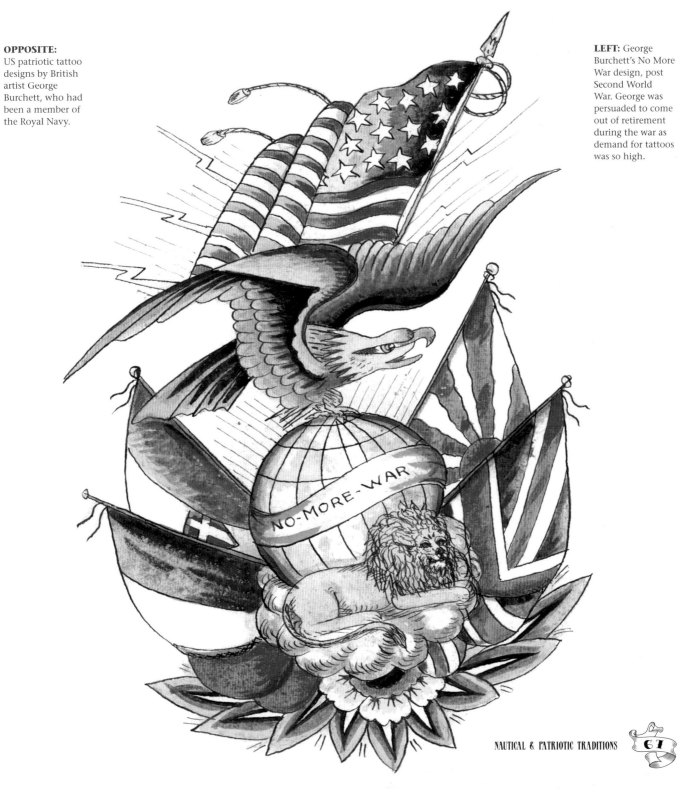

NO-MORE-WAR

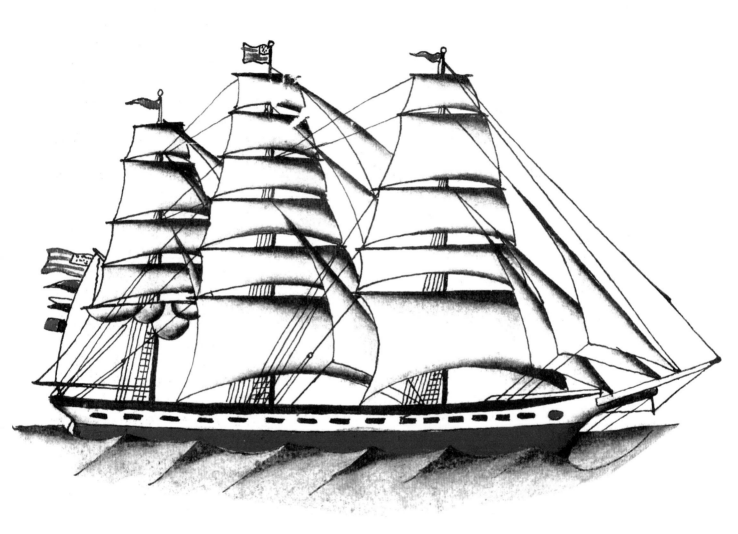

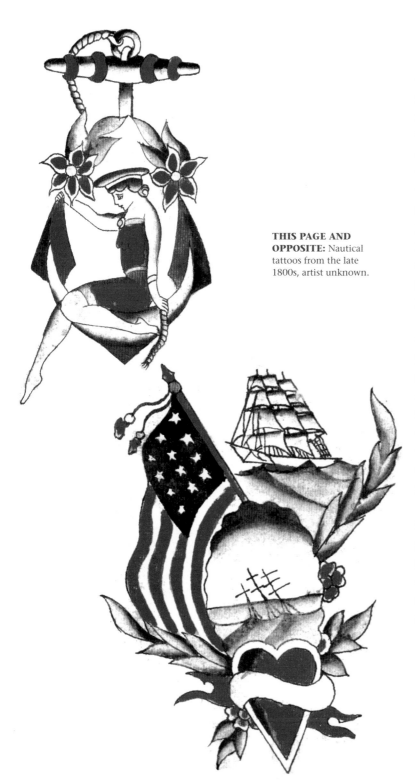

THIS PAGE AND OPPOSITE: Nautical tattoos from the late 1800s, artist unknown.

Captain Cook and his explorers were not the first nor the last to bring back evidence of native tattoo culture in foreign lands. In 1576, Sir Martin Frobisher, who had failed to find a route to China, returned to England with a tattooed Eskimo woman. In the early 1600s, John Smith, a British settler in Virginia, wrote of being seized by tattooed Native Americans who intended to kill him, only to be rescued by the real-life 13-year-old Pocahontas. And it was in 1691 that William Dampier sailed back from the Philippines with the tattooed slave curiosity Giolo, the Famous Painted Prince (see page 41). In the early 1800s, after Cook's death, the English naturalist Charles Darwin filled his diaries with impressions of the tattooed Pacific Islanders he had personally discovered.

But it was the efforts of Cook's team – the writings, the drawings, the extraordinary Omai and the newly inked tattoos shown off by the crew members (including artist Sydney Parkinson) – that captured the imagination of sailors everywhere and kick-started the tradition of tattoos in the Royal Navy. Some 21 of the 25 mutineers on the *Bounty* in 1789 had been tattooed in Tahiti, and these markings later helped to identify them for the parts they had played in overthrowing their captain, William Bligh, a veteran of the Cook voyages.

By the late 1800s, the British Army not only tolerated but encouraged tattoos, and not just among the rank and file but for the officers, too. Field Marshall Earl Roberts believed that everyone should be permanently marked with their regimental crest, reasoning that it would boost morale. On a more practical if morbid level, it would help to identify dead and injured soldiers more quickly.

Royal Tattoos and A-List Clients

High society had flirted with tattoos for a short time in the previous century after falling in love with Captain Cook's exotic Omai. Now, again, the fad was rife among aristocrats and military officers, the wealthy and the privileged in Britain. They followed the example of the Prince of Wales – the future King Edward VII – who had a Jerusalem Cross etched into his arm in 1862. Twenty years later he arranged for his sons, Albert and George (his successor to the throne), to visit the great Japanese tattooist Hori Chyo, and also to bare their flesh in Jerusalem for his own original tattooist.

With tattoos once again fashionable in upperclass circles, the wealthy sought to be illustrated by the likes of Tom Riley and Sutherland MacDonald, who styled themselves as "respectable" tattooists and were both adept at promoting themselves – Riley, most famously, with his water buffalo stunt (see also page 23).

MacDonald learnt the fundamentals of tattooing in the British Army, and is also said to have had art-school tuition before setting up shop in central London. He went on to forge an individual style that utilized Japanese influences in both design and technique: he was proud of creating a shade of green that no other tattooist could reproduce. Taking inspiration from Eastern wood carvings, he turned out stylized representations of all sorts of animals, reptiles, birds and mythical creatures, and also, allegedly, scored a first by copying world-class paintings on to his clients' skin. One of these, *Head of Christ Crowned with Thorns* painted in the 1630s by the Italian artist Guido Reni (see also page 177), went on to become a popular backpiece emulated by tattooists across Europe and the United States.

By virtue of his undisputed talent and polished self-publicizing, MacDonald became a darling of the A-list with a clientele that included royals, top-ranking navy officers and international leaders. In 1897 *The Strand Magazine* reported that his work was "the very finest tattooing the world has ever seen." He tattooed in London in Jermyn Street until his death in 1937.

Tom Riley's career followed a similar path. He was a naturally talented artist who studied tattoo craft in the army and carried out his practical work experience on fellow soldiers. Leaving the forces, he became a full-time tattooist, opening a shop in London and using his ingenuity to attract column inches and fulsome praise. Like MacDonald – his only real competition – Riley was very much in demand among the bluebloods and the well-off, at home and abroad. He was not above travelling long distances to court custom in Europe.

This was a million miles from the working-class tattoo culture that was steadily growing in every port, in the sailors' ramshackle playgrounds, as the century drew to a close. But Riley's success was largely enabled by this "downmarket" wellspring. He was the first person in Britain to enjoy the novelty and the huge benefit of the electric tattoo machine, patented by his cousin Sam O'Reilly in New York, and suddenly the process of tattooing became faster, more reliable, less painful and popular like never before across the entire western world.

REMARKABLE DESIGN TATTOOED ON H.R.H. THE DUKE OF YORK.

RIGHT: The Duke of York (later King George V), being tattooed by Hori Chyo with the image of a dragon, shown opposite. Hori Chyo was a traditional Japanese tattooist who, according to George Burchett's memoirs, had tattooed many British aristocrats.

LEARNING THE ROPES

By no means all of the great old-time tattoo artists had been sailors themselves, despite the roll call of famous practitioners who had very obviously been at sea, among them those known as Sailor Jerry, Sailor Charlie Barrs, Sailor George Fosdick, Sailor Gus and Sailor Walter. Other artists learned from older tattooists, either by paying for lessons or by becoming protégés or apprentices. The apprentices had to be prepared to work as skivvies, helping out around the parlours, going on errands, and cleaning and mending equipment. They cut stencils and traced flash designs when they weren't discreetly watching the masters at work, and so they received a thorough grounding in every aspect of the job before graduating to the tattoo machine itself.

Unlikely as it may sound, some prospective tattooists got to grips with the basics by mail order. Paul Rogers was one such enthusiast. Born in North Carolina in 1905, Rogers would eventually become one the world's most respected vintage tattoo artists, on account of his confident and colourful designs. He worked in cotton mills from his early teens, acquiring his first tattoo at 21. He subsequently sent off for a tattoo kit, and practised on friends and family before joining a travelling carnival – carnivals and circuses offered the other, third, established training option for up-and-coming tattooists (see also page 21).

Baltimore's Charlie Geizer took this route. He was the same age as Rogers, but he joined the circus as a young boy, going on to perform as an exhibit with a noteworthy backpiece – the Garden of Eden – before turning tattooist. The husband and wife team Joe and Mabel Darpel likewise trod the circus path – Joe as an attraction with a body suit tattooed by Bert Grimm and Mabel as a knife-thrower – before they set up as artists in 1927. All of these people, via their differing journeys, ultimately arrived in the ports of America, having inscribed sailors with the enduring emblems of the era.

New York and Chicago were the United States' first centres for tattooing, beginning in the mid-nineteenth century. From New York's ensuing history, the names of Sam O'Reilly, Charles Wagner, "Lew the Jew" Alberts and Brooklyn Joe Lieber are among those who live on in legend, with the Coney Island seaside resort also becoming famous as a centre for many tattooists.

The tradition quickly spread along the East and West Coasts of America, and in southern parts such as New Orleans, where Charlie Geizer stopped for a time. The tattooists moved from one town or city to another, often collaborating with others during their travels, before settling down in one location – if indeed they ever did truly settle.

THIS PAGE: Tattoo flash from Tattoo Johnny, undated. Ropes were common sailor motifs, as were images containing the linking chains of an anchor. Traditionally, deckhands had a rope tattooed around their wrist to show their profession.

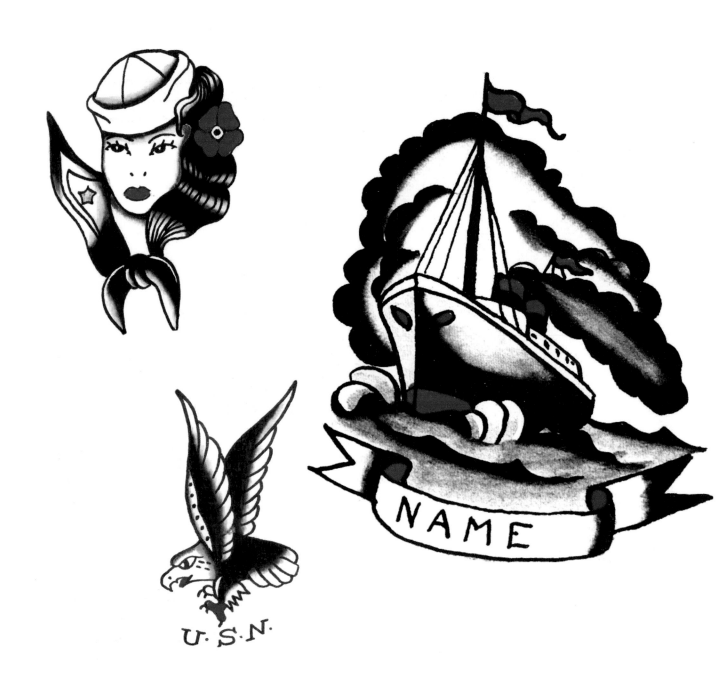

NAME

U·S·N·

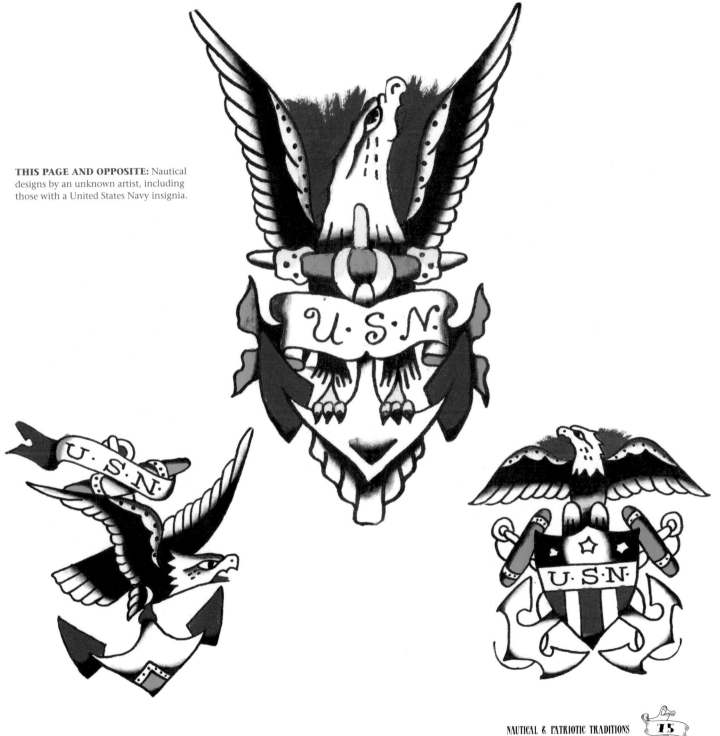

THIS PAGE AND OPPOSITE: Nautical designs by an unknown artist, including those with a United States Navy insignia.

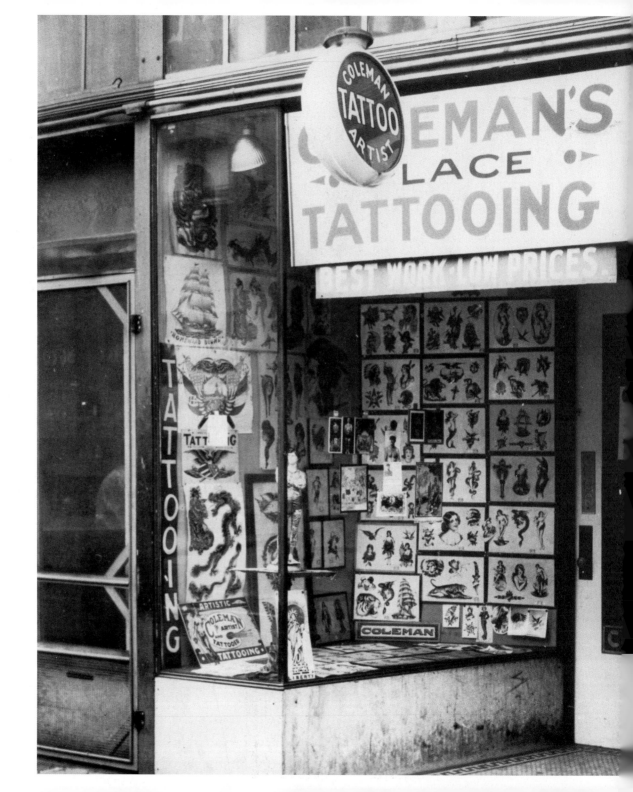

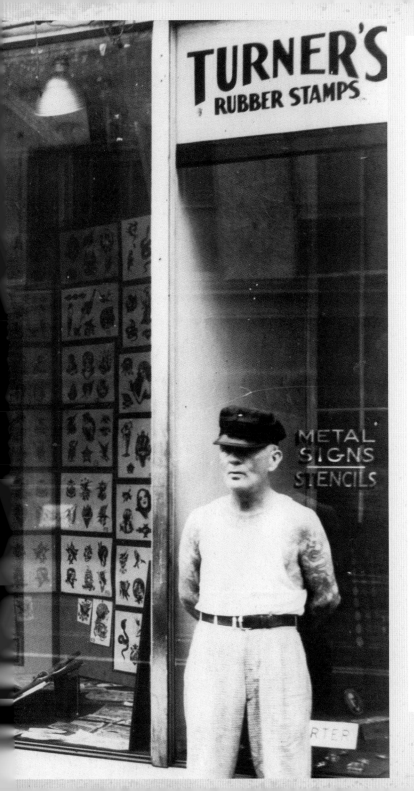

THE EAST-COAST PORT OF NORFOLK, VIRGINIA

The most important East Coast tattooing location in the US outside of New York was the busy navy port of Norfolk, Virginia, where a community of talented artists plied their trade throughout the early to mid-1900s. They included Augustus "Cap" Coleman, Sailor Charlie Barrs, Paul Rogers, Bill Grimshaw and Joe and Mabel Darpel, who ran a supply business from here in the 1940s.

Cap Coleman was based in Norfolk's Main Street, a prime location near the red-light district, and he built a reputation that is revered today – as it was in his heyday, among sailors and fellow artists alike. He adhered to the traditional bold outlines and vivid colours of old-school tattoo but varied the format with a stylized approach to ships, anchors, mermaids and so on, and this became his signature. He also operated a sideline supplying materials and machines. Coleman had moved to Norfolk from his Cincinnati, Ohio, hometown in 1918, and after that, at different times, invited Sailor Charlie Barrs and Paul Rogers to come and work with him. Both took up the offer.

In the late 1940s, Sailor Charlie also worked with Bill Grimshaw in Norfolk, but he is much more strongly connected with the West Coast. Paul Rogers, after an itinerant career, decided to give things a go in Norfolk.

LEFT: Cap Coleman outside his tattoo parlour in Norfolk, Virginia, where he settled around 1918. Flash decorates the shop window on East Main Street.

He had long worked on the carnival circuit where by good fortune he met his wife, Helen – daughter of the owner of the John T Rea Happyland Show. They spent ten years touring America each summertime, but when the fairgrounds and circuses shut up shop for the winter, Rogers would return to the cotton mills to earn his crust. He took the plunge into full-time tattooing in the early 1940s, opening a shop in Charleston, South Carolina. Three years later, he relocated to Norfolk at the behest of Cap Coleman.

Rogers stayed in Norfolk until the local authority banned tattooing in 1950. He then opened a shop across the Elizabeth River at Portsmouth, Virginia, before travelling on to a number of other towns where he went into business. Finally, he returned to Portsmouth, and that's where he and Helen now rest in peace.

Cap Coleman also moved to Portsmouth when the ban was introduced, as did Bill Grimshaw. Poignantly, Coleman, whose life's work centred on sailors and nautical art, died from drowning in 1973, having apparently lost his footing and tumbling into the Elizabeth River. He left a great deal of money to local charities and organizations.

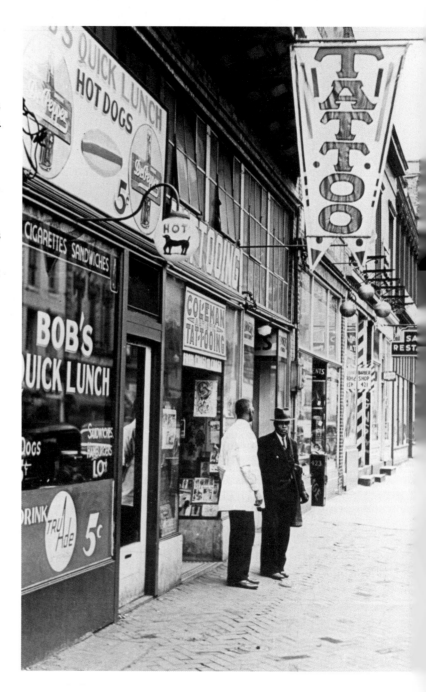

RIGHT: Another period view of Cap Coleman's shop in Norfolk, Virginia, before the town prohibited tattooing in 1950.

OPPOSITE: Cap Coleman at work. His particular vivid stylizing is known as the "Coleman School" of tattooing, which is still popular today. A master of shading, he created easily readable, open designs that, with their firm black outline, remained clear even when the colours had faded.

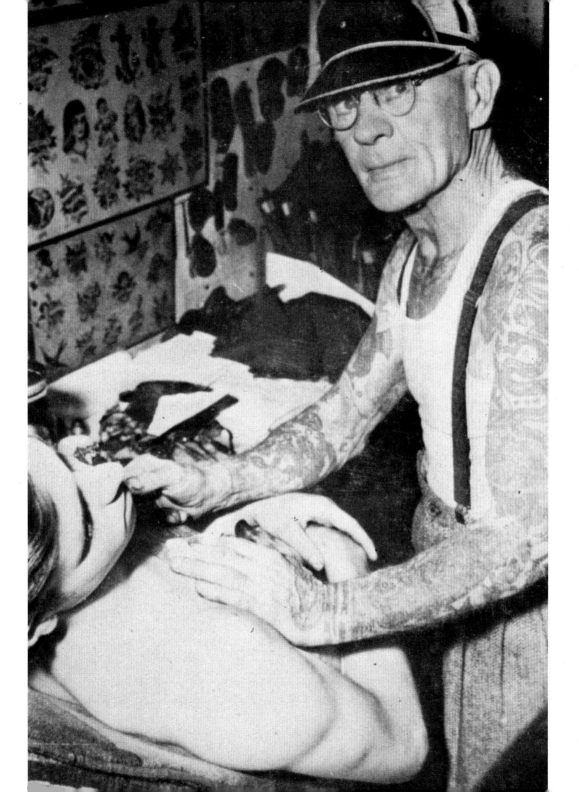

TATTOO TOWNS ALONG THE WEST COAST

The West Coast of America seemed to be more popular than the East among the greats of the tattoo world, as there were many naval bases and work was better paid, with northern towns such as Seattle and Portland proving profitable destinations. Sailor George Fosdick, Charlie Geizer and Bert Grimm all stopped off in Seattle, but Portland was the enduring attraction.

It was here that Fosdick hung up his hat, in or around 1912. Fosdick, born in Wisconsin in 1885, designed some spectacular body suits during his career. In the mid-1920s, this work would have cost the customer a whopping $300. Fosdick was not a typical character in tattoo circles. Granted, he had sailed with the navy and the marines, but according to those who knew him, he was pathologically shy and private, unlike his flamboyant peers. In 1924, in a newspaper interview quoted by Tattoo Archive, he revealed only a little about himself: "Father had a large family, money was not plentiful, so early in life I had to fend for myself. For a time I

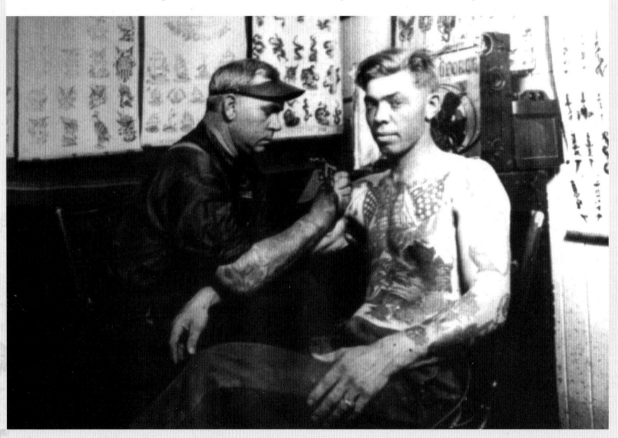

LEFT: Sailor George Fosdick at work in his tattoo parlour in Portland, Oregon.

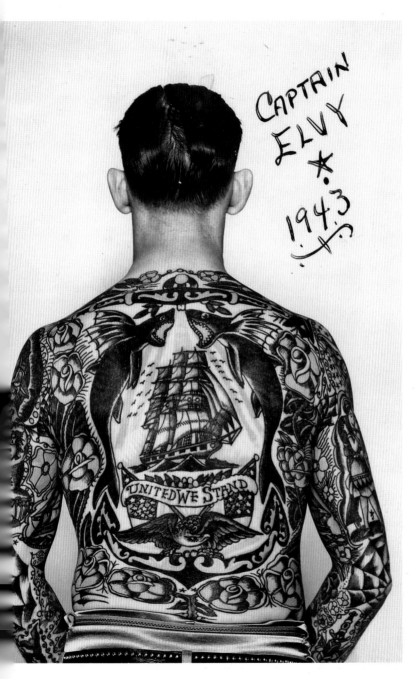

followed the sea; then later in life, I learned the art whose age nobody knows."

Despite his reticence, Sailor George inspired the admiration of neighbours including Sailor Gus and Charlie Western – and he took under his wing an eager child called Bert Grimm, who began frequenting the local parlours shortly after Fosdick's arrival. The young Grimm, not even a teenager, wanted to live and breathe the atmosphere of these macho, adult gathering places, and to carry out menial tasks for the tattoo artists he was already determined to learn from. Sailor George later shared shop space with Grimm in Portland. This was Fosdick's most famous base, although he moved to Seattle in the 1930s before eventually returning.

Fosdick linked briefly with Sailor Walter Larson in Portland in the early 1940s, and in 1943, as a solo act, he decorated the back of the mysterious Captain Elvy with a grand sailing ship, underpinned by a banner declaring "United We Stand". Elvy was a known circus attraction, performing with the Wallace Brothers sideshow around this time, but he remains an enigmatic figure. Photographed from behind, generations of tattoo fans are familiar with the intimate details of Elvy's rear view without ever seeing his face or knowing anything much about his life. Sailor George Fosdick died in 1946 leaving us none the wiser.

San Francisco was a flourishing tattoo town, especially during the Second World War, when it was packed with sailors and shipbuilding workers. But tattooing was also in strong evidence previous to this. One Tom Berg, an English immigrant, had a shop on the edge of the

LEFT: Captain Elvy and his ornate full-torso tattoo, rendered by Sailor George Fosdick in 1943.

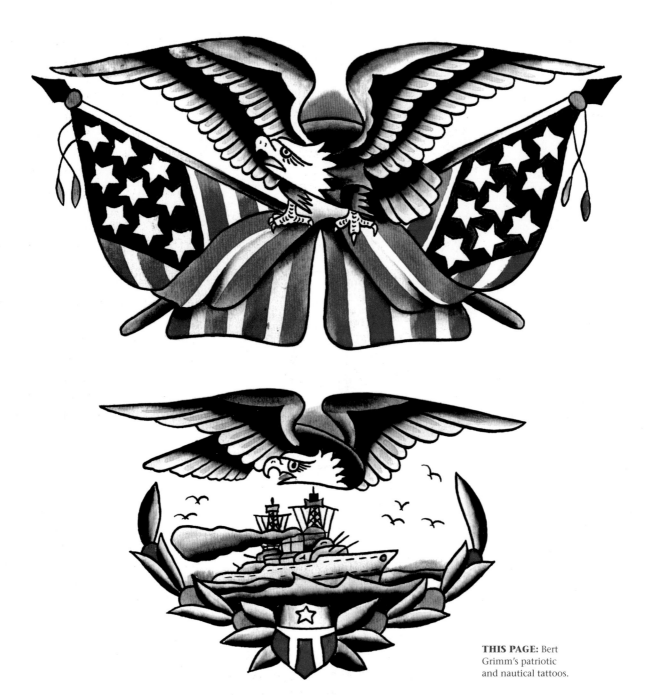

THIS PAGE: Bert Grimm's patriotic and nautical tattoos.

notorious red-light district in the early 1900s with Adolph Hasberg. Berg worked by hand and with the electric machine, producing unusually sophisticated designs and characters with very beautiful and elegant facial features, as well as running a supplies business. Clement John Eddy, known as "Pop Eddy", from Nevada City, was another well-known tattooist and supplier in San Francisco, opening several parlours. The well-travelled Charlie Geizer passed through. Geizer also worked briefly in San Diego, as did Sailor Charlie Barrs, who had become one of America's most influential tattooists during his years in Los Angeles.

Barrs took up residence in a penny arcade in Main Street, Los Angeles, during the 1920s. Bert Grimm worked with Barrs for a couple of years at the arcade, later declaring him to be "the granddaddy of all good tattooing".

Barrs' early life, at home and at sea, is shrouded in mystery. He is known to have received his dramatic Head of Chris backpiece in Philadelphia before travelling to California and the penny arcade. After waving Grimm off to Chicago in 1926, Barrs recruited a new collaborator, Owen Jensen.

Born in Pleasant Grove, Utah, in 1891, Jensen ran a business in San Pedro, close to central Los Angeles. Delighted to be headhunted by one of America's most highly rated tattoo artists, he sold his business to a friend called Sandy Dillon, himself inked by Sailor Charlie and Bert Grimm, and headed off to join Barrs. Jensen was one of the restless breed – he spent years roaming the United States with his wife, Dainty Dotty, a "fat lady" circus attraction and tattooist. Jensen also built and supplied tattoo machines, which were much in demand, and finally wound up at Nu-Pike.

The Pike was a big amusement park and arcade at Long Beach, Los Angeles, filled with noisy fairground rides as well as novelty shops, fortune-tellers' booths and tattoo parlours. This was where Bert Grimm opened his legendary shop – Bert Grimm's World Famous Tattoo – in the 1950s. Jensen worked at Nu-Pike with Grimm and later with Lee Roy Minugh.

By the turn of the 1970s, the Pike was in decline, overrun by violent thieves and criminals, and Jensen began to worry for his own safety, with good reason as it turned out. In 1976, he died after being robbed, beaten and stabbed in his own shop – for a grand total of $30. The Pike closed down three years later.

LEFT: A nurse and sailor girl by Bert Grimm. The "Rose of No Man's Land" is a reference to Red Cross nurses who served during the First World War.

NAUTICAL & PATRIOTIC TRADITIONS **83**

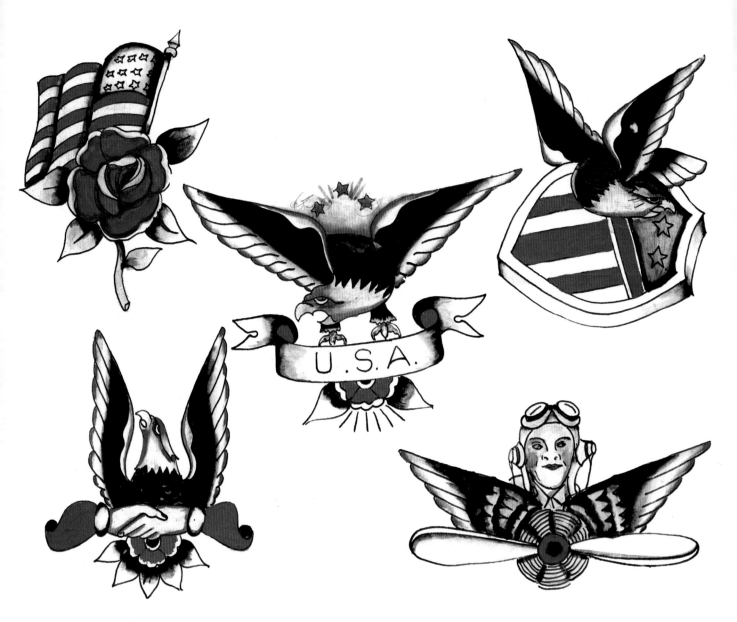

ABOVE AND OPPOSITE:
Patriotic tattoo flash by Bert Grimm.

NEW YORK AFTER THE WAR

Some tattooists fared less well after the First World War. Lewis "Lew the Jew" Alberts was forced to move out of New York when war ended, as he was unable to compete with the many other tattoo shops that had set up in his neighbourhood during the war years, when the demand for tattoos had peaked.

Lew, from Newark, New Jersey, was another of those sailors who was taught the rudiments of tattooing at sea. Born in the 1880s, he was always inclined towards an artistic occupation: it is rumoured that he started a career in wallpaper design before enlisting in the US Navy. By all accounts, he came to grips with the tattoo needle during the 1898 Spanish-American War, practising his designs on those shipmates brave enough to bare their flesh to a novice. He was a quick learner, though, because the conflict, over Spanish rule in Cuba and the Philippines, lasted for only four months.

Returning to his homeland, Lew headed for New York City and established a base in or around Chatham Square, where Sam O'Reilly and Charles Wagner were famously located. Now he had a mission. Blazing a trail for the likes of Sailor Jerry, who came after him, he was determined to raise the standard of tattooing in the city. He considered that in his area, much of the local tattooists' designs were an insult to the paying public, although it must be said that there's no recorded criticism of O'Reilly and Wagner. Lew set about creating new, improved and exciting flash.

We'll probably never know if there's any truth in a story put about by Bert Grimm, another legendary tattooist, that at this time Lew passed off some of artist Charlie Western's work as his own. According to Grimm's tale, held by the Tattoo Archive, Western sold all his flash to Lew in a moment of drunkenness.

Whether this is true or not, Lew came up with striking arrays of sentimental, religious and patriotic images, and is credited with creating the classic black panther design. He later sold some of his flash through Charles Wagner's supply business, when the two joined forces for a few years in Chatham Square. Among their greatest achievements was the body suit they completed for Painless Jack Tryon, who was described as the most handsomely tattooed man in the world.

From Chatham Square, Lew moved on to Brooklyn, but in 1919, he was confronted with competition from other tattooists on his doorstep, since wartime demand had fallen off steeply. By the end of the Roaring Twenties, he had left the city to work irregularly from his home in Newark.

THE ORIGINAL SAILOR JERRY

All of the sailors-turned-tattooists were great characters, surrounded by the myths and legends of the disreputable world they inhabited. "Sailor Jerry" – born Norman Keith Collins in 1911 – remains one of the most famous of all. He was arguably the most significant and widely respected American tattoo artist of his generation, and the most copied, and today the rights to his images are fiercely protected. Especially noted for his pin-up girls and themes of heartbreak, his work is boldly designed with great saturation of colour and shading.

Collins built his reputation in a small parlour in the bawdy Chinatown area of Honolulu, Hawaii. Like all the other tattoo districts in port towns, this was a seedy red-light area filled with bars, strip joints and brothels – a natural magnet for sailors on shore leave, raring to go.

From such beginnings, Sailor Jerry's name has become a brand and a merchandizing phenomenon that sees his classic images from the 1940s to the early 1970s spread across T-shirts, aprons, baby clothes, glassware, handbags, wallets, belt buckles, Converse trainers and bottles of own-brand Sailor Jerry rum.

One might wonder what Collins, who died in 1973, would have made of this absorption into the commercial mainstream of designs that were originally intended for the biceps of "outsiders" – the hard-drinking, brawling soldiers and sailors who roamed the world and lived life on the wild side.

Collins understood these macho men. He'd been a seaman too, taking to the ocean waves at the age of 19 with the US Navy, and it was during his early travels that he acquired his first tattoos and, importantly, became intrigued by the artistic techniques of tattooists in South East Asia.

Opening his first tattoo shop in Chicago before moving to Hawaii, Collins incorporated the flowing lines and mystic nuances of the South East Asian designs into his traditional American images of ships, skulls, snakes, tigers, eagles, hearts, flowers, bluebirds, banners, cartoons and the saucy pin-up girls that became his speciality, along with pertinent military and political cartoons. He did all this with a devilish humour and a vivid daring that perfectly reflected the personalities and experiences of his customers.

So many of his rivals tried to copy his eye-catching tattoos that eventually he had the legend "The Original Sailor Jerry" added to his business cards. Collins insisted on precision, and his unique flair for detail and shading brought a special quality to his designs. He abhorred second-rate tattooists, or "scab vendors", and spoke out loudly against them. Leading by example, he set new standards in artistry, materials and safety: he painted his flash on high-quality paper; he sought out pigments that

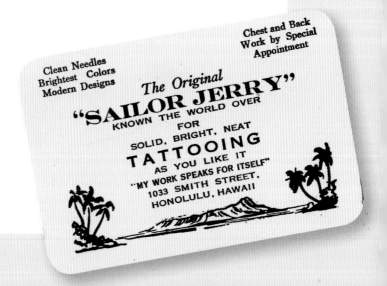

opened up a whole new spectrum of colours and shades (having first tested them, on himself, for toxicity); he improved the machinery and the needles; and he ushered in a strict regime of sterilization.

A dedicated craftsman, Collins nevertheless made time for other interests. He continued to sail, steering tourists round the waters of Waikiki in a three-masted schooner. He also played the saxophone in a dance band, hosted a late-night radio chat show, rode a Harley-Davidson, and wound up the citizens of Honolulu with a series of impudent practical jokes.

Sailor Jerry was generous with his knowledge, hosting tattoo conventions and encouraging younger artists, among them Don Ed Hardy and Mike "Rollo Banks" Malone, who took over his shop when Collins died. Despite being a conservative and a traditionalist who disliked the idea of women tattooists, Collins nonetheless supported females who showed talent. In his final years, he invented "feminigraphics" – small, colourful, single-needle tattoos for ladies – joking in a letter to his student Shanghai Kate, "These pretty young girls are going to make a dirty old man out of me yet."

LEFT: The back of Sailor Jerry's business card with the contact details for his shop in Honolulu, Hawaii.

RIGHT: The front of Sailor Jerry's business card, showing a Japanese-inspired design.

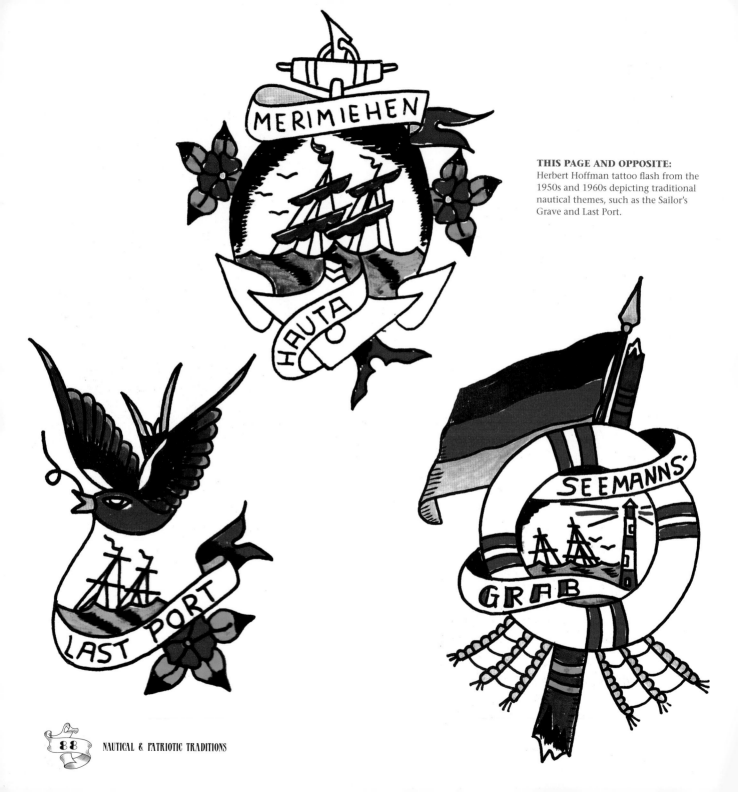

THIS PAGE AND OPPOSITE:
Herbert Hoffman tattoo flash from the 1950s and 1960s depicting traditional nautical themes, such as the Sailor's Grave and Last Port.

MERIMIEHEN

HAUTA

LAST PORT

SEEMANNS-

GRAB

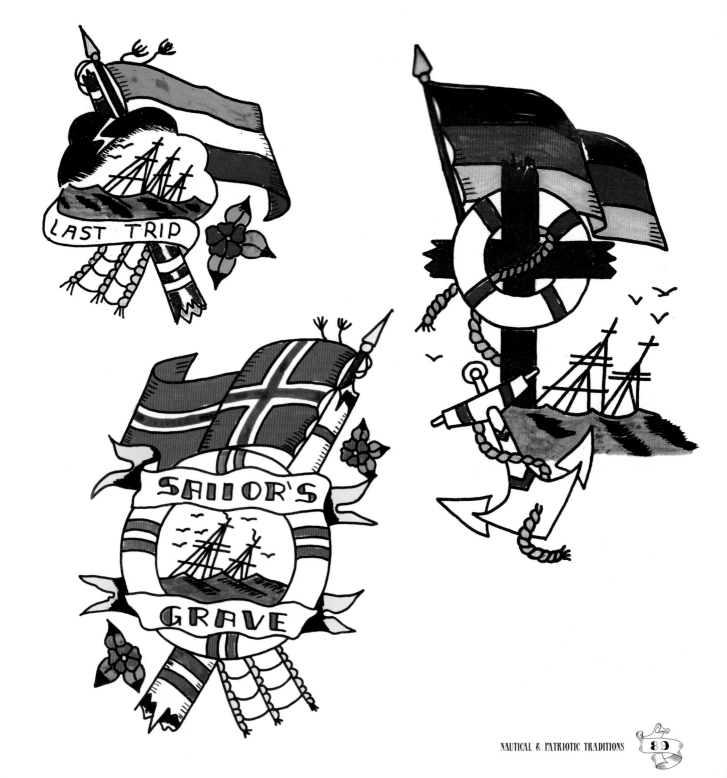

LAST TRIP

SAILOR'S GRAVE

CONTINENTAL CREATIVES

While the United States was grabbing most of the attention during the war years, with its star artists and massive sailor population, Europe was quietly producing some exceptional vintage tattooists. In Denmark, Ole Hanson was fêted by kings and commoners for the fluidity of his outlines. He was especially famous for his flowing representations of water, something most tattooists found impossible to accomplish.

Hanson went to sea as a young lad of 14 when the Second World War broke out in 1939. He learnt to tattoo on board and, within a few years, was prolifically inking designs on his fellow sailors. Two years after the war ended, he set himself up in business in Copenhagen, buying one of the world's oldest tattoo shops from its previous occupant, Tato Jack. During his 40-year residence at the shop, Hanson made a worldwide impact with the quality of his tattooing, using customized machines that he built himself. His clients included the King of Denmark, Frederick IX and he was subsequently known as the "King's Tattooer".

Meanwhile, in Rotterdam, Holland, Albert Cornelissen was building a convincing reputation. A veteran seaman who was enlisted with the Dutch Royal Army and then touring with US merchant ships, the enterprising Cornelissen didn't simply hang around waiting for custom to come to him: he went to greet the ships as they docked, standing at the end of the gangplank, where he dished out business cards to the disembarking sailors. After opening a shop in Rotterdam in 1950, he travelled with a mobile tattoo

BELOW: A robustly rendered Ole Hansen clipper ship, sailing forcefully through his trademark choppy waves with a fiery sunset in the background.

OPPOSITE: Ole Hansen in his tattoo parlour at 17 Nyhaven, Copenhagen, the site of over a hundred years of tattooing.

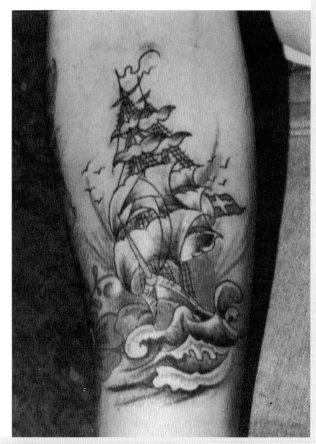

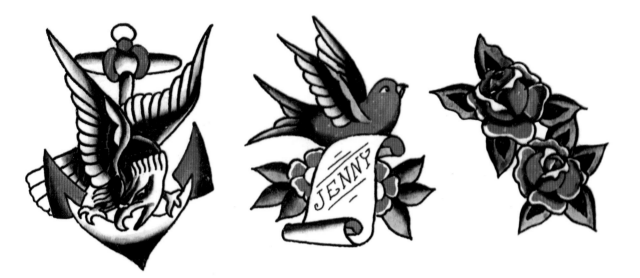

unit throughout Europe, visiting forces bases for many years, before finally settling in Hamburg, where his son now operates a tattoo studio.

Cornelissen was a major influence upon a new generation of artists, including Peter de Haan, also known as Tattoo Peter. Born in 1925 in the Dutch fishing town of IJmuiden, Tattoo Peter lost his left leg in an accident during the Second World War. After a period of busking around the ports of Holland, he became a mobile tattooist in the early 1950s, finally opening a parlour in Amsterdam's red-light district, where he made a good name for himself.

However, the golden age of the old-time tattoo was coming to an end by the advent of the 1960s. It was an era that had seen rapid improvements in technique, equipment and colours. The early exponents had generally been primitive craftsmen who copied other artists' flash designs with slight changes so as to claim originality; many of the tattoos administered in these early days were crudely simplistic or cartoonish. But the rise of talents including Cap Coleman, Paul Rogers, Charlie Wagner, Sailor Jerry and Bert Grimm, men who were able to work their own unique styles into traditional designs, transformed vintage tattoo into an art form.

ABOVE: Anchor, swallow and rose tattoos by Tex Rowe, a Pennsylvania-based tattooist.

THIS PAGE AND OPPOSITE: A variety of tattoos in the old-school style from Tex Rowe, including patriotic and nautical themes.

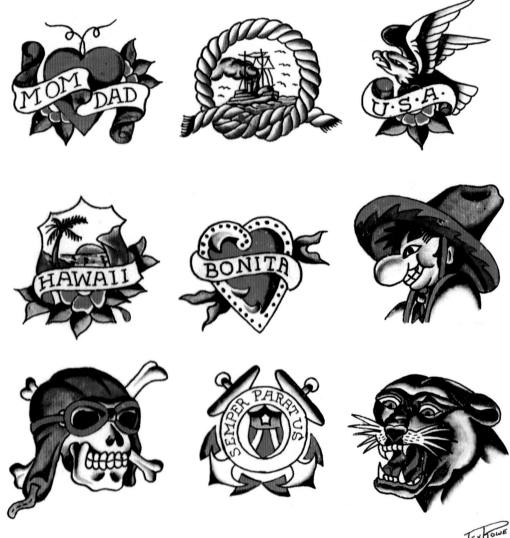

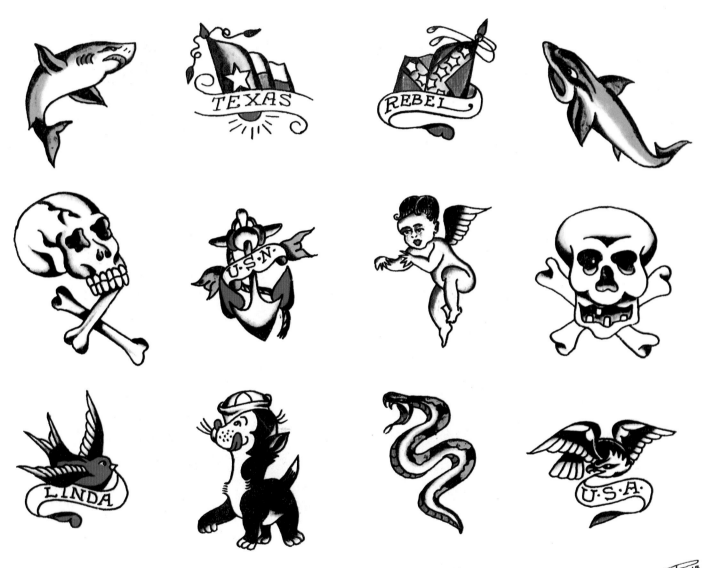

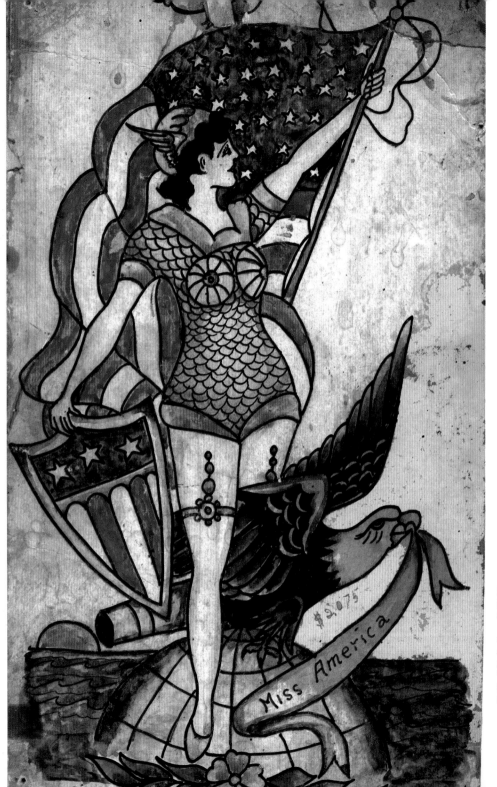

LEFT: A Miss America tattoo design by Charlie Wagner.

OPPOSITE: American and Canadian service flags from the Second World War, including a Pearl Harbor memorial, artist unknown.

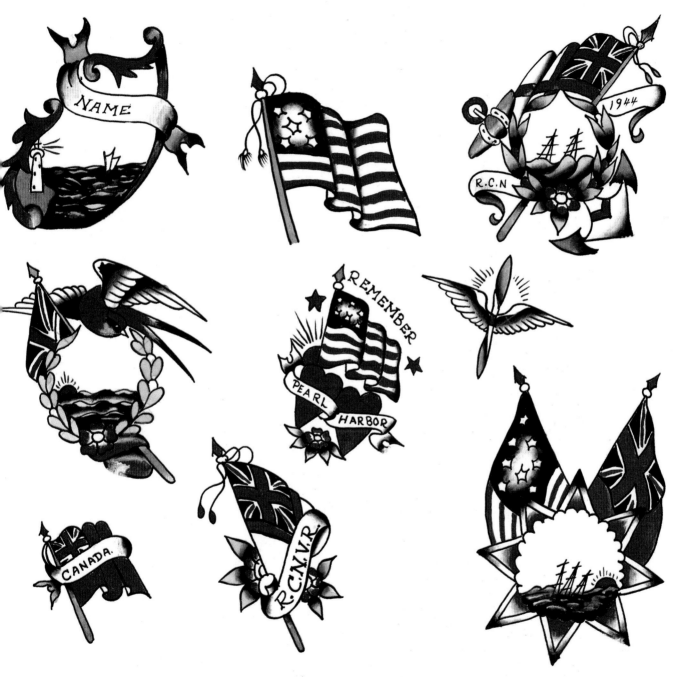

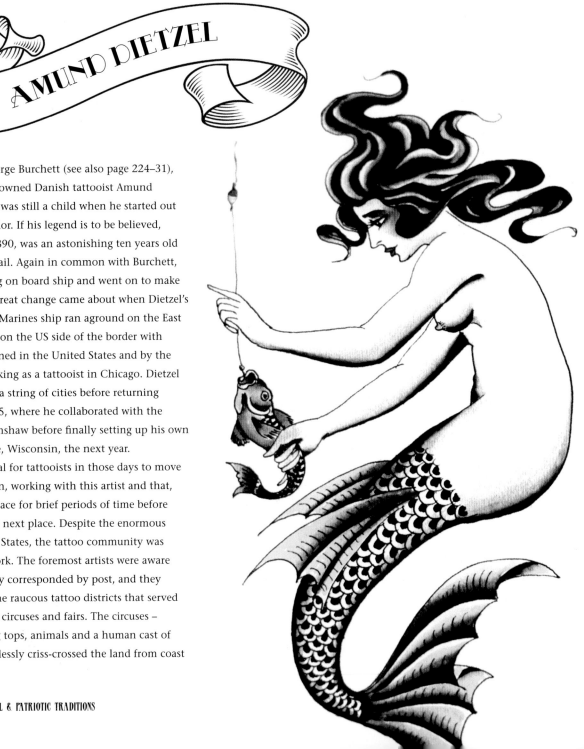

Like George Burchett (see also page 224–31), the renowned Danish tattooist Amund Dietzel was still a child when he started out as a sailor. If his legend is to be believed, Dietzel, born in 1890, was an astonishing ten years old when he first set sail. Again in common with Burchett, he learnt tattooing on board ship and went on to make it his career. The great change came about when Dietzel's Danish Merchant Marines ship ran aground on the East Coast of America, on the US side of the border with Canada. He remained in the United States and by the age of 17 was working as a tattooist in Chicago. Dietzel travelled through a string of cities before returning to Chicago in 1915, where he collaborated with the esteemed Bill Grimshaw before finally setting up his own base in Milwaukee, Wisconsin, the next year.

It wasn't unusual for tattooists in those days to move from town to town, working with this artist and that, sharing parlour space for brief periods of time before heading off to the next place. Despite the enormous size of the United States, the tattoo community was a close-knit network. The foremost artists were aware of each other; they corresponded by post, and they met in ports, in the raucous tattoo districts that served the sailors, and at circuses and fairs. The circuses – complete with big tops, animals and a human cast of hundreds – relentlessly criss-crossed the land from coast

to coast by rail, providing natural gathering grounds for tattooists and performers. The sailors and the circus folk were inextricably linked in these years, and it was an entanglement that happily resulted in classic old-school tattooing.

Amund Dietzel prospered in Milwaukee, gaining a reputation over the years for magnificent sailing ships, often requested as backpieces. Like many of his contemporaries, he was willing to share his wisdom with the young hopefuls who came to his shop. Tattooing was a skill, a trade that was passed from one generation to the next, in person. Among the great Dane's protégés was a certain Phil Sparrow, who later enthused about Dietzel's personal and artistic confidence, and the purity of his work. His designs, said Sparrow, were full of "old-fashioned charm" and "nostalgic attractiveness", his navy girls "rosy-cheeked and full-faced". Sparrow went on to open his own tattoo shop in Oakland, California, and he in turn became a mentor to Don Ed Hardy, whose early designs are now at the forefront of the vintage tattoo revival, adorning clothing worn by some of the world's most famous celebrities.

Dietzel, meanwhile, had a busy time during the Second World War, and he wasn't alone. "Wartime is boomtime for tattoos" blared a magazine headline in 1943, at a time when the tattoo shops of America were struggling to cope with the huge crowds of sailors rolling into port asking to be emblazoned with flags, eagles, anchors, pin-ups and the ever-popular US Marines'

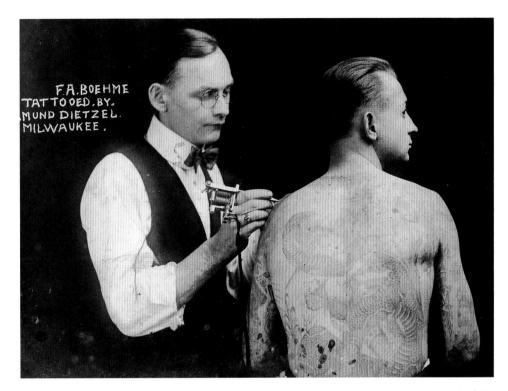

motto *Semper Fidelis*, a Latin expression meaning "always faithful". Most parlours rose to the occasion, working constantly to capitalize on the hectic demand. Dietzel had four artists, himself included, working 12 hours a day to cater for everyone.

Dietzel was a practical sort of person, not given to panic. When, in the early 1960s, a backlash against tattooing caused the local authority to raise the minimum age in Milwaukee to 21, Dietzel ignored the exodus of his contemporaries. He simply shrugged and kept on working, knowing that his business was still safe. But it was only secure for a short while because in 1967, tattooing was banned altogether. "Milwaukee used to be a very nice town," Dietzel remarked mildly. He'd worked there for 51 years.

ABOVE: Amund Dietzel at work on a shoulder design for a customer, F A Boehme, in Milwaukee.

OPPOSITE: An elegantly drawn mermaid tattoo by Amund Dietzel.

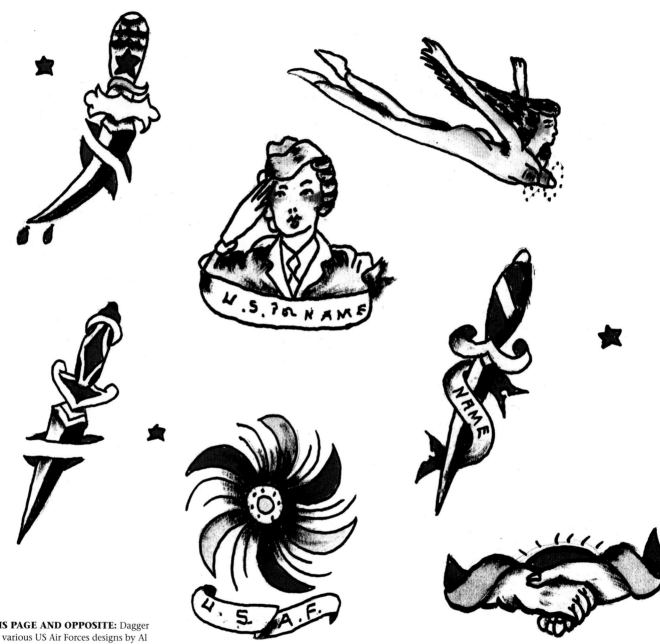

THIS PAGE AND OPPOSITE: Dagger and various US Air Forces designs by Al Kemp, an artist based in Tampa, Florida, from 1921 to 1961.

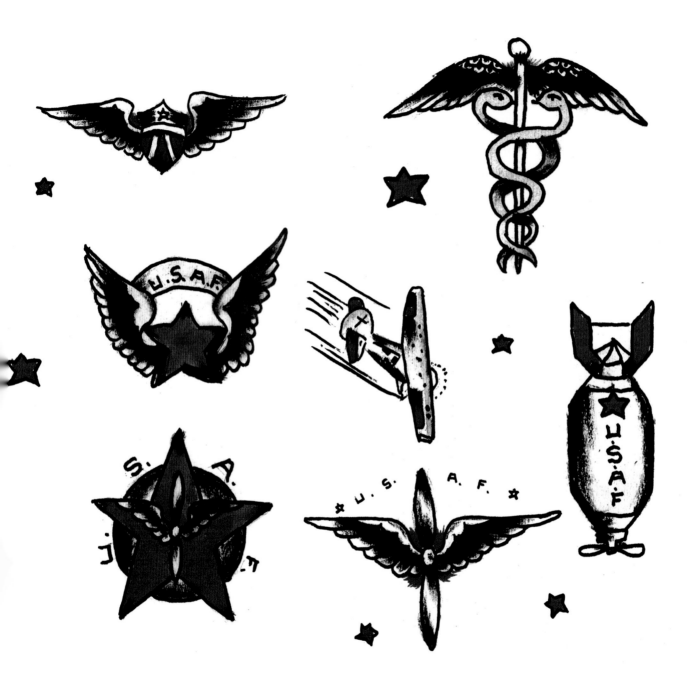

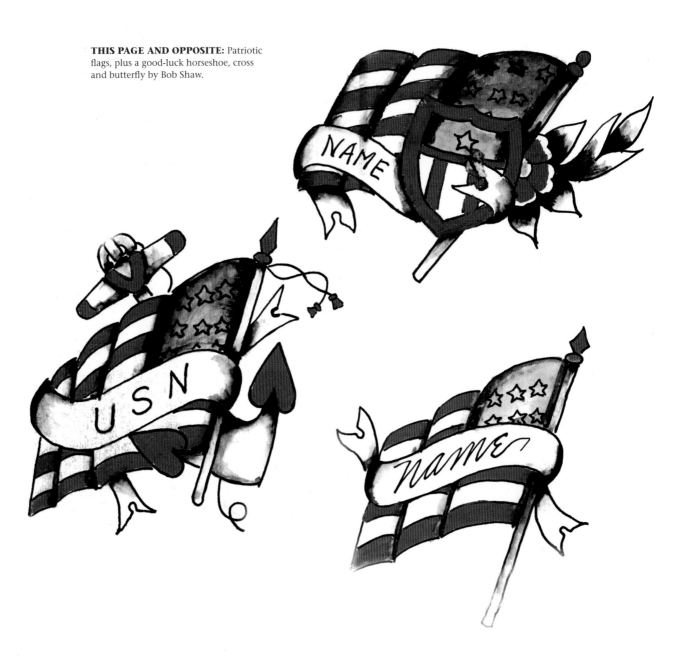

THIS PAGE AND OPPOSITE: Patriotic flags, plus a good-luck horseshoe, cross and butterfly by Bob Shaw.

NAME

USN

Name

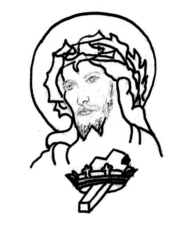
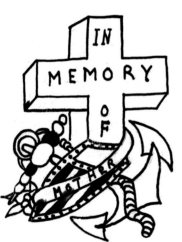

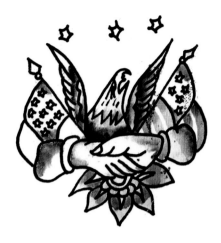

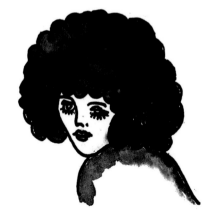

THIS PAGE AND OPPOSITE: An assortment of undated and unknown flash depicting roses, girls, patriotic US Army and Navy emblems and memorial and religious designs.

THIS PAGE: US Air Force tattoos by Joe Darpel.

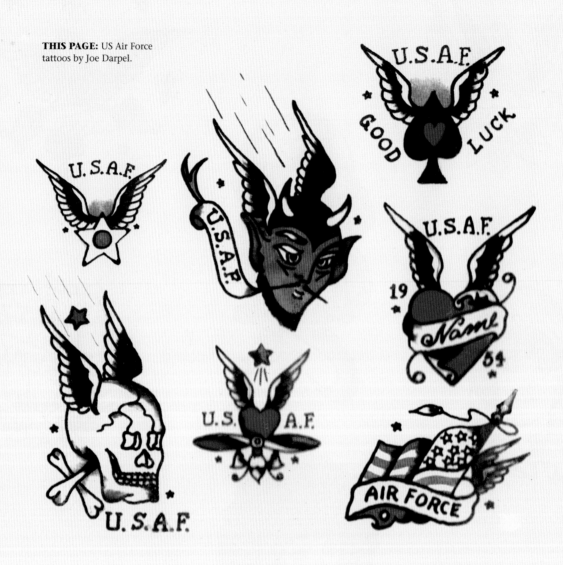

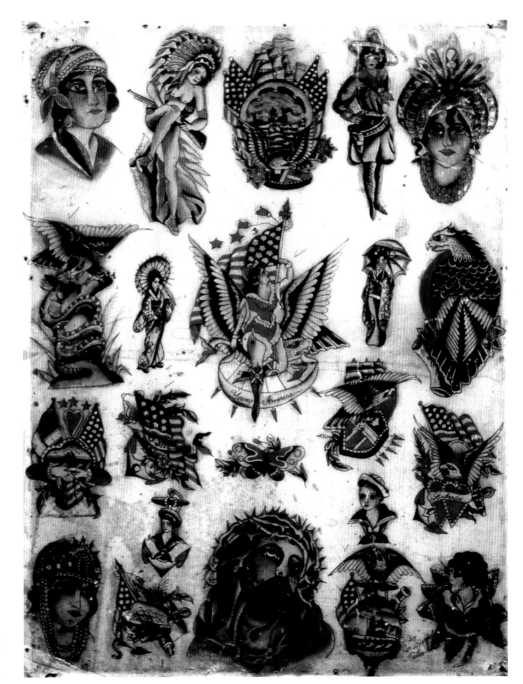

RIGHT:
Joe Darpel
Americana
designs, heavily
featuring the
US flag and
American Eagle.

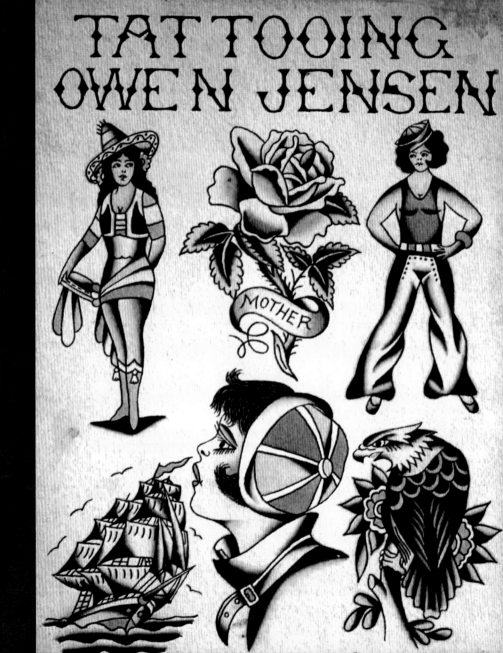

GIRLS, HEARTS & BANNERS

The American forces' favourite tattoos changed dramatically in the years between the world wars. Although patriotic images were still prevalent, pin-ups became more popular, partly due to their real-life counterparts, such as Betty Grable, whose image graced countless GI lockers.

During the First World War, from 1914 to 1918, many servicemen sported the American flag, eagles, military symbols and other reminders of their country and their mission. By 1939, with the onset of the Second World War, tastes had broadened. Tattooists settling near military bases reported that while clients continued to ask for sailing ships, anchors and patriotic emblems, others elected to go into battle with images that spoke of home – banners displaying the names of girlfriends and wives, surrounded by roses or hearts, or held aloft by fluttering bluebirds. "Mom" was a big seller, but the great classic was the buxom beauty, whose popularity endures.

The golden age of illustration was in full bloom by the 1920s with artists such as Enoch Bolles, George Quintana, George Petty and Earle K Bergey delighting in drawing the female form as overtly sexy and voluptuous. Pin-ups by Alberto Vargas were also very much in evidence in the barracks and as nose-art of the airforce. Additionally, special booklets of pin-up art by Gillette Elvgren were created by the Louis F Dow Calendar Company to be sent overseas. Naturally these were much sought-after by sailors and soldiers, who would request similar images as tattoo art.

RIGHT: Unusual blueprint tattoos from England, circa 1920s, depicting a spider lady, a portrait and a tastefully concealed "English Rose". A spider web is a very old tattoo image, sometimes associated with prison terms and other times with a struggle, or being "caught in a web".

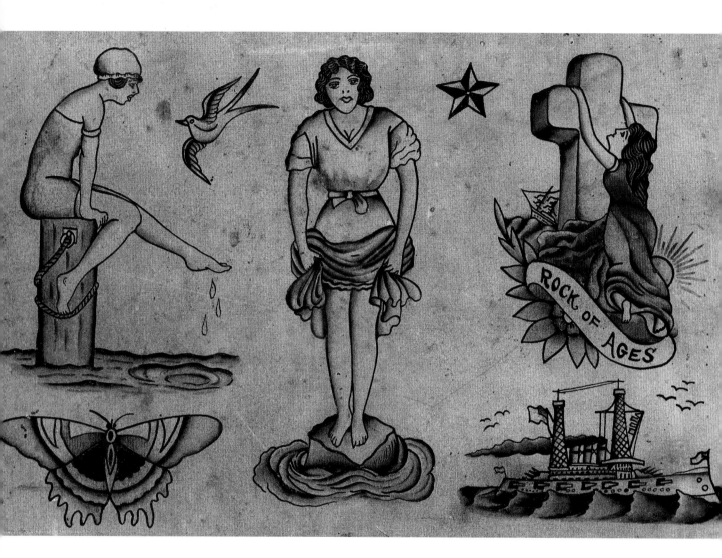

ABOVE: Gus Wagner flash, undated. Born in Ohio in 1872, August "Gus" Wagner was a merchant seaman, and later a tattoo artist and circus entertainer, sporting over 250 tattoos himself. Despite the advent of electric tattooing machines after 1890, he remained faithful to hand instruments.

BELOW, LEFT: A red-cheeked Red Cross nurse, circa 1920s, by George Fosdick.

BELOW, RIGHT: Romantic tattoo designs, probably single-needle, from the early 1900s by Tom Berg. An English tattooist who came to the United States, Berg is said to have worked with Adolph Hasberg in San Francisco.

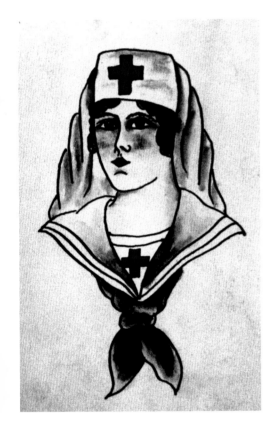

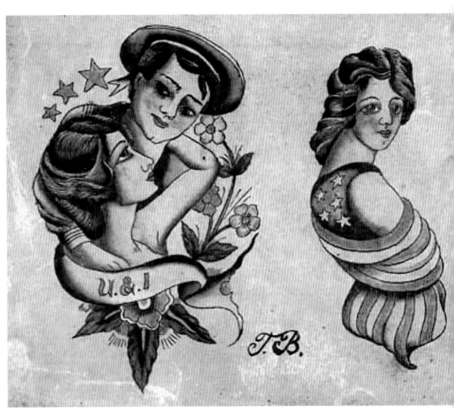

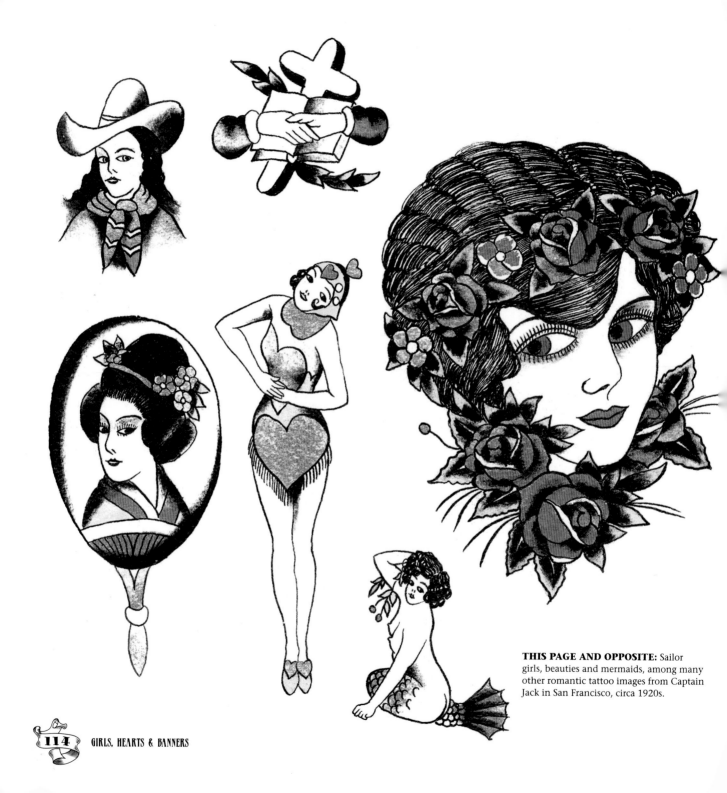

THIS PAGE AND OPPOSITE: Sailor girls, beauties and mermaids, among many other romantic tattoo images from Captain Jack in San Francisco, circa 1920s.

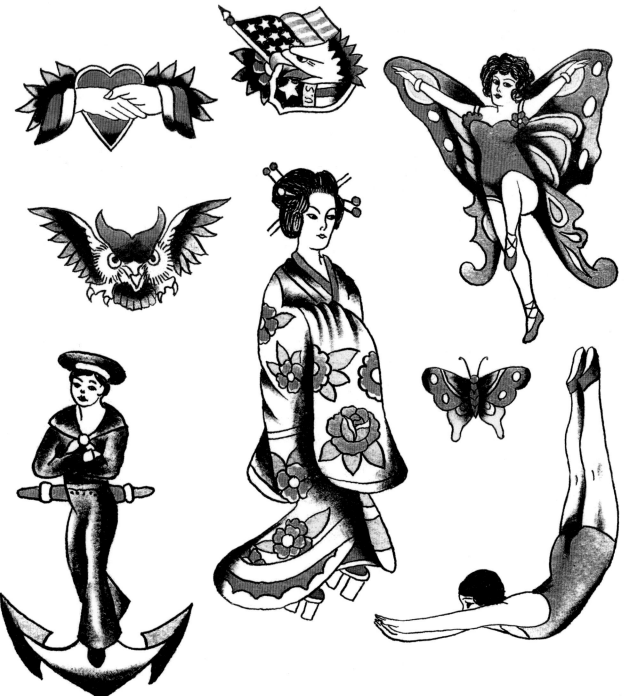

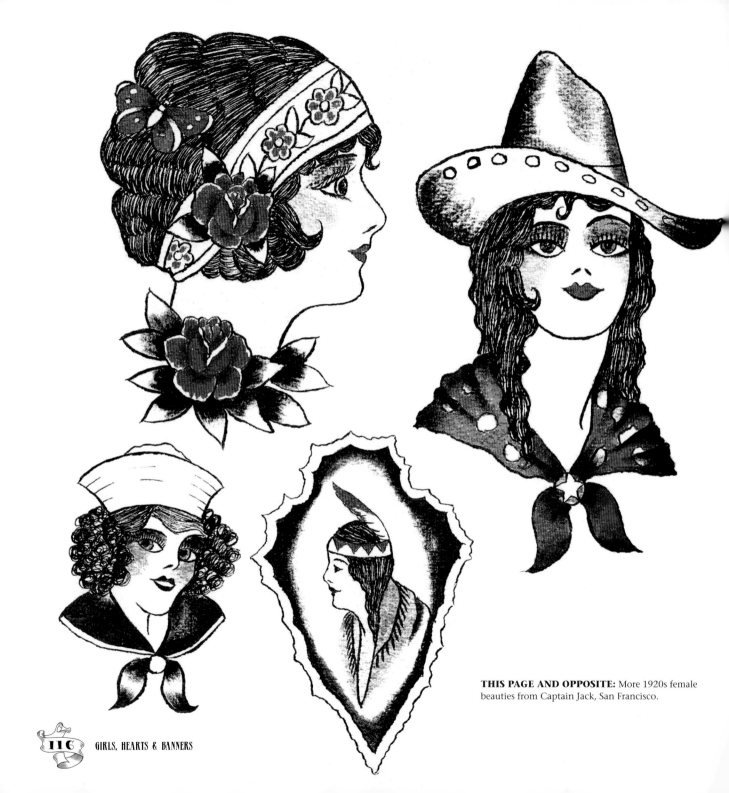

THIS PAGE AND OPPOSITE: More 1920s female beauties from Captain Jack, San Francisco.

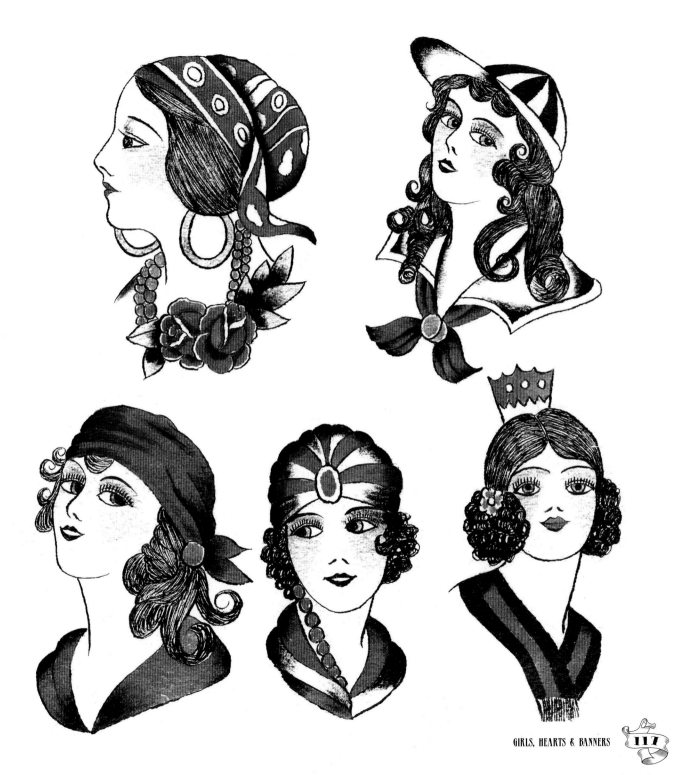

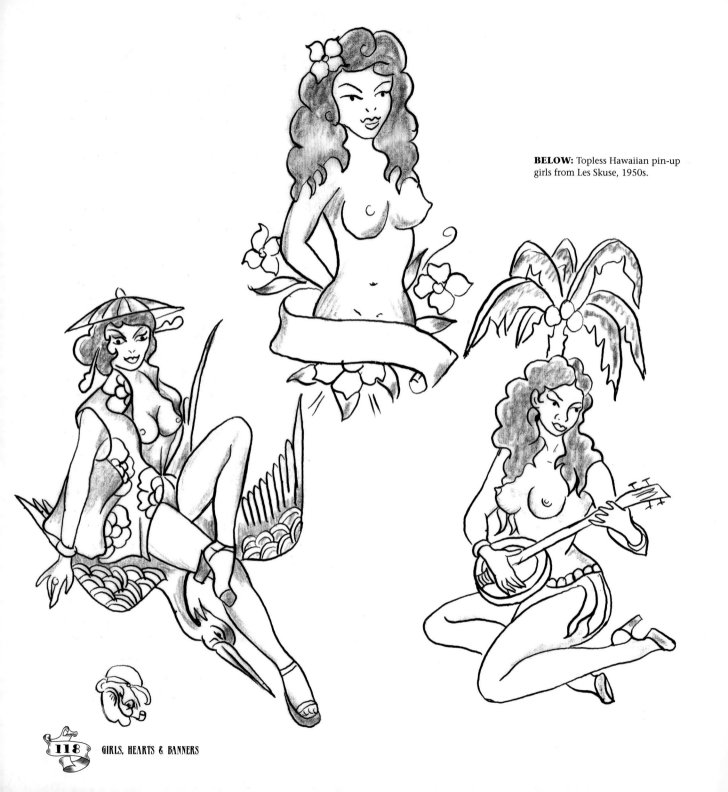

BELOW: Topless Hawaiian pin-up girls from Les Skuse, 1950s.

NAUGHTY NUDES AND PIN-UP GIRLS

Buxom beauties came in two varieties. One was the nude, the other was the pin-up girl – curvaceous, coquettish and modestly presented with a scrap of clothing or a strategically placed prop. The nude had been around for decades in American tattooing. Particularly famous was the naked hula girl who, positioned properly on a bicep, would swing her hips and jiggle her breasts as the owner moved his arm, often whistling to amuse his friends while she danced to his impromptu tune.

Legendary tattooist Bert Grimm created nudes for countless customers, explaining: "They wanted the girls to have enormous but shapely and protruding breasts. They wanted something to turn them on. They wanted erotic, not to say obscene, designs of women of all races and occupations." Certainly, Grimm's cowgirls, Hawaiian temptresses and personifications of Lady Luck left little to the imagination. And Sailor Jerry Collins, in Honolulu, sailed pretty close to the wind with his titillating depiction of a naked lady only just covering up her dignity with a giant cobra. In comparison, his topless women, posing unabashedly or lolling around in hammocks urging everyone to "Rise and Shine", seemed positively timid.

The pin-up girl was not obscene or explicitly revealing, although her dimensions were voluptuous and she was always seductive. The twinkling flirtatiousness of these less overtly sexual figures became hugely popular during the Second World War. These tattoos not only provided welcome female company for men far from home, but they were sure to remain appealing afterwards. They (and

LEFT: A Bert Grimm design entitled Bikini Woman from the 1950s; the traditional hula girl has here evolved into a more modern figure yet retains her defined Polynesian features.

the girls painted on the noses of American fighter planes) reflected the growth of pin-up culture in magazines, posters and postcards.

Sailor Jerry mastered the genre with a series of designs that have been copied and merchandized ever since. His gals had curves in all the right places; they were pretty, they wore make-up, they were tantalizing, and they were crafted affectionately and with humour. Collins took inspiration for his pin-ups from the work of other tattooists – Pinky Yun from Shanghai, China; Ole Hansen from Copenhagen, Denmark; and Doc Forbes from Vancouver, Canada – before making them his own with his unique flair.

The late Mike "Rollo Banks" Malone, a protégé of Collins, spoke to *Prick* magazine in 2005 about who were his greatest influences. He said: "Well, ya know, [Sailor] Jerry because, if you're gonna do regular good freestyle American tattooing, Jerry was the guy that could do it. He could really put on those pin-ups. He was excellent at it. He was a great technician and a great artist and he understood the absurdity of the whole thing. And that's what made his stuff great too."

BELOW: A tattoo of a hula girl, with palm trees and a rising sun in the background, displayed on the arm of a US sailor, circa 1940.

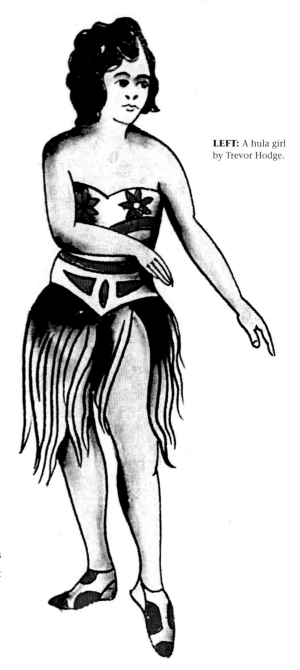

LEFT: A hula girl by Trevor Hodge.

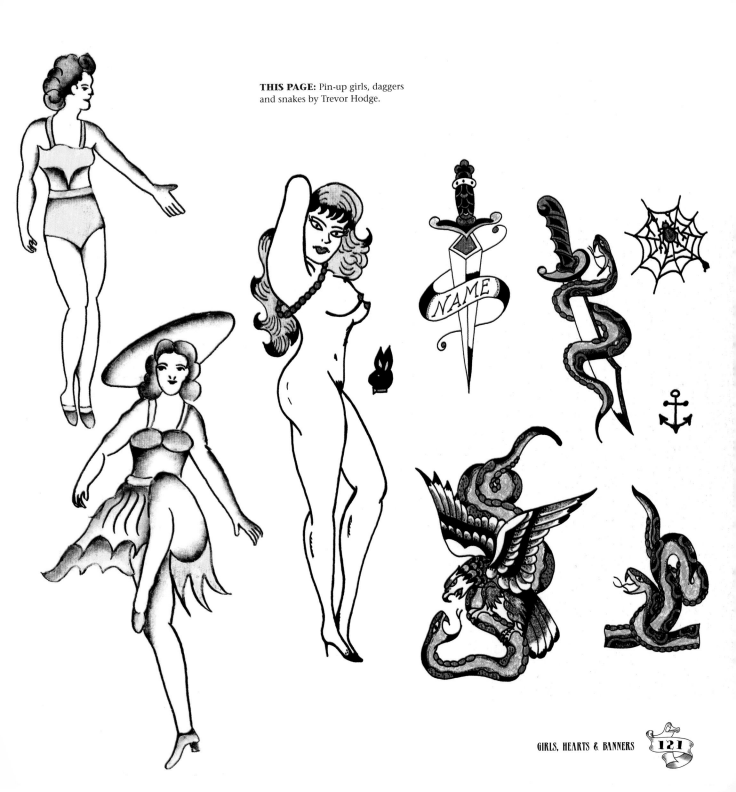

THIS PAGE: Pin-up girls, daggers and snakes by Trevor Hodge.

NAME

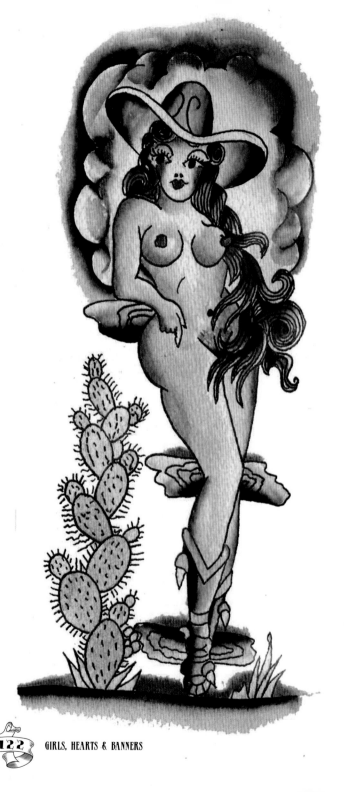

Sometimes the pin-up served a dual purpose. She could be dressed like a forces girl in an audaciously skimpy version of the uniform, or in a bikini or a micro-minidress fashioned from the Stars and Stripes, perhaps with an eagle looking over her shoulder, to offer solidarity in combat as well as the essential teasing familiarity.

Often, the pin-up appeared with other images in a setting designed to say something about the owner, or to issue a warning. My Ruin or Man's Ruin was one such theme, worn by men wishing to declare their vices in a macho or a witty way, possibly even remorsefully. In such a scenario, the lovely lady would typically be pictured lounging in a cocktail glass with her legs playfully swinging over the rim, surrounded by the clutter of a misspent life: empty liquor bottles, dice, playing cards, piles of coins, horseshoes, an eight-ball and, sometimes, a skull, with or without crossbones.

Pin-up girls provided welcome female company for men far from home, and they sometimes symbolized the raucous nights enjoyed by sailors in the good-time ghettoes of ports where they stepped ashore. Nowhere is this more memorably summed up than in Sailor Jerry's classic Stewed, Screwed and Tattooed image, a light-hearted collage with a lady's face, a broken heart, an empty glass, a bottle, some stars and the slogan arranged brightly around an anchor. It's a timeless favourite, still sold today, and copied and adapted by many artists.

The pin-up girls, immortalized in ink, were popular because they would never age. Endlessly enticing, they also reflected the growth of pin-up culture in magazines, posters and postcards of the era, as did the delectable beauties painted on the noses of American fighter planes.

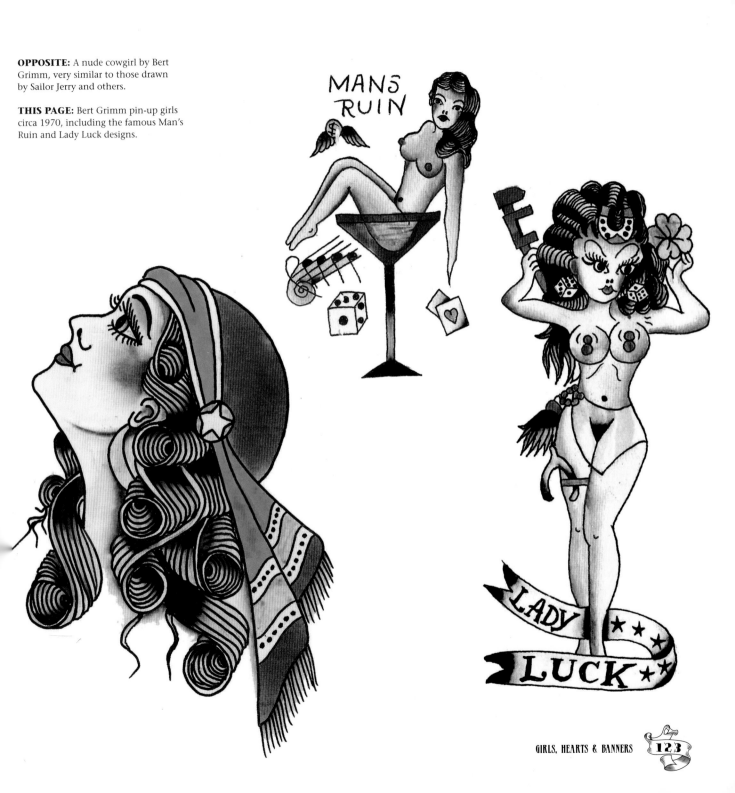

OPPOSITE: A nude cowgirl by Bert Grimm, very similar to those drawn by Sailor Jerry and others.

THIS PAGE: Bert Grimm pin-up girls circa 1970, including the famous Man's Ruin and Lady Luck designs.

MANS RUIN

LADY LUCK

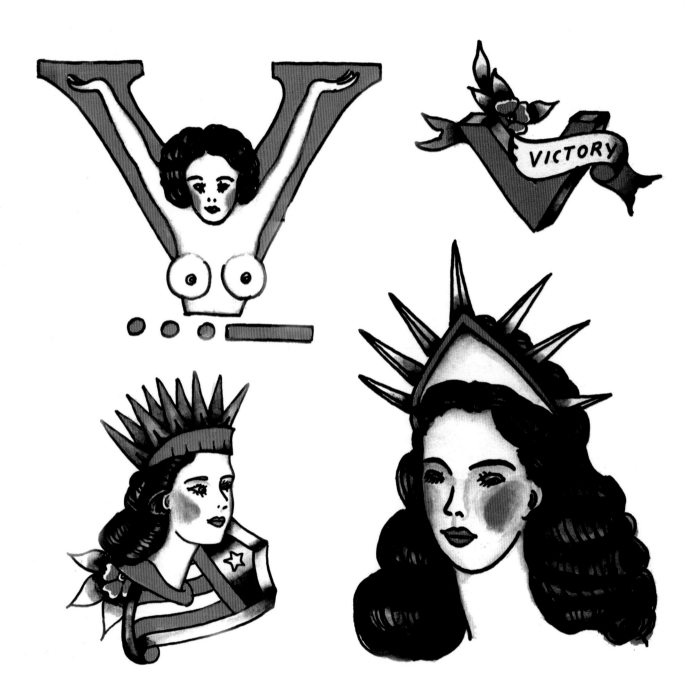

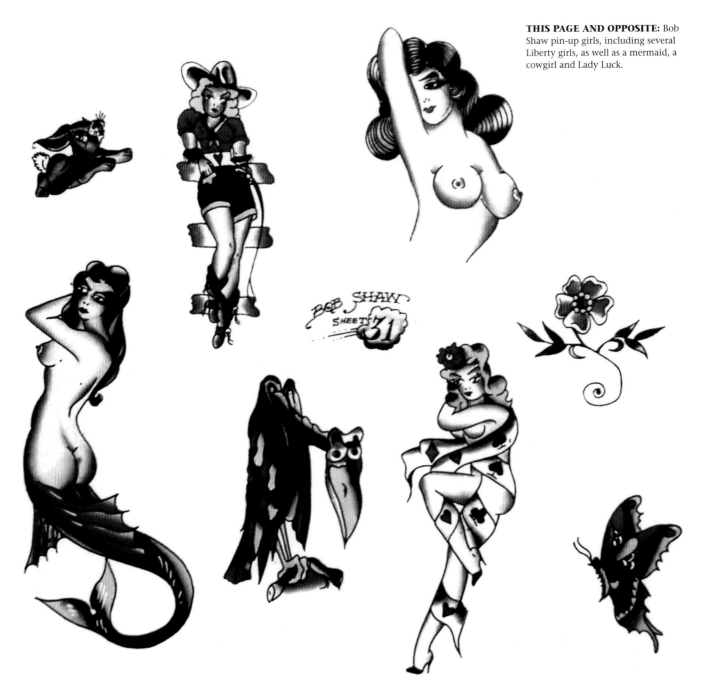

THE GREAT COVER-UP

BELOW: Early pin-ups from the 1930s depict a curiously undefined "nude", a sailor girl and a hula girl – all are the same figure in different guises, as the idea was to be able to cover up the nude to conform with US military standards.

The rise of the pin-up girl in the Second World War was really boosted by the US Government, when it decided to declare war on the nude tattoo. Reviving an arcane edict issued in 1909, young men were barred from enlisting in the Navy if they had a naked lady hiding anywhere on their person. The ruling stated: "Indecent or obscene tattooing is cause for rejection; the applicant should be given an opportunity to alter the design, in which event he may, if otherwise qualified, be accepted."

Any prospective sailor with a nude tattoo was therefore obliged to cover the lady's modesty with clothes or other details, and tattooists became inundated with customers demanding to have their nudes adorned with fans, flags, Hawaiian garlands and grass skirts, alluring underwear and exotic costumes. Alternatively, a new design could be added to camouflage the trouble spots – anything from an animal to a flower. The possibilities were endless, and many artists responded with great ingenuity. New York's influential Charlie Wagner remarked: "For going on 50 years, I've been turning out tattooed ladies, most of them naked, and now all I do is cover them up."

Indeed, Wagner used this selfless contribution to the war effort as a

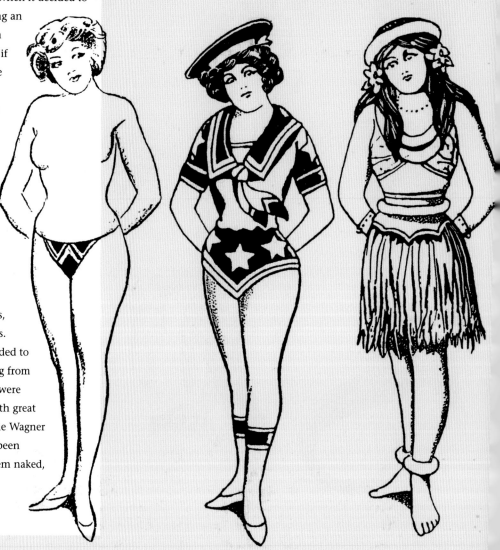

mitigating factor in his defence when, in the early 1940s, he was taken to court accused of infringing sanitary regulations in his shop in Chatham Square. Charlie, aged 67 at the time, had not been cleaning his needles properly. Once he had impressed the New York magistrates with details of his personal success in qualifying many young men to join the services, he was sent back to work with a $10 fine and a telling-off. In addition to their cover-up work, tattooists were turning out thousands of delightful new pin-up girls whose naughtiness was sexier, many considered, than the full-frontal exhibitionism of the nude.

LEFT: An early nude tattoo stencil, circa 1920s, which would have been embellished in various ways. Her curvy body with its wide hips and round belly looks very different to the hourglass pin-ups of the mid-twentieth century.

RIGHT: A Don Nolan sailor girl from 1969 sports the curvy lines and barely concealed buxom physique of the traditional pin-up.

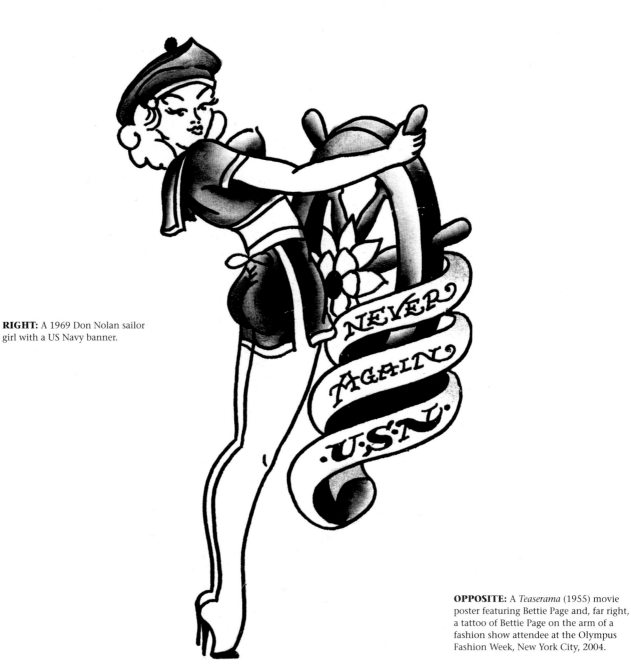

RIGHT: A 1969 Don Nolan sailor girl with a US Navy banner.

OPPOSITE: A *Teaserama* (1955) movie poster featuring Bettie Page and, far right, a tattoo of Bettie Page on the arm of a fashion show attendee at the Olympus Fashion Week, New York City, 2004.

BETTIE AND BETTY

The love affair with pin-ups continued throughout the 1950s, with tattoo artists taking inspiration from the icon Bettie Page. Crowned Miss Pin-Up Girl of the World in 1955, Bettie was a stunning model from Nashville, whose long black hair, blue-grey eyes staring out from under a trademark fringe, and vital statistics of 36–23–35 inches, captured the imagination of photographers, editors and readers everywhere.

The three-times married Bettie rose from a broken family background in Nashville, Tennessee, to gain a BA degree. She took the modelling world by storm and posed as a *Playboy* centrefold. The key to her huge appeal was that she possessed seemingly opposing qualities that worked well together. Bettie was something of a girl next door, someone who could be attainable, but nevertheless wasn't. She was ordinary and extraordinary. She was shy and spicy, respectable and risqué, intelligent and mischievous – a good girl hinting at erotic possibility. And these were the same charms that tattooists sought to capture in their pin-up girls. When Bettie came along, hailed as the "Girl with the Perfect Figure", she provided tattoo artists with the perfect female blueprint.

Another Betty proved equally irresistible to tattoo artists and their customers. Betty Boop, the world's first female cartoon star, soared to fame in the 1930s with a persona based on the Jazz Age flappers of the previous decade. Complete with short black hair, mascara and lipstick, miniscule skirts, her trademark garter with a heart, high heels and a naive sensuality – her "boop-oop-a-doop!" – she became a tattoo pin-up, cast in all the popular poses in parlours across America and Europe. Sometimes she

appeared as Lady Luck or as a siren. She also cropped up in the cocktail glass as a symbol of Man's Ruin.

Unlikely as it may seem, Betty Boop started out in life as a dog, before the animators transformed her into the ditzy but savvy and kindly young spark of cartoon legend. Betty's film career fizzled out around the time that the Second World War began, but she lived on in her admirers' skin and in the flash of old-school tattoo artists, including Sailor Jerry Collins. Recent years have seen a huge revival in the popularity of Betty Boop, coinciding with the return of the vintage tattoo. This pin-up girl is back in all her glory, in the style devised by Collins, Brooklyn Joe Lieber, Pinky Yun, Ole Hansen, Doc Forbes and company.

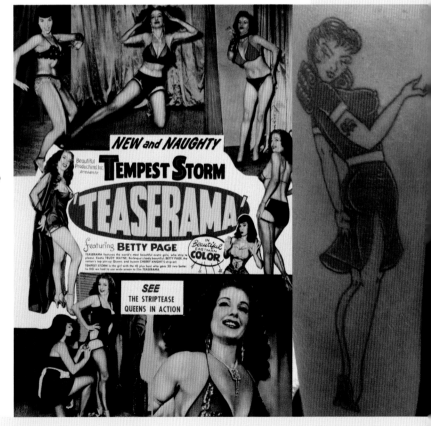

BERT GRIMM

BELOW: Bert Grimm at work in St Louis.

OPPOSITE: Bert Grimm flash depicting patriotic images, a pirate and a demon.

A born storyteller, Bert Grimm captivated generations of customers with theatrical tales of a wild and wonderful past. Like all the most memorable characters in the tattoo community, he expertly wove a blurred web of truth and fantasy as his legend grew and grew. He was also a born tattooist, a master, who could turn his hand to just about anything, from a wicked cartoon to an elaborately detailed backpiece.

Grimm was born in 1900 near Portland, Oregon, where he spent his boyhood watching and learning from great tattooers at work, before setting up professionally in Chicago, allegedly aged 16. Shortly after this, he went on the road, tattooing, with Buffalo Bill's Wild West Circus – or so he claimed.

Although his most celebrated shop was Bert Grimm's World Famous Tattoo at Long Beach Nu-Pike (where at one time he ran five tattoo joints), Grimm had already forged a huge reputation at St Louis. It was here that he spent the longest part of his career and also supposedly tattooed Bonnie and Clyde and Pretty Boy Floyd in the early 1930s, as he never tired of telling his clients, even after he moved to the Pike in 1952. Grimm had another great talent, and that was persuading people to get inked, even if they hadn't intended to.

CW Eldridge, founder of the Tattoo Archive, met Grimm when he arrived in San Francisco in 1983 to be

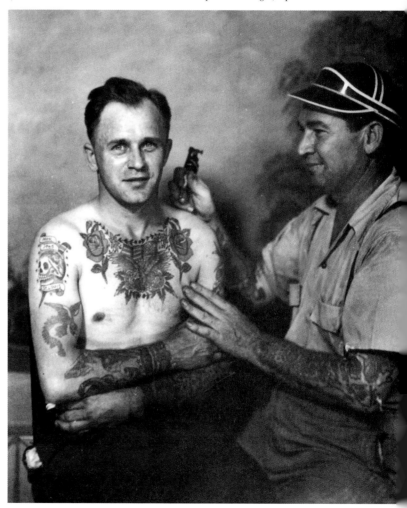

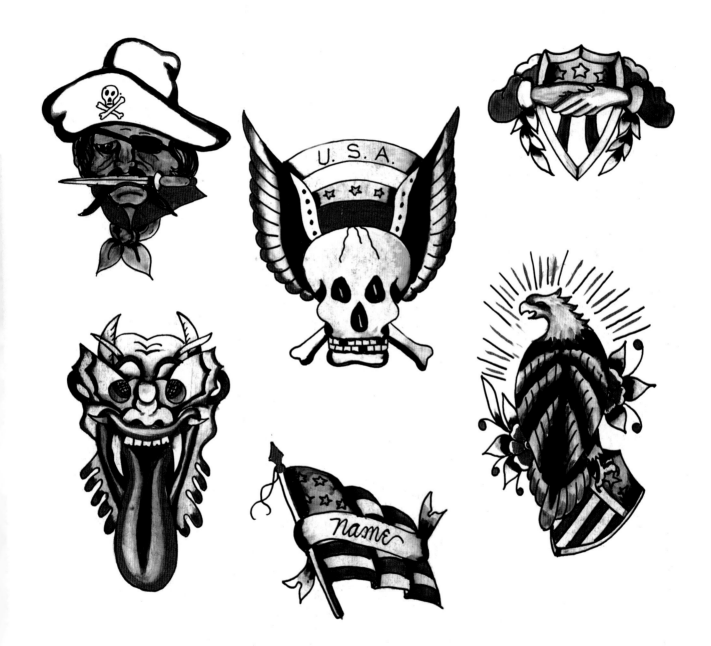

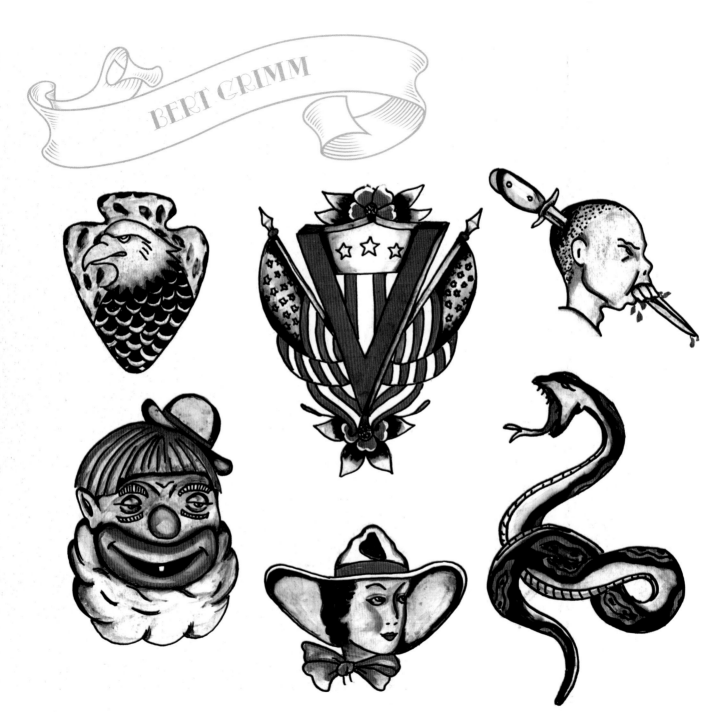

inducted into the Tattoo Hall of Fame, organized by Lyle Tuttle. Eldridge built a tattooist's trunk for Grimm so that he could work out of his hotel room.

He remembers: "I got to know Bert actually quite well. He had his shit together. He was married, he was settled down and he knew how to make money. He was quite a character. He was a true salesman. He could sell an Eskimo a refrigerator."

"He was as charismatic as hell," agrees eminent tattooist and historian Lyle Tuttle. "You just wanted to jerk all your clothes off and get tattooed all over. A lot of my tattooing is by Bert – my front, other than the eagle on my chest. He did my torso and sides. My backpiece is 100 per cent Bert Grimm, who probably was one of the best commercial tattoo artists going. He could cover more area in a less amount of time than anybody I know. He was fast, but his style was simple. I know a guy that has 40 hours on his backpiece, cos it's over-complicated. My backpiece took 14 hours, and I can stand across the street with my shirt off and you could tell what I have on my back. These over-complicated tattoos, across the street, it looks like a muddle."

Tuttle adds that Grimm was an accomplished diplomat: "He could handle any situation. You're dealing from bank robbers to bank presidents, and you've gotta have that touch, that personality."

Grimm sold his last business in Long Beach to Bob Shaw in 1970 and moved back up to Oregon. He made a couple of attempts at retirement, but couldn't resist returning to tattooing. He died on 16 May 1985 after a long, colourful and illustrious career.

RIGHT: Bob Shaw with his full-torso tattoo by Bert Grimm.

OPPOSITE: Assorted Bert Grimm flash.

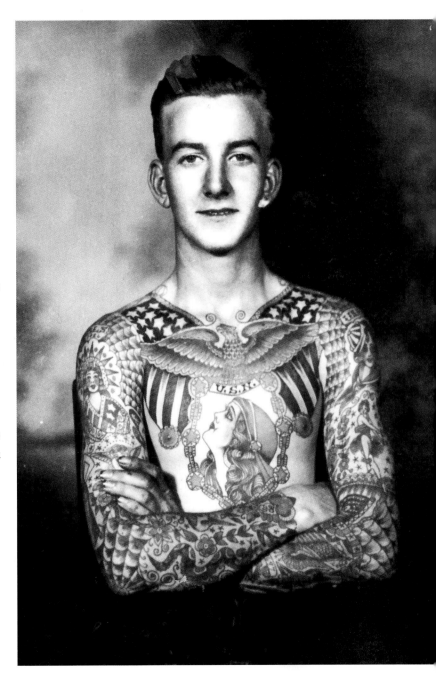

BERT GRIMM

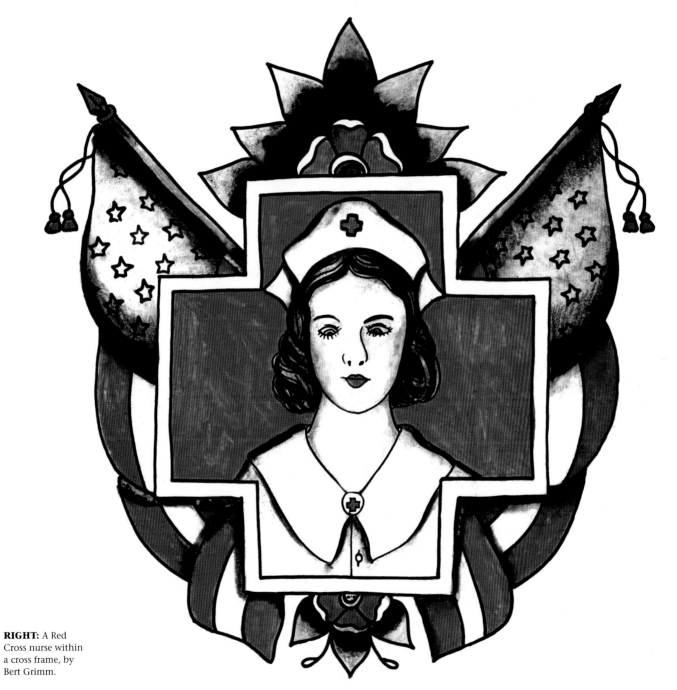

RIGHT: A Red Cross nurse within a cross frame, by Bert Grimm.

THE ETERNAL HEART

Pin-up girls were all well and good, as a diversion and a comfort in some small way to soldiers and sailors posted to faraway places in the war years of the early 1940s, but the greatest reassurance to many such men was their bond with the wives, fiancées, girlfriends and children they had left behind. The mainstay for younger servicemen was the unconditional devotion of their mothers. And so the heart tattoo, which usually appeared with names or other images, became an artist's staple.

The heart has always been fundamental to Western tattooing as an enduring avowal of love. However, the symbol's importance stretches way back before the days of Christ. Somewhere around 400 BC, or earlier, the heart became associated with Eros, whose deity seems to have covered all the bases: love, lust, sex and fertility. Travelling quickly through history to Africa in 7 BC, we find the surprising theory that the heart came to represent amorous desire even more strongly because its shape resembled that of the fennel seed, which was believed to act as a natural contraceptive.

As the centuries passed, the heart design retained its connection with romance while also coming to stand for key religious principles, not least the Christian cornerstones of faith, hope and charity. The eternally beating heart has additionally been used to signal virtue, beauty, knowledge and truthfulness, and during the Middle Ages, it entered art and literature as a sign of the Holy Grail.

The outline of the heart design only roughly resembles the actual body organ. Some have ventured that, instead, the image is supposed to celebrate the pubic triangle and therefore womanhood in general. Other meanings attached to the heart symbol include light, warmth (especially in relation to the seasons) and life itself. In Tarot, a burning heart relates to happiness, wisdom, fertility and life from water. Universally, however, the heart design speaks powerfully of love and of a person's emotional core.

Certainly, this was the case when servicemen were queuing up for their tattoos in the Second World War, and artists' flash sheets displayed a generous choice of hearts, almost always coloured red.

The simplest option was a single heart with no further adornments – a small, discreet tattoo for the more modest customer. Circus tattooists often used single hearts, stars and musical notes to fill in gaps or enliven the body illustrations of a sideshow performer. Together, these symbols represented a hope for joy and good luck.

A basic adaptation was the heart pierced by an arrow. This dramatized the love element, indicating that the wearer was deeply smitten – "pierced" – and happy to endure the sharper aspects of the experience. Some tattooists, including Captain Don Leslie, offered a handshake design, in which two hands are clasped in front of a heart, or a pair of hearts, indicating love, friendship and loyalty. In a different depiction, two hands holding a heart suggested parental love. The most common expression of this was contained in the traditional "Mom" tattoo, with the lettering enclosed in a ribbon or banner draped across the heart. A double banner made room for "Dad".

In the same way, men paid tribute to their sweethearts, or simply had the words "True Love" inked into the design. Bert Grimm produced some neat twists on the fundamental idea, creating ring banners, in which

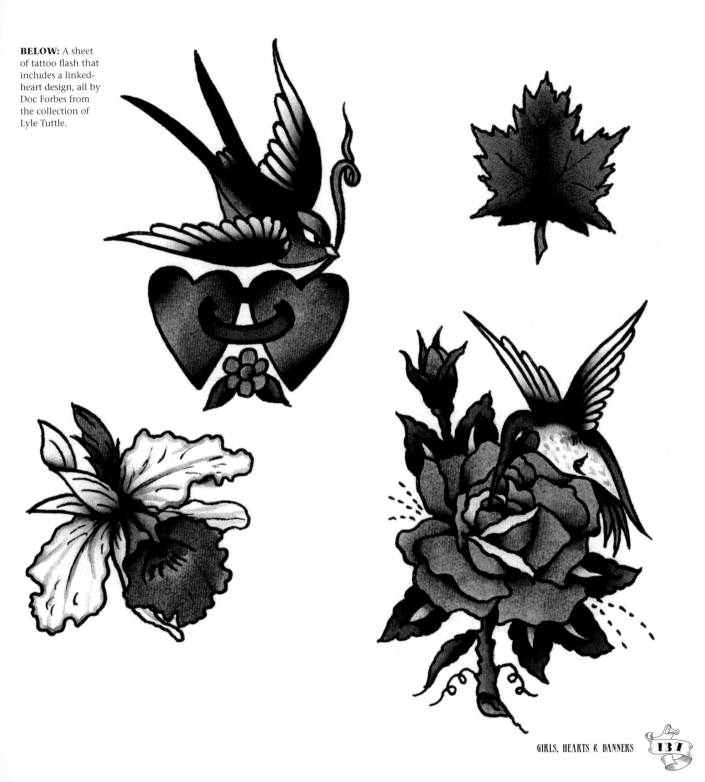

BELOW: A sheet of tattoo flash that includes a linked-heart design, all by Doc Forbes from the collection of Lyle Tuttle.

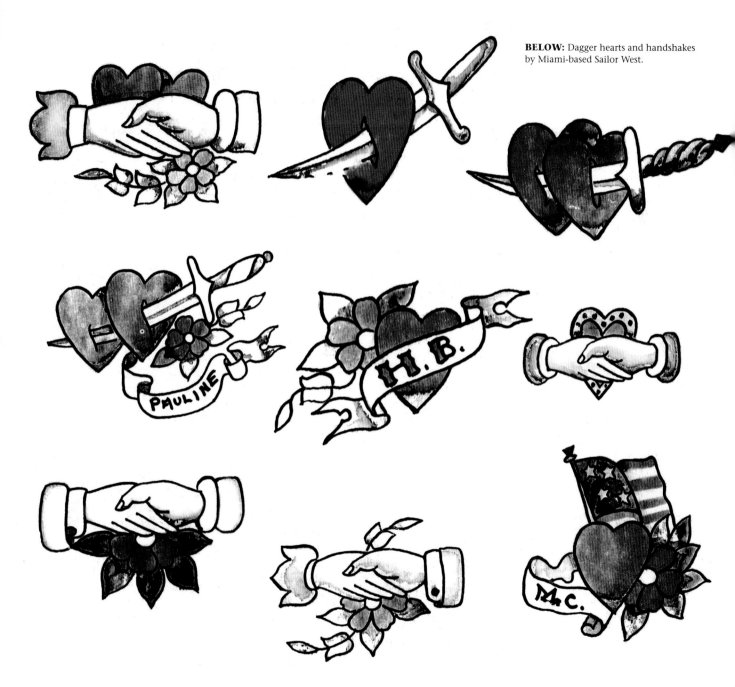

BELOW: Dagger hearts and handshakes by Miami-based Sailor West.

the banners encircled the hearts, and the heart-cross name banner, whose centrepiece was the religious cross.

Hearts and ribbons were frequently accompanied by bluebirds, leaves and flowers, most popularly the rose. In the West, the rose has long been the most powerful floral symbol of love, with its attendant intimations of beauty, purity and passion. The red rose is particularly meaningful, having appeared in songs, paintings, poems, literature and legends that go back thousands of years to ancient civilizations. The flower itself remains a potent declaration of adoration, whether presented singly, in a bunch of a dozen, or as part of a bouquet. Without its thorns, it is said to symbolize love at first sight, while rosebuds signify youthful romance. In tattoos, roses were often etched decoratively around the outlines of the heart, but in some instances, the flower's stem and leaves were wrapped right around it.

By adding a crown to a heart tattoo, owners elevated the object of their affections to the status of a prince or princess, king or queen. The heart could also be used as a form of shorthand, as with the modern-day slogan "I [Heart] NY", a recent merchandizing phenomenon. By having a heart tattooed next to, for instance, a place name, an animal or a cross, the bearer was able to reveal something about his life and loves. Heart-shaped American flags spoke for themselves.

Fluttering bluebirds, roses and euphoric happiness weren't for everybody, of course. Shakespeare once observed, memorably if pessimistically, that "the course of true love never did run smooth", and for many people, it was an adventure that ended bitterly and so deserved a realistic commemoration.

Few tattoos were more poignant than the bleeding heart, more forthright than the jagged, broken heart and the heart in two halves, or more violent than the heart

and dagger, a classic design still very much in use today. In a graphic depiction of emotional murder, the dagger is seen to plunge through the heart – which is often still festooned with flowers and the trappings of the True Love tattoo – while blood drips from the blade's tip and the hole it has torn. The use of a dagger is doubly disturbing, since this is a weapon used up close and personal, therefore implying a shattering betrayal by a loved one.

Sailor Jerry turned out some noteworthy variations on this theme, his hearts speared with all manner of evil-looking instruments, not least a torpedo, and a broken heart sympathetically riven by one word: "Busted!" Collins also pictured the human organ rather than the heart symbol in some of his creations, and he was apt to issue warnings about the fairer sex. One enduring image features a raven-haired beauty wearing a black necklace and dress, her head at the centre of a pair of crossbones, with a damning description – "Poison" – jumping out at the viewer. The Poison tattoo is another old-time standard, re-worked and updated over the years by many different artists.

The "warning" concept evolved gradually into the unapologetic disdain for sentimental romance that became a favourite tattoo theme for the devil-may-care rebel, the outsider and the plain loser. "Love Kills Slowly", written on banners ranged round a heart-topped skull, "Death of Love", with a slashed heart and a grinning skull, and "Love Is a Gamble", complete with dice, coins, playing cards showing four aces and a heart containing a question mark, are typical old-school ideas that have progressed into today's mainstream courtesy of Don Ed Hardy's fashion lines.

Hardy and his friend Mike "Rollo Banks" Malone, both Californians, were admirers and students of Sailor Jerry, whose legacy they inherited. Malone took control

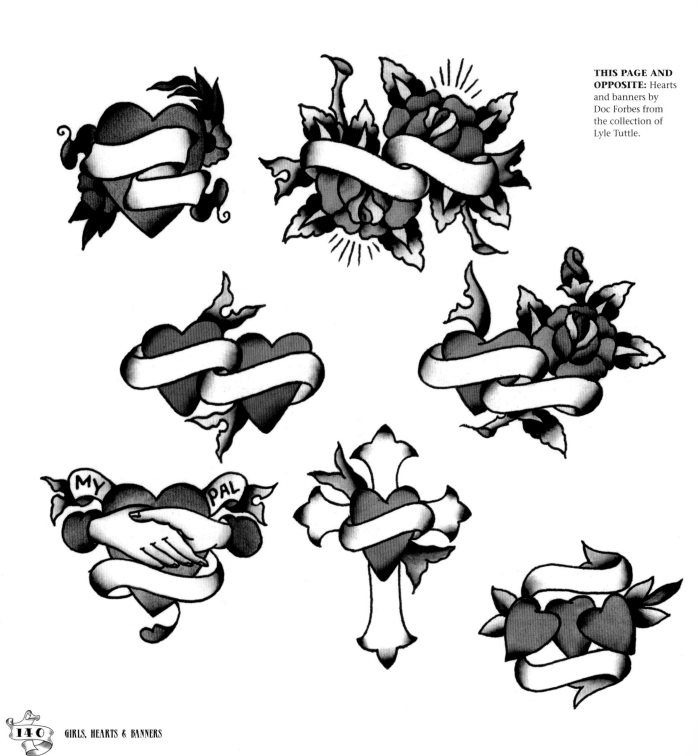

THIS PAGE AND OPPOSITE: Hearts and banners by Doc Forbes from the collection of Lyle Tuttle.

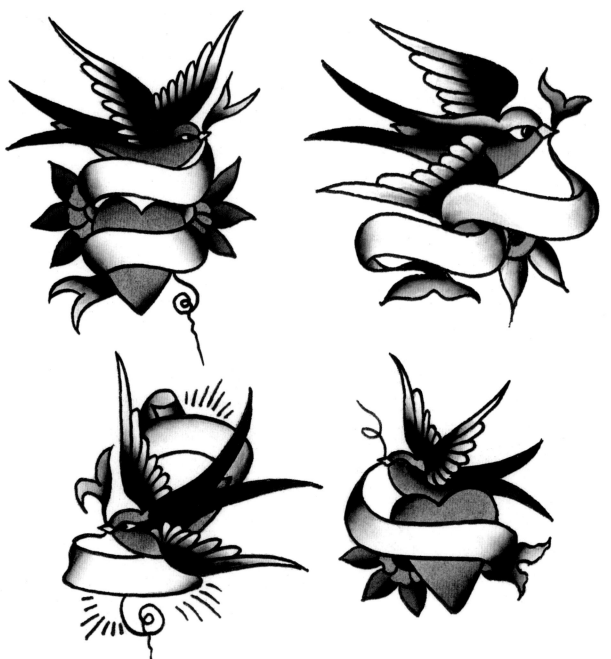

of Jerry's legendary tattoo shop in Honolulu and, with Hardy, became the legal owner of Collins' flash. Later setting up in business as Sailor Jerry Limited, Hardy and Malone promoted his work through a series of books and branded merchandizing including clothes, rum, accessories and flash designs, all on sale online and at the Sailor Jerry showpiece store in Philadelphia.

Both Hardy and Malone became respected and influential tattoo artists. In 2007, Malone took his own life after a long illness, leaving a note that simply said it was "time to check out". Hardy, a printmaking graduate, has carried on a multifaceted career. He no longer tattoos very much, but he writes, lectures, organizes or curates exhibitions, and acts as a spokesman for the tradition, as well as running parlours, painting, drawing, making lithographs and supervising his own retail empire. In all this, he has achieved a celebrity that rewards his years of devotion to old-school tattoo design.

THIS PAGE AND OPPOSITE: Hearts and banners from the East Coast tattoo artist William Grimshaw.

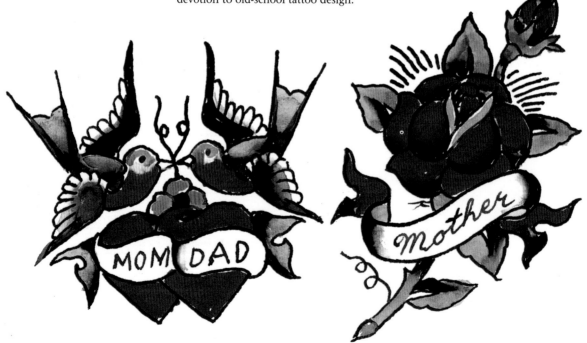

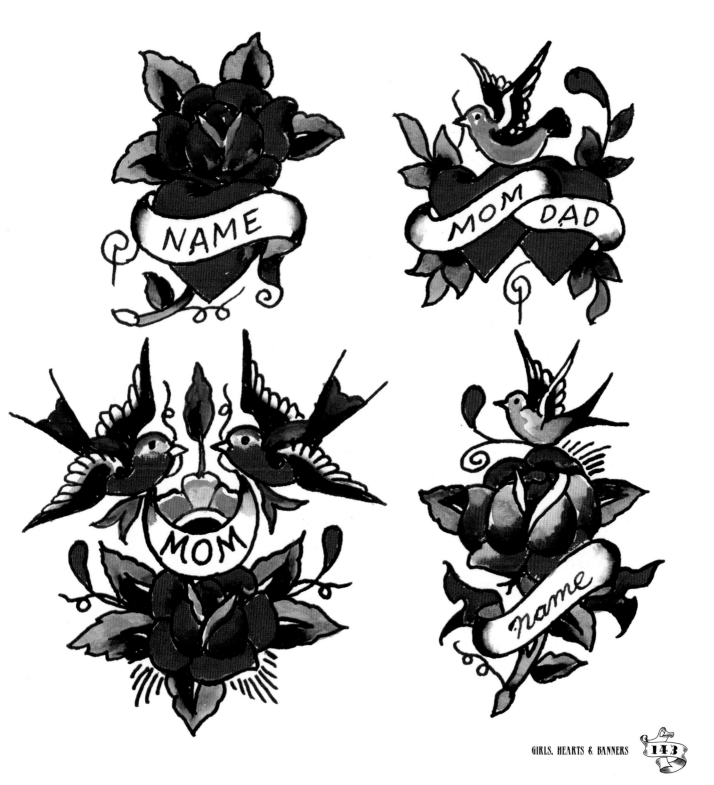

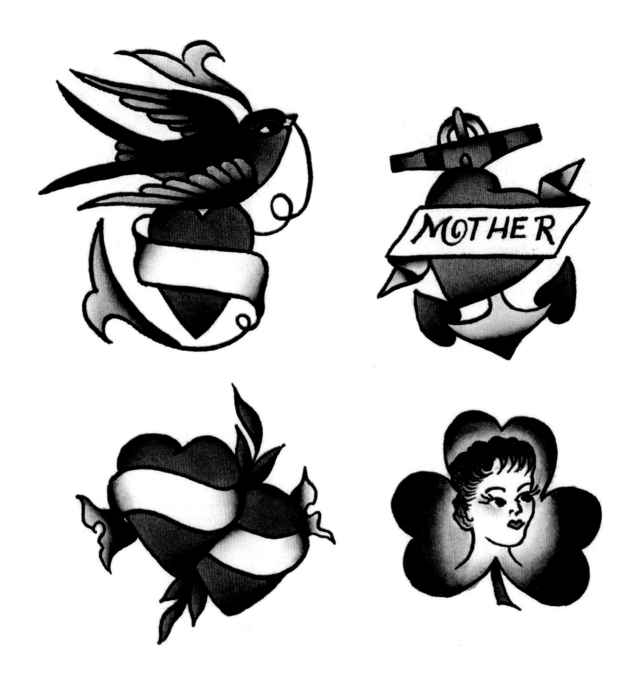

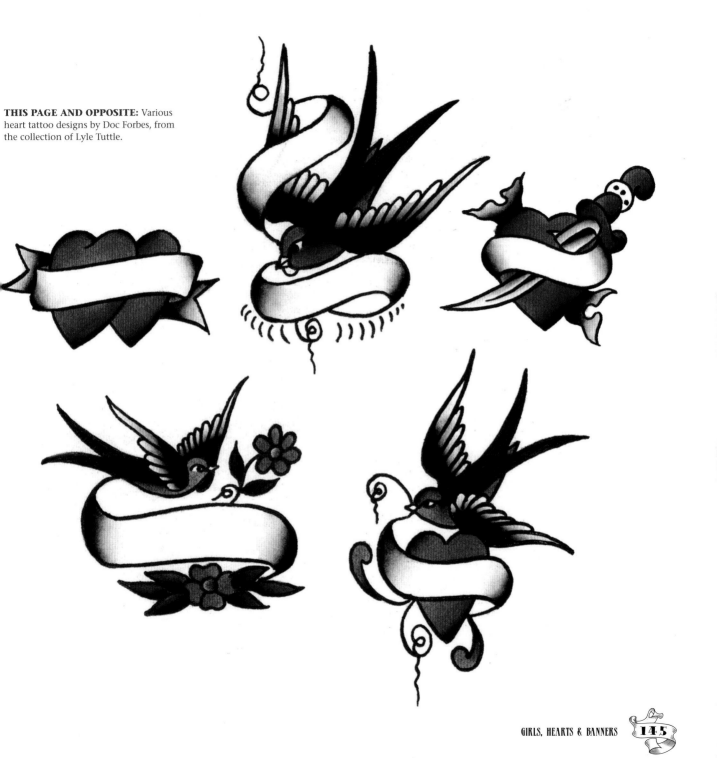

THIS PAGE AND OPPOSITE: Various heart tattoo designs by Doc Forbes, from the collection of Lyle Tuttle.

MEMORIAL TATTOOS

Images of hearts, ribbons and flowers may be most popularly associated with love and happiness, but sailors often asked for the same images to be used in memorial tattoos. In these circumstances, "Mom" and "Dad" signified great loss as well as love and pride. There were many variations, including hearts carried aloft by wings or punctured by the stem of a rose.

Bert Grimm created some particularly moving tributes. In one, a scroll addressed to "My Dear Mother" rested at the foot of a cross bearing a heart, set among leaves and yellow roses. A simpler but equally affecting image featured the words "In Memory Of" inscribed on a cross, with a banner saying "Mother" draped across it. Captain Don Leslie, meanwhile, constructed a scenario specifically for sailors, in which the memorial – a large wooden cross with a bright red heart, a "Mom" banner and some colourful flowers – appeared, island-like, amid rippling blue waves, under cloudy skies. Of all the symbolic declarations of love, the memorial tattoo was one that no artist ever wanted to get wrong.

Much of the work pictured here is by Doc Forbes, a Vancouver-based artist. Along with Charlie Snow of Halifax, where the circus entertainer Leo "Circus Leo" Leopold also opened shop and later Sailor Jerry Swallow, Forbes was one of the most famous tattooists in Canada, working from the 1920s until the 1970s. His style of simple images with bold outlines was perfect for creating bold memorials, flowers and hearts.

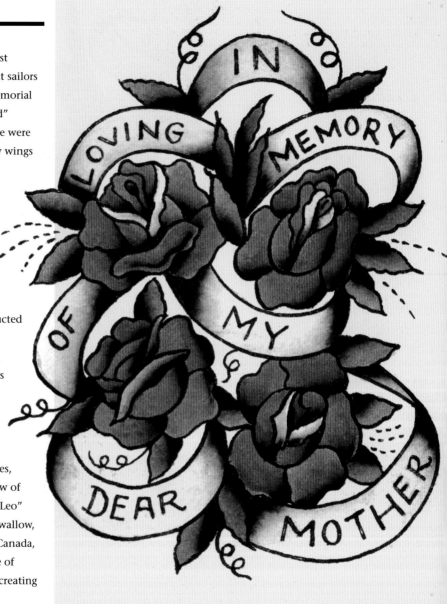

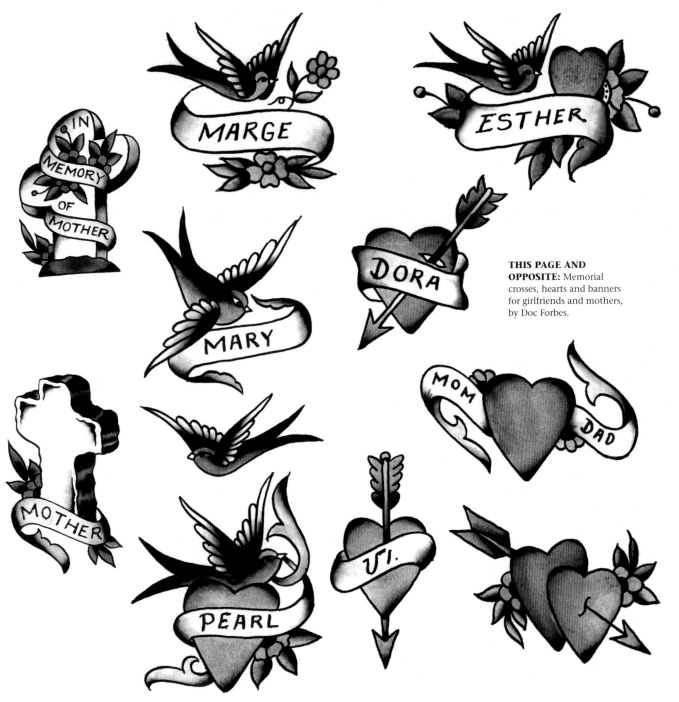

THIS PAGE AND OPPOSITE: Memorial crosses, hearts and banners for girlfriends and mothers, by Doc Forbes.

IN MEMORY OF MOTHER

MARGE

ESTHER

DORA

MARY

MOTHER

MOM

DAD

PEARL

V'I.

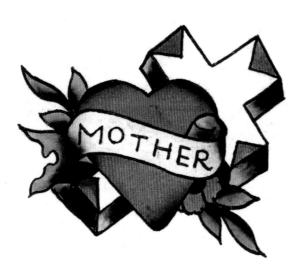

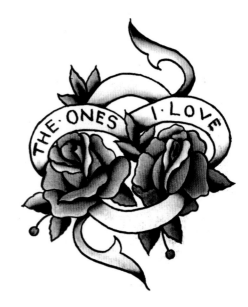

RIGHT: Two banner tattoos by Doc Forbes: a "Mother" memorial design with a heart, banner and cross and a "The Ones I Love" rose design.

LEFT: A girl with a banner memorial tattoo on her upper thigh, posing in Doc Forbes' tattoo parlour.

OPPOSITE: A sheet of flash depicting hearts, banners and assorted designs by Trevor Hodge.

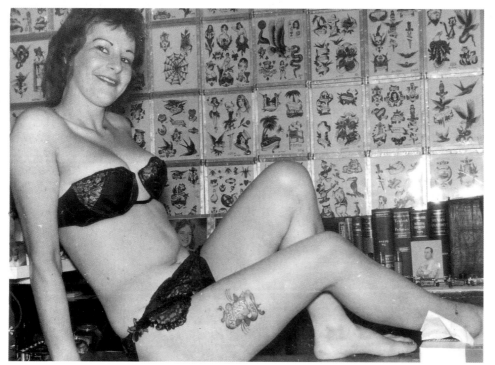

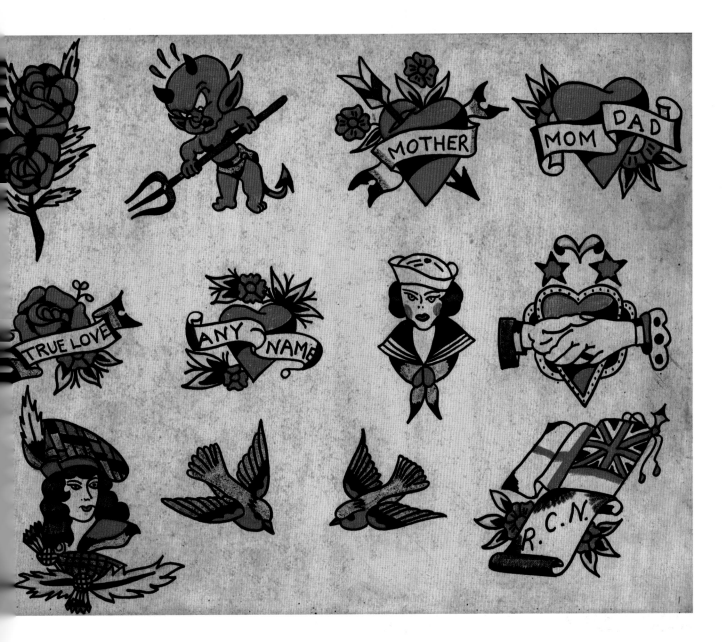

RIGHT: A Death Before Dishonour tattoo by English artist Lone Wolf, circa 1950s. Traditionally having military associations, the motto, especially when combined with a skull and dagger, has been adopted by prisoners to mean they have served time for murder.

A from the famous old times te Heart

LONE-WOLF, LUTON, LONDON, ENGLAN

(50s)

DEATH

BEFORE

DISHONOUR

THE GOOD, THE BAD & THE SUPERSTITIOUS

While no one bore any ill-will towards the soldiers, sailors and circus folk who paraded their tattoos with such chutzpah during the years around the First and Second World Wars, there existed a huge distaste for civilians bearing body-markings. Such people were to be avoided at all costs: they were immediately identified, rightly or wrongly, as jailbirds, gangsters or misfits.

Tattoo culture certainly did sweep the criminal underworld during this era. The branding of prisoners, deserters and other undesirables as a mark of shame – a practice commonly carried out in Europe and the Far East from ancient times – had been outlawed in the mid-1800s. But a new phenomenon had arisen. Far from feeling humiliated by their incarceration, many convicts were proud of it. And so they tattooed each other with symbols relating to their sentences, their misdeeds and their alliances with fellow prisoners.

THIS PAGE: Nazi and devil tattoos by Doc Forbes, most likely for the biker gang market.

OPPOSITE: Dagger designs, including one with a skull, by AG Robinson from East Hastings, Vancouver.

THE GOOD, THE BAD & THE SUPERSTITIOUS

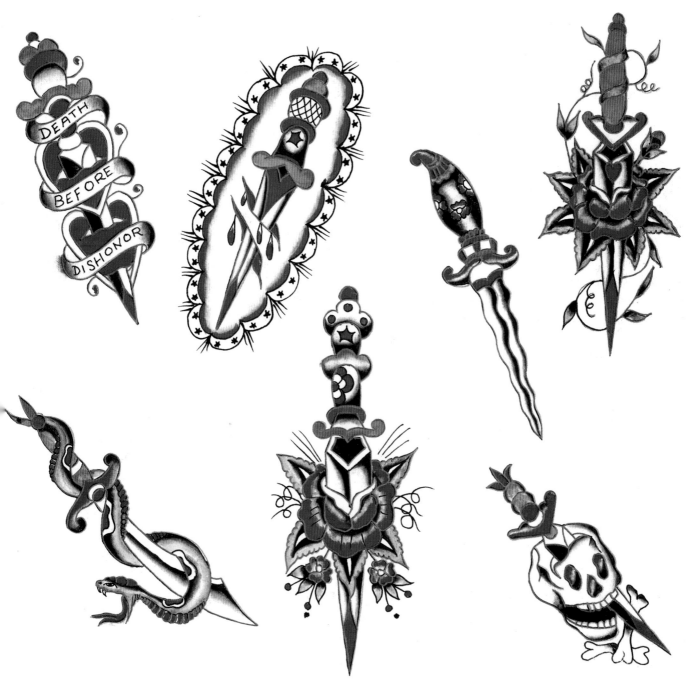

PRISON TATTOOS

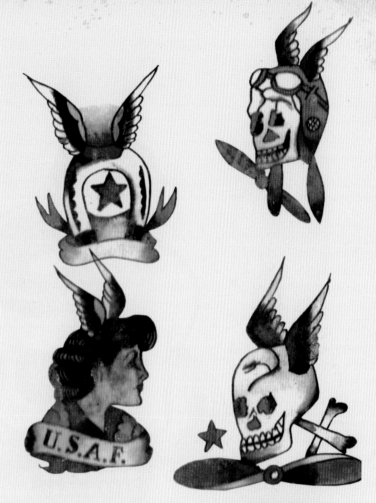

Prison tattoos were carried out with unsophisticated equipment: makeshift needles placed in a narrow, hollow tube, and ink from pens or any heated substance known to produce a permanent dye. The ensemble could be linked to a motor to create a primitive "tattoo gun".

Needless to say, this type of tattooing was far from perfect. It carried a high risk of infection, since there was no provision for sterilizing the needles, the hands of the tattooer or the skin of the recipient. Although the nightmare of HIV was still decades away and undreamed of, prisoners were vulnerable to blood-borne viruses and serious skin complaints caused by infection in the unhealed tattoo. In addition to this, the amateur artists were using common-or-garden ink, which presented another set of dangers. The ink could be toxic; it could also trigger allergic reactions or provoke irritations. Many convicts walked out of the prison gates with scars and skin deformities caused by ink being pushed too far into the flesh.

This may have been all part of the appeal. Since the prison tattoo was often worn as a declaration of hard outsider status, the simple fact that a man had undergone such a roughly administered procedure could be seen as another example of his toughness, his willingness to shrug off pain or danger of any kind.

The tattoos crafted in jails were of wildly varying quality. Most were pretty poor. Since the prison population was probably not over-crowded with trained tattoo artists, the men had to do the best they could with whatever limited talents they possessed, using improvised equipment. The lack of materials meant that the ink was almost always dark blue or

THIS PAGE: Skull designs by Joe Darpel.

OPPOSITE: Dagger tattoo flash by Bert Grimm.

black, and the designs were frequently child-like, badly drawn and clumsily detailed.

Some budding artists, however, honed their skills while they served their time and turned into exceptionally good tattooers. The lucky lags who enjoyed the services of these men returned home with markings worthy of a licensed practitioner. One school of thought proposes that the fineline tattoo technique – with its delicate, precise outlines and careful detail and shading achieved by one needle only – was developed by necessity and then refined within the prison system.

Some of the most common tattoos simply reflected the day-to-day grind of captivity; the prison wall, for example, or the clock with no hands, which was usually inscribed on the upper arm. Hourglasses, chains, locks and spiders and cobwebs on the arms or shoulder also signified the passing of time in jail. Some captives had their prison ID number tattooed on to their bodies. Tombstones containing numbers referred to the length of a sentence. There was a certain optimism, though, in the image of the sun shining through cell bars, which spoke of the prospect of freedom. This could also be expressed by a bird outside the bars, or by the prison wall's bricks tumbling outwards. Many prisoners adopted a philosophical attitude toward their circumstances with a depiction of the age-old theatre mask linking tragedy and comedy, a reminder that there was often a heavy price to pay for good times on easy street.

Some men chose to remember those they had left behind. A female face, sometimes crying, symbolized the wife or mother waiting loyally on the outside. Tombstones appearing with dates and the letters RIP commemorated the death of a loved one, as did tattooed "teardrops" falling from the corner of the eye. The teardrops – still in currency today – had other meanings too. Each drop could represent a prison term. Together, they could sum up a person's sadness at being in jail.

However, the teardrops were sometimes used to send out an altogether more serious message: that the wearer had committed murder. A whole series of tattoo symbols were endowed with coded meanings understood throughout the criminal community. Thus, villains, thieves, fighters and cold-blooded killers could silently advertise to each other their particular areas of expertise without having to exchange a word. The

THIS PAGE AND OPPOSITE: Skull and snake tattoos by Bert Grimm. The skull commonly acts as a *memento mori* – "remember you are mortal". Particularly potent is the snake emerging from the skull's eye sockets; the snake signifies immortality and knowledge that persists beyond death.

 THE GOOD, THE BAD & THE SUPERSTITIOUS

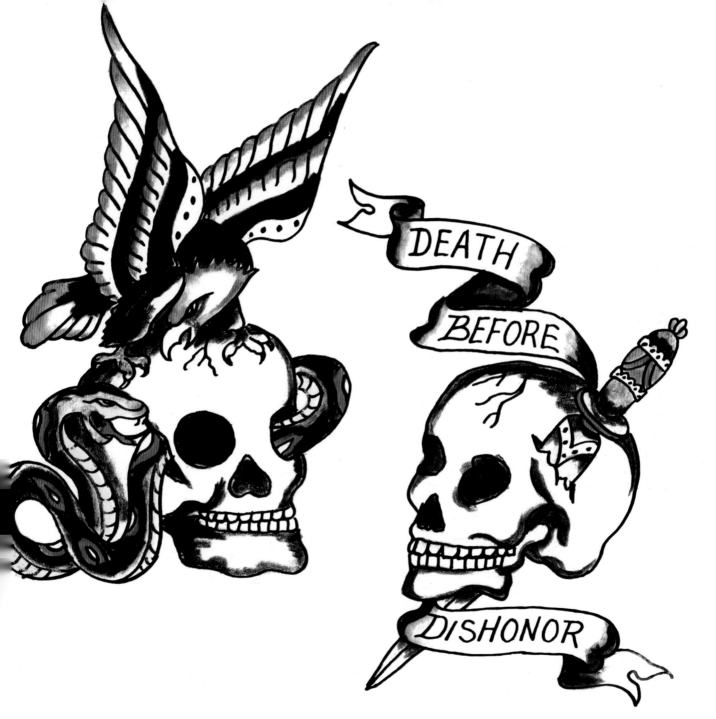

DEATH BEFORE DISHONOR

RIGHT: An identity tattoo, artist unknown. These were often used to mark the end of a tour of duty or a prison term.

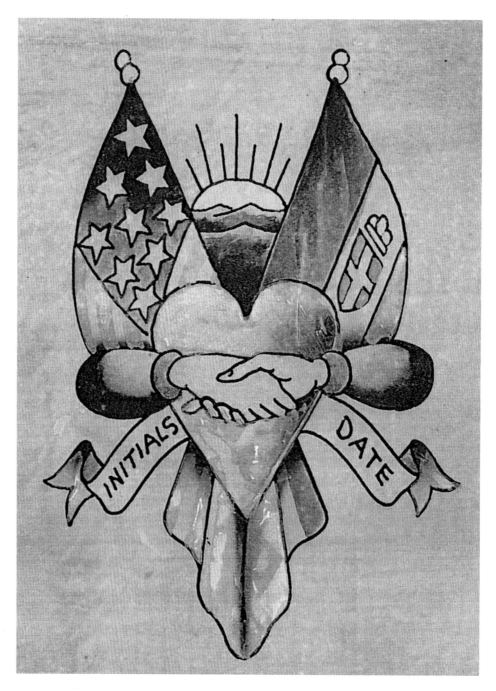

most feared and respected captives were those who had taken a life. Another accepted badge of honour for the murderer was the image of a knife or dagger embedded in a skull. Knives and daggers dripping with blood, or held in the teeth of a skull, were adopted by criminals letting it be known that they were utterly fearless and willing to kill.

Less conspiratorially, there were inmates who wanted purely to convey their hatred of the prison system or, perhaps, authority in general, and while many chose the ferocious imagery of the dagger and the skull, others made their protests with jokey cartoon tattoos.

Some jailbirds who had not been inked during their sentences or who wished to improve on the quality of their tattoo collection, visited licensed parlours upon their release to have these self-same designs administered in colour by old-school artists – no longer serving time but acknowledging time.

BELOW: Cracked skull tattoos by Joe Darpel; these for the US Air Force.

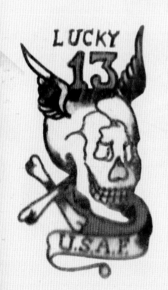

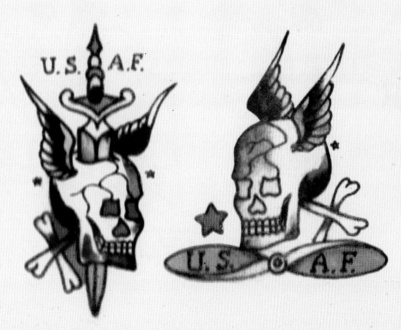

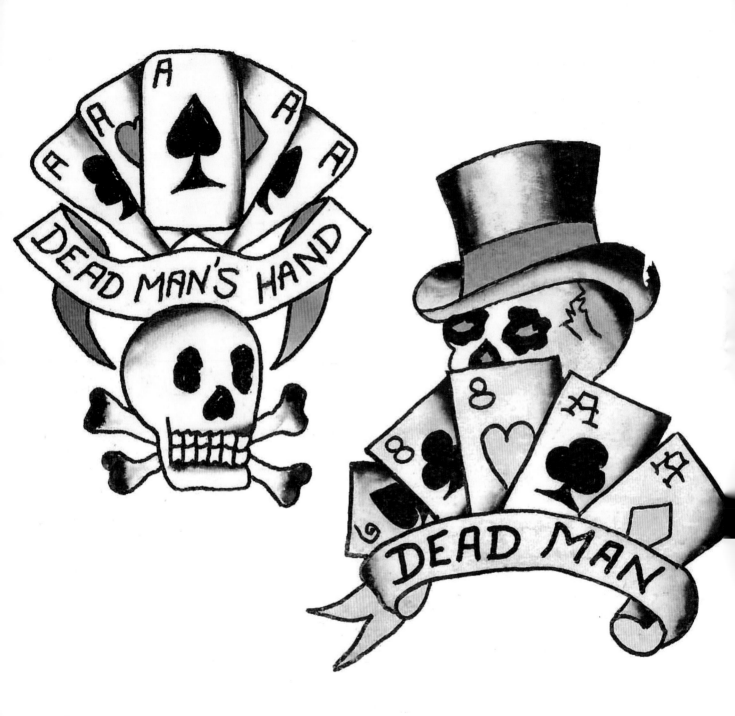

THE GOOD, THE BAD & THE SUPERSTITIOUS

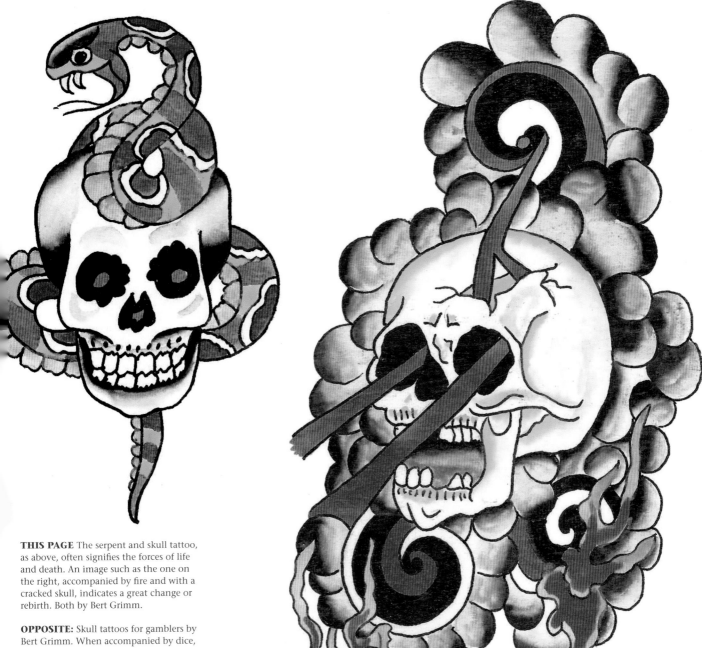

THIS PAGE The serpent and skull tattoo, as above, often signifies the forces of life and death. An image such as the one on the right, accompanied by fire and with a cracked skull, indicates a great change or rebirth. Both by Bert Grimm.

OPPOSITE: Skull tattoos for gamblers by Bert Grimm. When accompanied by dice, cards or a black cat, the skull tattoo serves as a "reverse bad luck" charm, hoping to bring good fortune to the wearer.

GANGS AND OUTSIDERS

By the 1950s, the concept of prison gangs was becoming well-established. It was in the interest of every newcomer, for his own protection, to hook up with one of the active gangs in jail. These were usually grouped according to racial belonging. Each had its own logo, which the members wore as a tattoo. Sometimes the prison gangs had links to street gangs, or criminal or other organizations in the outside world, many of these also bearing unique emblems. The most "romantic" of these were the bikers.

The Hells Angels originated in southern California in 1948 amid the stunning landscapes of mountains, lakes, beaches, parks and deserts that surround the towns of Fontana and San Bernardino. The Angels have always insisted that they were not a gang; they were, and remain, a motorcycle club. However, they captured the imagination and personified the fears of the American public at large throughout the 1950s and beyond with their freewheeling lifestyle and fearsome reputation. Only a Hells Angel was entitled to wear the club logo, on the leather jacket or vest, or inked into the skin. That logo – the death's-head – is of memorable vintage quality: it comprises a patch showing the profile of a skull clad in an aviator's hat, from which immense wings spread out into the distance, fanned by the wind.

Other bikers' clubs were founded at this same time and, for their members too tattoos were a regular part of life. Like the Angels, they displayed their logos loud and proud, with an assortment of other tattoos that proclaimed their status as outsiders, living apart

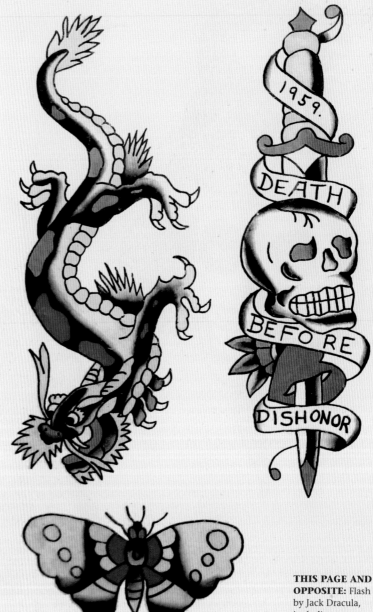

THIS PAGE AND OPPOSITE: Flash by Jack Dracula, including two Death Before Dishonour daggers, circa 1959.

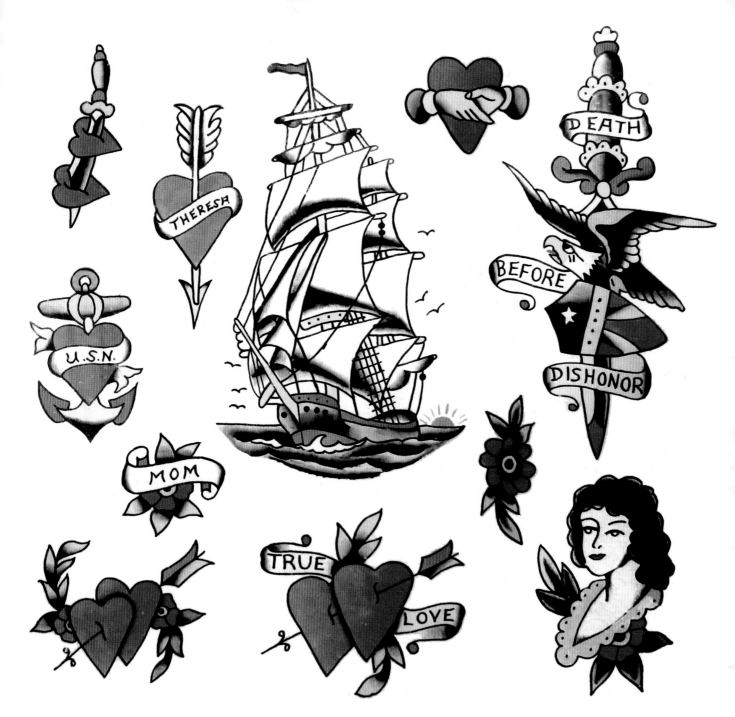

THE GOOD, THE BAD & THE SUPERSTITIOUS

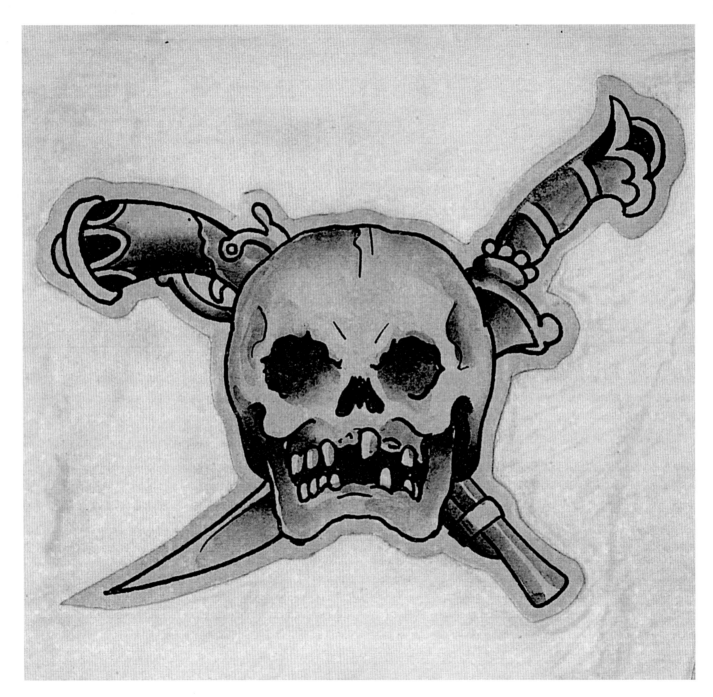

from conventional society, relishing the thrill of the open road in a brotherhood. The riders' arms, at the very least, were fully tattooed, the designs often interconnecting to form sleeves.

Skulls, weapons, wheels, wings and flames were popular symbols, since not only were they descriptive, bold and confrontational but they also spoke of the wearer's bravery, his willingness to take the ultimate risks, to truly live on the edge.

The wheel, or the complete motorcycle, with wings was the classic biker's tattoo, since it encompassed the twin themes of power and speed. Such designs frequently incorporated other images including the eagle, symbolizing independence and freedom, the American flag, worn patriotically, and bright orange or red flames. In biker artwork, the flames stood for passion and danger, loaded with the threat of something uncontrollable or devastating. Also common were double lightning bolts; the allusion to the German SS was intended to be aggressive (if not sympathetic to the Nazis). Many tattoos were accompanied by phrases such as "Ride Free", "Live To Ride" and "Live Fast, Die Young", which came into parlance via the 1949 Humphrey Bogart movie, *Knock On Any Door*.

Some of the great soldier and sailor slogans found their way on to the bodies of bikers, primarily those that upheld solidarity in the face of peril. The Death Or Glory tattoo was one that Sailor Jerry Collins

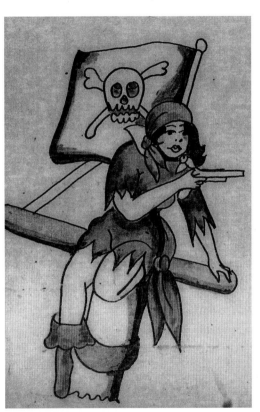

ABOVE: A Jolly Roger pirate girl tattoo. Many images traditionally associated with rebel life on the high seas were adapted for gangs and criminals.

regularly turned out, featuring the face of a ferocious tiger, although it often involved a skull. Death Before Dishonour typically appeared on a scroll or banners, with an eagle and/or a dagger included in the design. In Sailor Jerry's version, the dagger is driven through a heart, while Jack Dracula, a circus sideshow attraction-turned-tattooer, plunged his dagger not just through a heart but a skull too.

Skulls were a huge biker favourite, and they still are. More shockingly than any other symbol in the tattooer's repertoire, skulls, with their cavernous eye sockets and grinning teeth, represented the certainty of death, almost mocking the viewer. They served as a constant reminder that life is short and should be lived to the limit, and they emphasized the fearlessness of the rider. Cocking even more of a snook at the grim reaper, some bikers' tattoos, with dark humour, portrayed the skull wearing horns or a top hat. The flaming skull was another popular design.

Like pirates with their chilling Jolly Roger flag, bikers seized upon the image of the skull as something frightening and certainly anti-social. Perhaps it was no coincidence that the death's-head skull, beloved of motorcycle gangs, bore a striking resemblance to the pirates' emblem, distinguishable only by the position of the crossed bones. However, some sources say that bikers believed the death's-head skull to have protective properties.

CROSSES AND CRUCIFIXIONS

While criminals, outlaws, gangs and bikers were choosing tattoos that clearly identified their rebelliousness and their disregard for God-fearing society, opposite numbers of the population were putting their faith in religion or fate, and paying for tattoos that said so.

Crosses, crucifixes, angels, doves, praying hands, rosary beads, sacred hearts, the Star of David, the Rock of Ages and the lotus flower were staples of old-school flash. Soldiers and sailors going to war derived reassurance from religious markings, which they also hoped would persuade their gods to look after them. Circus sideshow exhibits were especially keen on holy tattoos, believing that these would be less likely to upset the public. The idea was that the punters would therefore be more inclined to part with hard cash for the signed pictorial pitchcards that promoted the attractions.

What's certain is that religious enthusiasm, for whatever reason it existed, resulted in some spectacular tattoo work. A number of circus and carnival exhibits were notable for the remarkable images crammed on to their bodies. Tommy Lee, who was inked by his wife Mildred Hull during the 1920s, showed off an incredible 400 godly illustrations, earning himself the nickname of "The Living Bible".

Tommy was also unusual for a ground-breaking example of role reversal, since it was more often the husband who inked his wife in order for her to become a well-paid tattooed lady. Millie, as her friends called her, was something of a legend in tattoo circles. It was rare, possibly unknown, to find female artists working

THIS PAGE AND OPPOSITE: Assorted images, including the Crucifixion, all belonging to one sheet of flash by Joe Darpel.

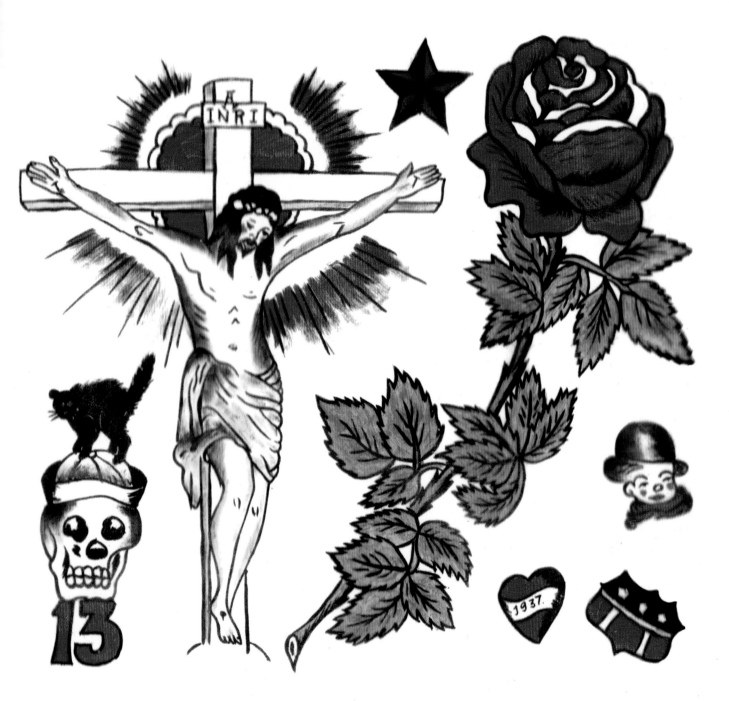

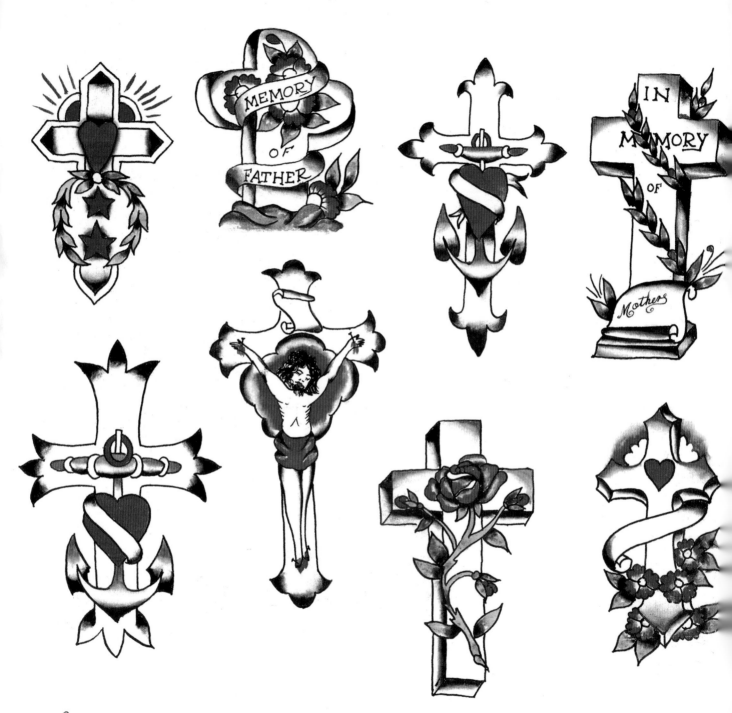

LEFT: Vintage flash of cross tattoos by AG Robinson.

RIGHT: The Crucifixion by British tattooist George Burchett.

in New York City's Bowery at this time, but Millie, undaunted, set up a successful business in a barbershop, just like many of her male counterparts. She was said to be accomplished at embroidery, an ability which was helpful to her tattooing. Slightly plump with a pleasant, heart-shaped face framed by shiny waves of hair, Millie was herself tattooed from shoulders to toes, with local hero Charlie Wagner among the contributing artists, although it's not known who was responsible for the intimately located tattoo that made her a member of the exclusive Butterfly Club. Millie continued to work through the 1930s and 1940s until, beset by personal problems in 1947, she killed herself by swallowing a vial of poison in a Bowery restaurant, undoubtedly to the great shock of her fellow-diners.

LEFT: A Bert Grimm memorial design with a cross.

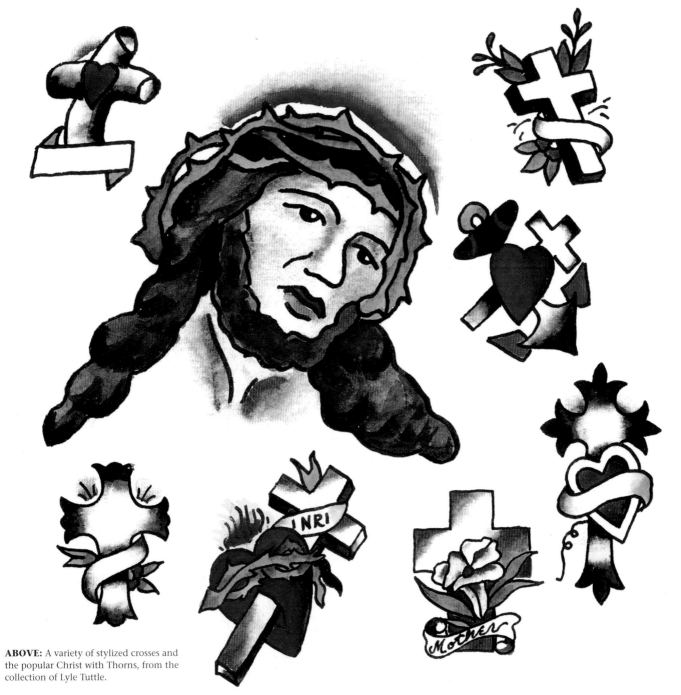

ABOVE: A variety of stylized crosses and the popular Christ with Thorns, from the collection of Lyle Tuttle.

INRI

Mother

RELIGIOUS BACKPIECES

BELOW: A Rock of Ages tattoo by Ole Hansen.

OPPOSITE: An ornately drawn backpiece of the Madonna and angels, circa 1915, appearing on an unknown male.

While many sideshow exhibits were liberally covered with religious images, including figures representing Jesus Christ, the Virgin Mary and Buddha, some enterprising personalities had bigger ambitions for their bodies. They wanted to arrange a host of smaller illustrations around a huge, devotional work of art on the back or the chest. This demanded more of the tattooers than had ever been asked before, and the most amazing consequence was adaptations of Leonardo da Vinci's *The Last Supper*.

Somewhere towards the end of the 1800s, tattoo artists embarked on the tremendously disciplined and challenging task of copying da Vinci's famous painting onto human skin. In the original masterpiece, Jesus is depicted with his twelve disciples at a long trestle table topped with a white cloth. He has just sat down to his final meal of bread and wine and has dropped a bomb by announcing that one person in the company is about to betray him. The disciples – six on either side of Christ – look variously agitated, fearful, angry, distraught, confused and questioning. The tattooers worked long and hard to capture such a complicated scenario with all of its movement and emotion.

Among the first recorded successes was that of Irishman Samuel O'Reilly, the acclaimed New York artist who shortly afterwards patented the electric tattoo machine. O'Reilly was already known as a prolific exponent of religious symbols, particularly the Rock of Ages, also known as the Sailor's Cross, which was a simple stone cross representing the solid foundation of a Christian's belief. O'Reilly was ready to stretch his creativity, and

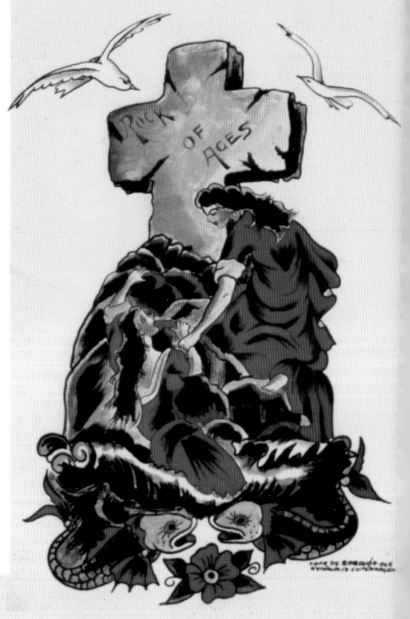

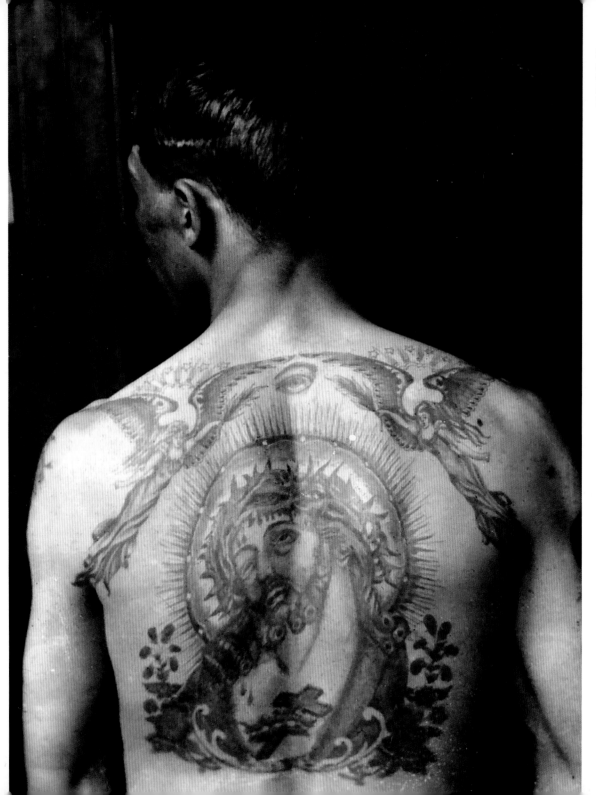

The Last Supper that he spread across the upper back of tattooed lady Emma de Burgh was sensational, underscored by a simple inscription, "Love One Another". In a personalized twist, O'Reilly surrounded Christ's head with a halo that doubled as a rising sun, ushering in the new day that saw Judas's betrayal and Peter's denials.

By 1891, Sam's handicraft was being admired across Europe as Emma and her husband Frank – also inked by O'Reilly – set off on an exhibition tour. They weren't the most attractive-looking people in the world, but their body markings met with admiration wherever they went, particularly in Germany. The de Burghs were a double act, a tattooed couple and a curiosity not unlike the married pairs in 1970s sitcoms who reflected each other almost exactly. Emma and Frank were plastered with multitudinous images of religious conviction and mutual adoration, but where Mrs de Burgh showed off the spectacular highlight of the Last Supper, Frank was flaunting a whole backpiece portraying the Crucifixion scene at Mount Calvary.

Depictions of the Crucifixion and the Last Supper would go on to test the patience and skills of tattooers for decades to come. In the 1920s, another tattooed lady – a slender, striking brunette known professionally as Artoria Gibbons – became famous for her backpiece version of the Last Supper, along with reproductions of scenes from paintings by the other Italian Renaissance masters, Michelangelo and Raphael. Artoria's tattoos were exquisitely carried out by her husband, the reputed Charles W Gibbons, also known as Red Gibbons.

Artoria billed herself as the "highest salaried tattooed lady" and she deserved to be, such was the intricacy and imaginative co-ordination of the artwork she displayed. According to some estimates, she could have been earning up to $200 per week, a phenomenal sum at the

LEFT: Tommy Lee was known as "The Living Bible" due to the large number of religious tattoos all over his body.

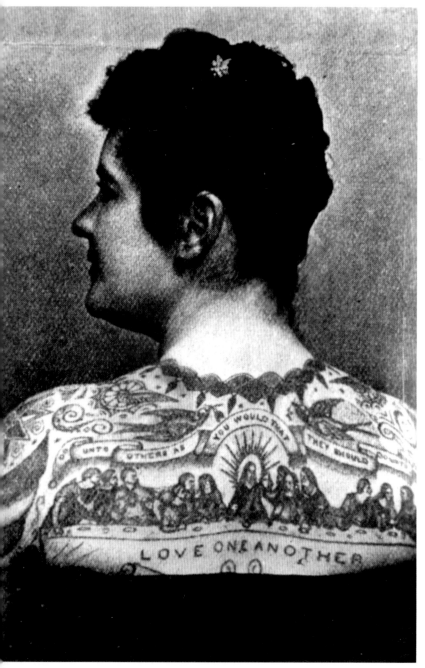

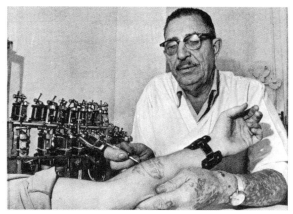

time. Far from feeling exploited, Artoria considered that she had made a good career, one which funded a decent standard of living for Red and herself. As an attraction, she also enjoyed extensive travel opportunities, which found her husband accompanying her as a mobile tattooist. In Artoria's exhibitions, and in her pitchcards, she therefore acted as a human showcase for Red's work.

She was born Anna Mae in 1893 in the farmlands of Portage County, Wisconsin, later moving with her family to Colville, Washington. At 14, she left home to take up a regular job in Spokane, where she met Red Gibbons, at that time tattooing in an arcade. After marrying in 1912, the couple moved to California and decided to work together in the tattoo trade. Gibbons then began inking her. Artoria, said to be a deeply spiritual person, collaborated with Red on her choice of tattoos, which also included some patriotic designs. A portrait of George Washington, the first president of the United States, stared out from her upper chest in an oval "picture frame", held in the folds of the Stars and Stripes.

Artoria went on to become one of the most famous performers of her day, working at sideshows with major big-top outfits such as Ringling Brothers and Barnum and

Bailey Circus, as well as carnivals and dime museums. As part of her necessary spiel, and like all exhibits worth their salt, she reportedly dramatized her life story, spinning tales of how she left home as a youngster to join the carnival with Gibbons – which, needless to say, was not the case. She took time out towards the end of the 1940s to look after Red Gibbons when he lost his eyesight after a violent robbery and an accident. Gibbons subsequently died, and Artoria carried on working into her old age. She passed away in 1985.

Another religious image that often appeared as a show-stopping backpiece was the head-and-shoulders depiction of Jesus at his Crucifixion. Known as Head of Christ or Crown of Thorns, this design appeared in some shape or form in every artist's flash, and some tattooers, including Sailor Charlie Barrs, themselves wore it big and bold in the centre of their backs.

A number of tattoo artists based their designs on Guido Reni's seventeenth-century painting, *Head of Christ Crowned with Thorns*, while others, for instance Joe Darpel, created their own rather more anguished renditions. New York tattooer "Texas" Bobby Wicks was even called upon to ink the image into the shaved head of another artist, Jack Redcloud. Texas Bobby – not known ever to have set foot in Texas, by the way – was a highly rated craftsman whose Head of Christ was among the best to be had in New York City. He had embarked on his career in Coney Island somewhere around 1916, before he was even out of his teens. This new kid on the block then joined forces with a friend, Burt Thompson, to work out of a mobile tattoo studio in a boat, before settling in New York with Charlie Wagner at his Chatham Square barbershop headquarters. Complete with tattoos from Wagner, Wicks is thought to have spent a short time working as an exhibit while continuing to tattoo,

but he'd given it all up by 1930 to specialize in painting carnival banners and scenery, his greater passion. Another potentially enormous Old Testament image, as shown off across the back of Baltimore's Tattoo Charlie Geizer, was the Garden of Eden, which lent itself to all kinds of pictorial interpretations of man's original sin.

None of this was without controversy. There were those devout souls who declared loudly that body-marking of any kind, including tattooing, disobeyed Biblical teachings, citing Leviticus, chapter 19, verse 28: "Ye shall not make any cuttings in your flesh for the dead, nor print any marks upon you: I am the LORD".

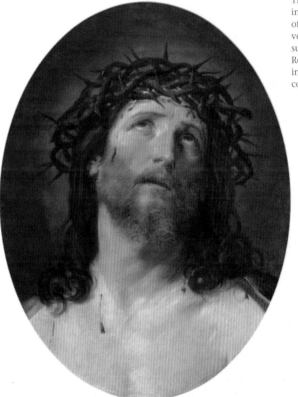

LUCK AND SUPERSTITION

The same vociferous and stern individuals would have been appalled at some of the imagery involved in the good-luck tattoos that were another stock in trade of the old-school artist in the 1900s. These images were popular among people who preferred to trust in chance and destiny rather than God and the church, or perhaps felt that a little extra protection against bad fortune wouldn't go amiss, especially if they were soldiers or sailors setting off into unknown dangers.

Simple, superstitious designs such as the four-leaf clover, the horseshoe, the rabbit's foot and the number 7 were commonplace and sometimes used in combinations, with and without the word "Lucky" emblazoned on a ribbon. Navy men sailing off into potentially stormy seas were fond of the nautical star tattoo, which they hoped would facilitate good navigation in the hours of darkness and ultimately invite a safe journey back to their home shores. Typically, the star would be surrounded by other lucky symbols, and these included the sunset or the sunlit skies that also saw sailors returning to their loved ones through placid waters in the classic Homeward Bound sailing ship tattoo.

Roisterers opted for more earthy imagery. Lady Luck was a huge favourite, regularly appearing as a tantalizing pin-up girl. In some designs, she flashed four aces – a winning hand of cards – or smiled knowingly as a pair of dice tumbled to a favourable result. These tattoos represented the naturally optimistic qualities of the gambler, the perpetual search for good luck, rather than the contrary, cynical warnings of that other great vintage classic, Man's Ruin.

LEFT: A Good Luck horseshoe tattoo from Les Skuse, circa 1950s.

OPPOSITE: Vintage Earl Brown flash showing tattoos with themes of luck and superstition, including the four aces and horseshoe, among a variety of tradesmen tattoos and masonic symbols.

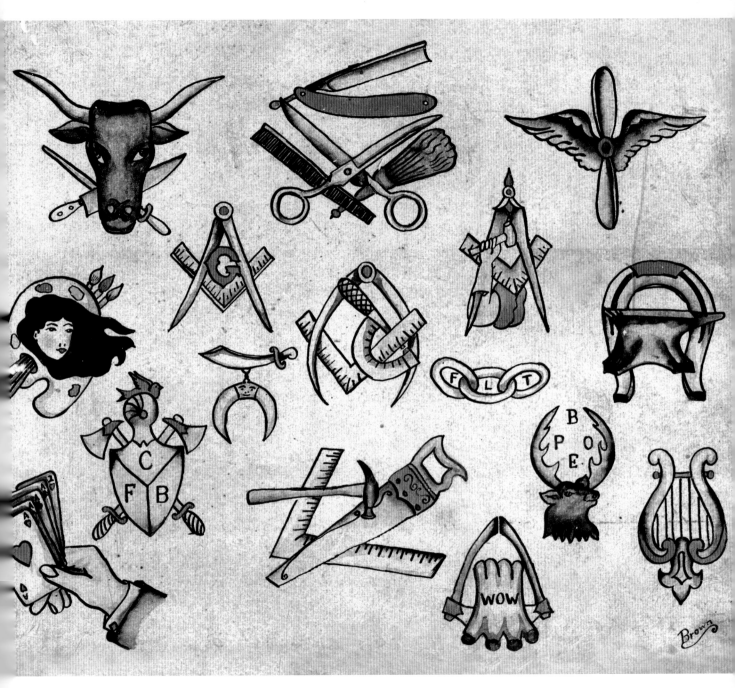

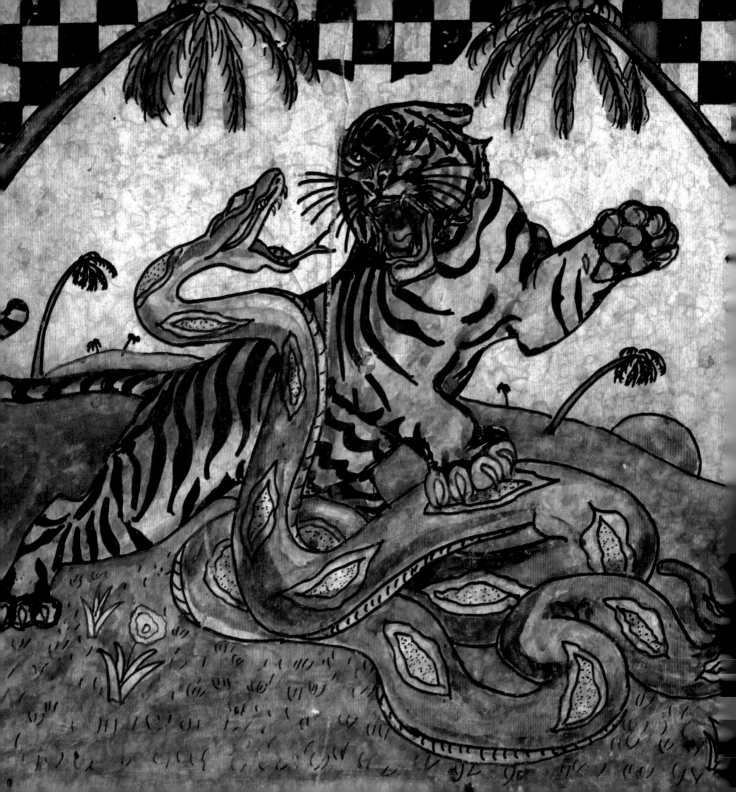

THE NATURAL WORLD

Animals have traditionally been among the most popular tattoos. Humans have always connected strongly with the kingdom of wildlife, enjoying rewarding relationships with domestic creatures, respecting the powerful beasts of the wild, and admiring the beauty of peacocks and butterflies, the graceful flight of birds and the harmonious playfulness of dolphins.

Customers' reasons for choosing one tattoo over another have been many and varied. Some simply liked the animal's appearance, or the mythology attached to it. The wolf, for instance, has long been surrounded by intrigue in fable and legend. Often, people identified in an animal qualities such as strength, nobility, courage, elegance and cunning that they imagined themselves to possess, or believed they might acquire by wearing the tattoo. Then there were those who liked the symbolic meanings attributed to certain creatures, or some wider concept or reality that they represented.

For example, birds are considered to be guides that carry the spirits of the dead to the afterlife, and as such are potent with religious and superstitious meaning, while butterflies commonly symbolize a new beginning or the start of a new life, just as a butterfly emerges from a cocoon. Panthers, tigers or lions are usually chosen by those who like symbols of physical power and strength, and foxes or snakes by those who value cunning. Inherent in such imagery is the enduring power of a world outside the human one, a world that operates on it's own particular set of rules rather than the order humans can impose. As a result, tattoos of natural images connect the wearer to a greater universal force.

RIGHT: Bert Grimm's Howling Wolf tattoo.

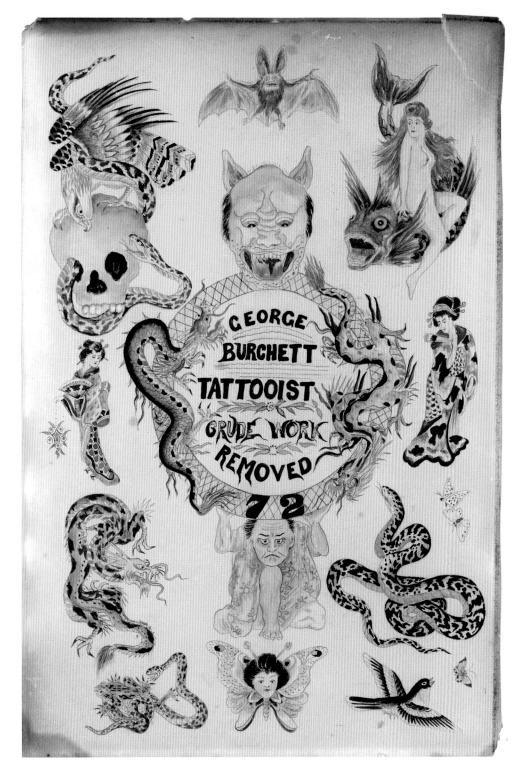

RIGHT: A poster advertising the work of British artist George Burchett. There is a strong Japanese influence in the renderings of dragons, serpents and geishas.

MASTERS OF THE SKY

In the old-school days, certain images appeared over and over in the artists' flash: for example, those in the United States could probably have tattooed an eagle with their eyes closed. The eagle was chosen to be America's national emblem in 1782. Soaring and swooping, king of the skies, this was the most magnificent of birds. It stood for supremacy, freedom, independence and long life, spreading wings that would sweep the country forward, into the future, with confidence.

Soldiers and sailors setting off to serve the US in the First and Second World Wars frequently asked for eagle tattoos, usually accompanied by the national flag or some imaginative adaptation of the Stars and Stripes pattern. Patriots followed suit, and post-war, the motorcycle gangs of the 1950s and after adopted the eagle as a symbol expressing not only national pride but also speed and dominance, maybe even ruthlessness, in the wide open spaces of America.

By contrast, the bluebird, another great nautical emblem, was delightfully sweet and cheery. Like the swift and the swallow, it brought glad tidings to sailors in real life by simply appearing, indicating that they were approaching shore, and the bluebird tattoo therefore acted as an appeal for good fortune. Dove symbols were equally hopeful, flying for peace with olive branches held in their beaks.

THIS PAGE AND OPPOSITE: Stylized birds by East Hastings artist AG Robinson, including an eagle, parrots and swallows, many with banners and hearts.

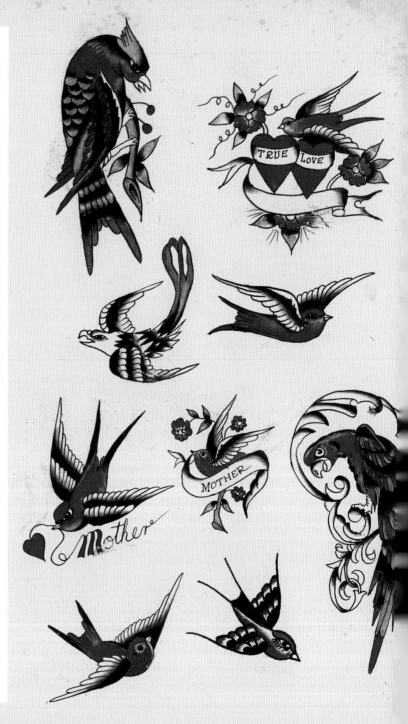

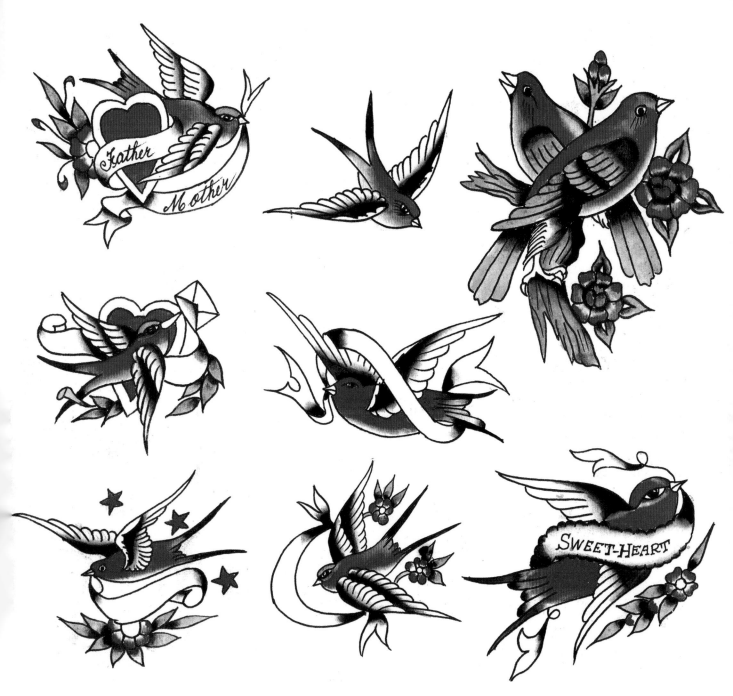

Father

Mother

Sweet-Heart

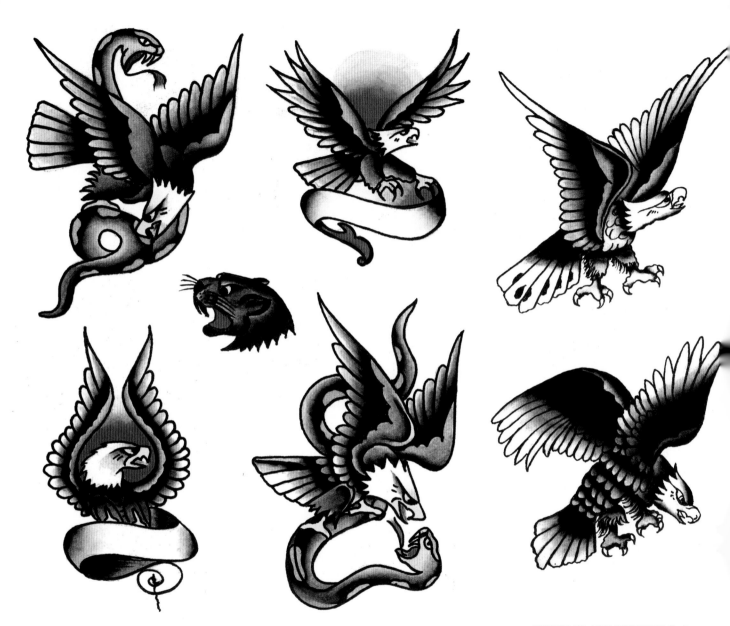

THIS PAGE AND OPPOSITE: Eagle tattoo flash by Doc Forbes, from the collection of Lyle Tuttle.

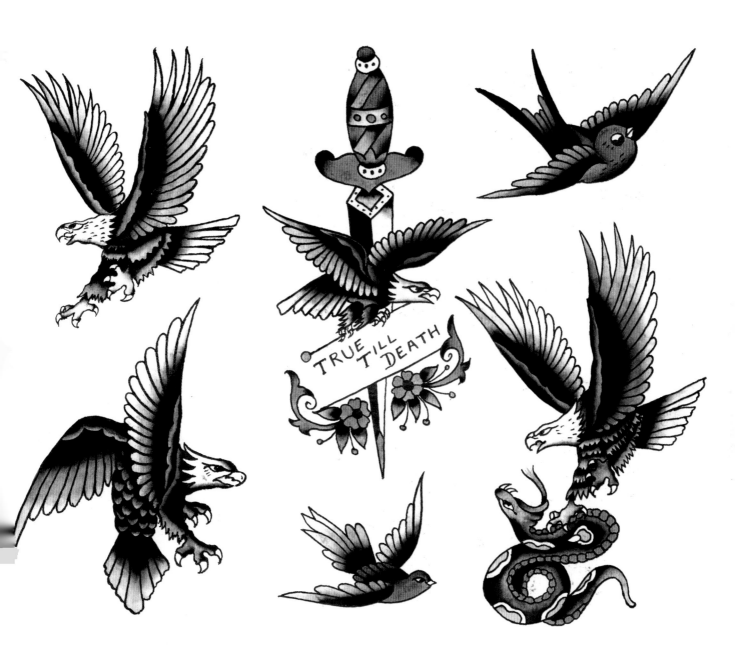

TRUE TILL DEATH

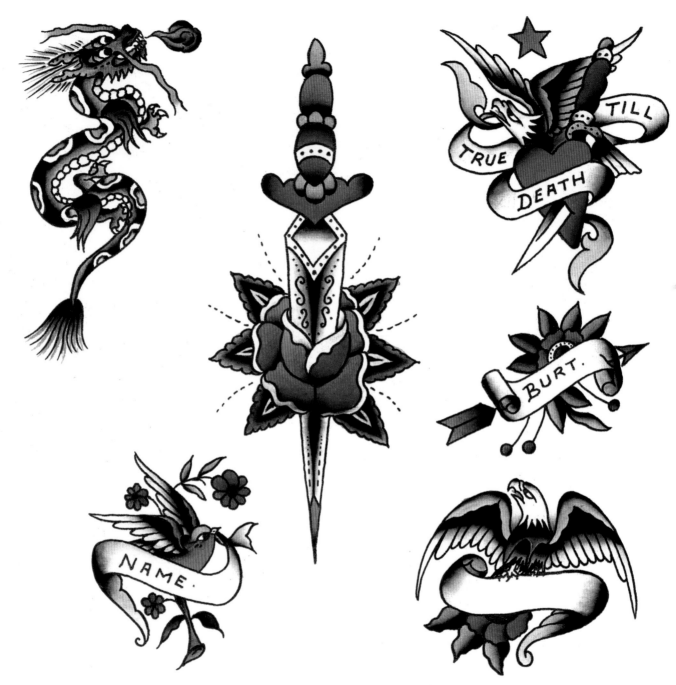

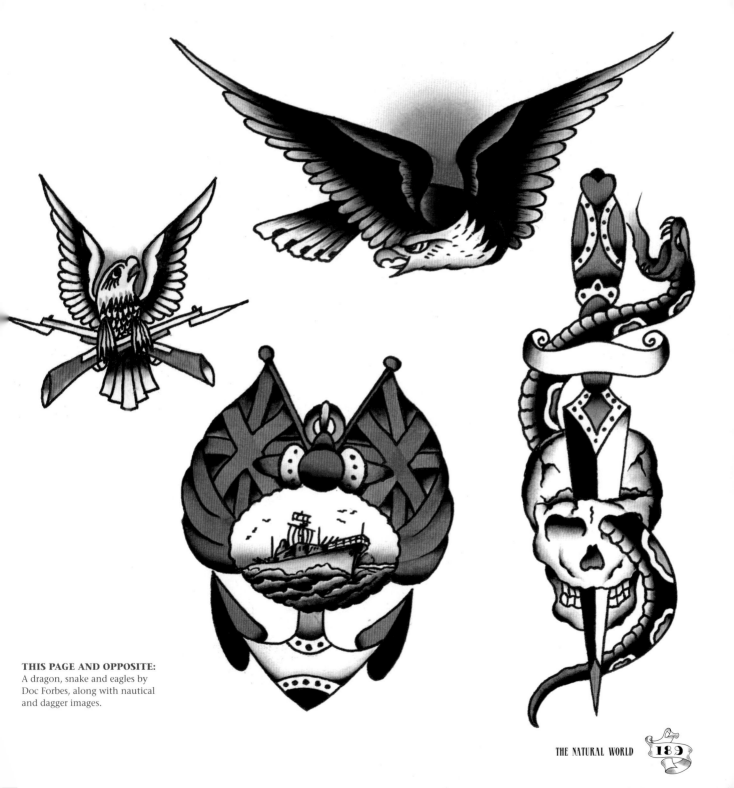

THIS PAGE AND OPPOSITE:
A dragon, snake and eagles by
Doc Forbes, along with nautical
and dagger images.

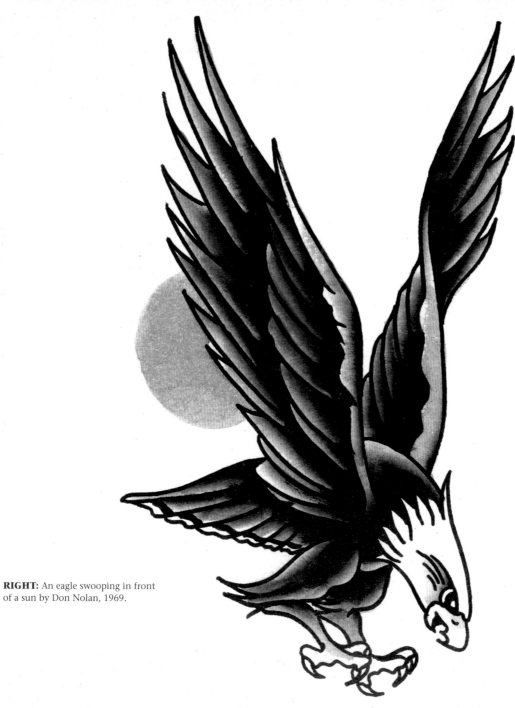

OPPOSITE: Tattoo flash of banners and an eagle by Colonel William Todd, 1952. The Colonel worked with Bob Shaw in Long Beach, California, for many years.

RIGHT: An eagle swooping in front of a sun by Don Nolan, 1969.

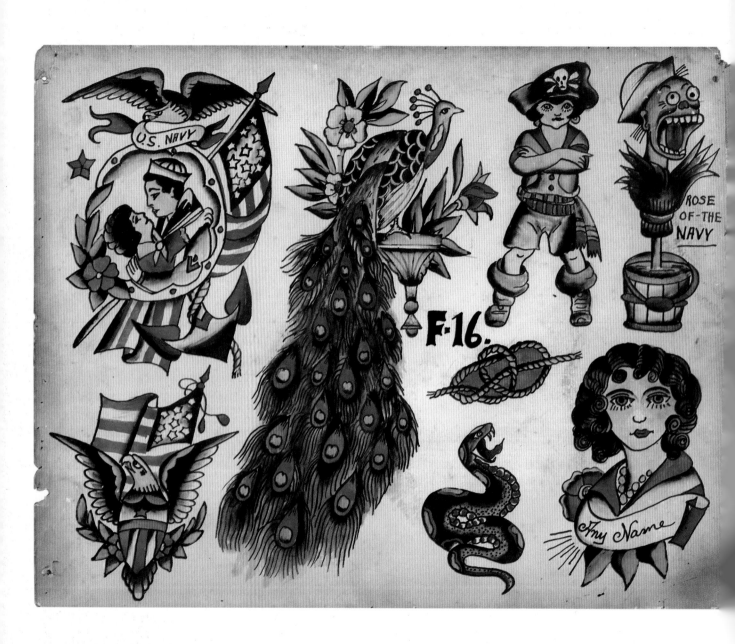

THE PEACOCK

The most spectacular of all the birds was the male peacock, whose showy spread of glamour lent itself perfectly to large backpiece tattoos – although the artists sometimes transformed what was clearly a masculine phenomenon into a dizzyingly feminine design. An example of this was the remarkable creation worn by Illinois-based Pearl Hamilton, a popular circus and carnival attraction during the 1920s and 1930s. Pearl's peacock feathers fanned out around the entire length and width of her back, but the figure at the centre of the display was neither male nor a bird. It was an elegant and inviting woman, revealing a substantial amount of bare flesh.

This was one of the most enormous peacock tattoos ever seen, and its stunning impact was hardly matched by the clumpy spider's web designs at the back of Pearl's knees, or the random arrangement of her other tattoos. But thanks to the peacock, she remained a crowd-pulling exhibit, touring in sideshows as the "Tattooed Doll" with her husband Ted, a mobile tattooer and a collaborator with artist Milton Zeis in the latter's mail-order tattoo supply business, the Zeis Studio, based in Rockford, Illinois.

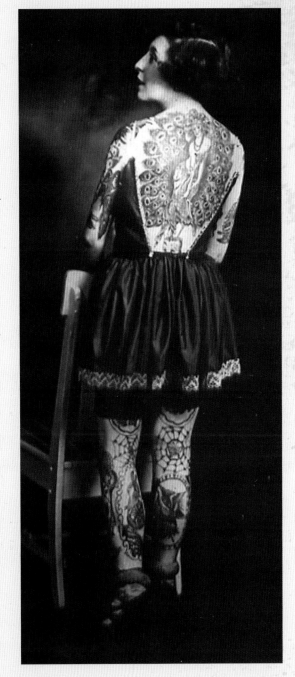

OPPOSITE: Unknown vintage flash that includes a peacock, centre.

BELOW: A peacock by Bert Grimm.

RIGHT: Pearl Hamilton, with her famous peacock backpiece, the centre of which is a woman, not a bird. Also known as the "Tattooed Doll", she toured the carnival circuit with her husband Ted Hamilton in the 1920s and '30s.

MILTON ZEIS

Milton Zeis was a pioneer. Among the first to make coloured flash commercially available, he also revolutionized the look of sales catalogues and inaugurated a 20-lesson course in tattooing for students learning from home and operating a supply company from the 1930s to the 1950s. He also set up one of the three big tattoo clubs that operated – and interacted – during the 1950s. One was the Bristol Tattoo Club, in England, whose president was Les Skuse. Another was the Sandusky Tattoo Club, fronted by Ohio tattooist Al Schiefly. Zeis's International Tattoo Club, like the others, offered its members discounts on tattoo work, and by banning drunks and insisting on orderly behaviour, these organizations generated goodwill from the public at large.

A much-respected and colourful character, Zeis was active in carnival and circus shows throughout his life, and was never afraid to play the clown – literally. It was sad but appropriate that at the moment he died, he was getting into character as Uncle Miltie, ready to entertain guests at a local ball.

Zeis's flash included all of the traditional old-school images, from hearts, flowers and four-leaf clovers to sailors' emblems, eagles and other creatures.

THIS PAGE:
Various editions of Milton Zeis' *Tattooing the World Over* instruction booklets and tattoo supply catalogue.

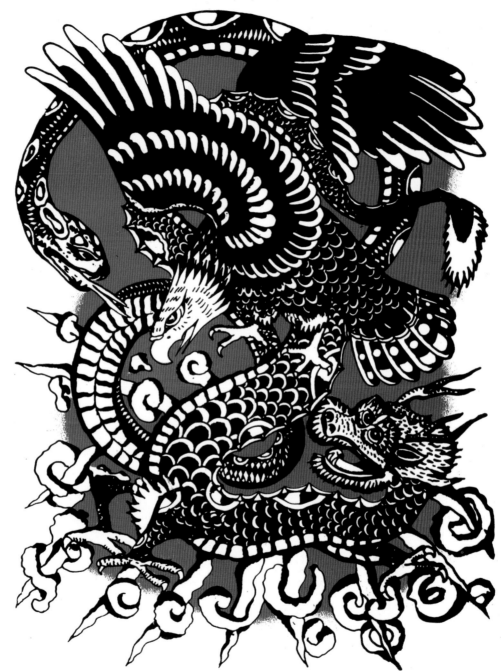

RIGHT: A dragon, snake and eagle design from inside the first edition of *Tattooing the World Over* by Zeis.

RIGHT: A sheet of flash by Milton Zeis, from the 1940s/1950s.

BELOW: Illustrations of electric tattooing machines from one of the Zeis catalogues.

ZEIS SPECIAL ELECTRIC TATTOOING MACHINE

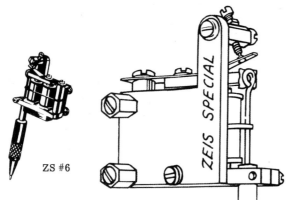

ZS #6

ZEIS SPECIAL ELECTRIC TATTOOING MACHINE

---- This machine is hand made of the finest material and will TATTOO. All metal parts are rust proof, and is set up and regulated the same as our other two machines. The housing of the frame is made of bakelite. All parts are replaceable. Coils are hand wound with #24 cotton covered magnet wire. Weight 9 oz. Springs have pure silver contacts. Needle bars are made of brass with #12 sharps. The Zeis Special Electric Tattoo instrument is a well balanced machine. Will not scratch.

Best sanitary tubes and needle bars. This machine may be run on either 24 volt transformer or batteries. Price for one machine $15.00, 3 or more $12.00 each

ZEIS DELUXE ELECTRIC TATTOOING *machine*

ACTUAL SIZE

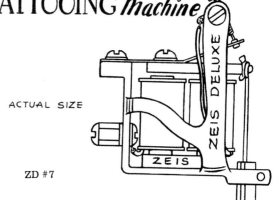

ZD #7

ZEIS DELUXE ELECTRIC TATTOOING MACHINES

This machine frame is cast in brass and is set up and regulated the same way as our other two machines. Coils are hand wound with #24 cotton covered magnet wire. Spring has pure silver contacts. Needle bars are made of brass with number 12 sharps. Weight 9 oz. The Zeis Electric Tattoo Instrument is easy to use and will do that HEAVY BLACK TATTOOING. Will not scratch. Chrome plated frame with best sanitary tubes and needle bars. This machine will run smooth on either 24 volt transformer or batteries. Outline or Shader is $20.00 for one, or two for $35.00

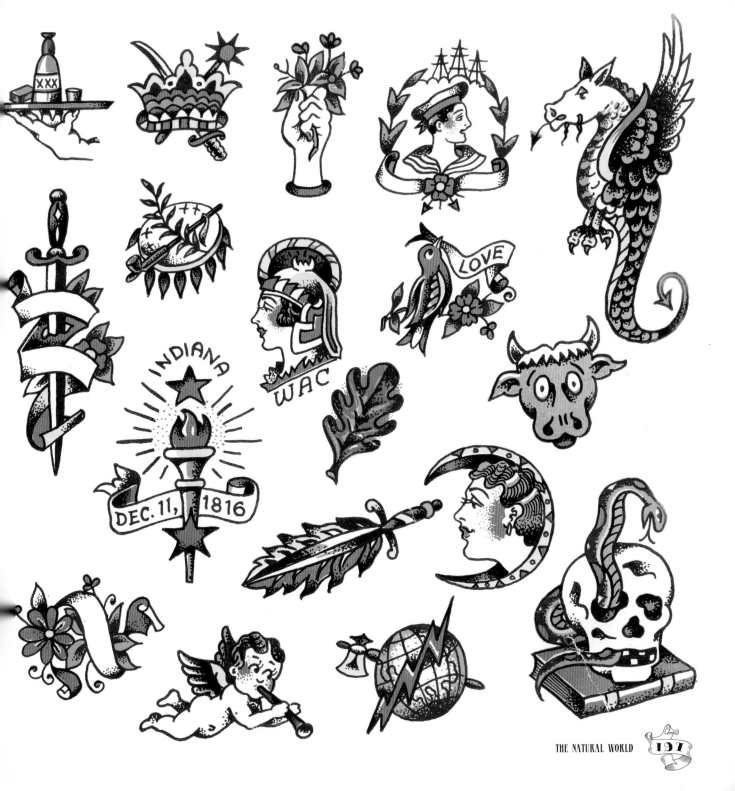

PHARAOH'S HORSES

Horses were another animal favourite. Man's relationship with the horse – in battle, hunting, transport, leisure, racing, and in royal stables or on the ranch or farm – has historically been based on friendship, loyalty, trust and mutual respect. In tattoos, the horse running wild was seen as a symbol of free-spirited beauty, muscle-bound power and great speed.

One particular design – Pharaoh's Horses – had became a classic by the 1920s, keeping old-school tattooers busy for hours on end as they inked three large horses' heads onto the backs and chests of customers, and onto each other.

The dramatic illustration was based on a famous painting by British artist John Frederick Herring Sr in 1848. Herring, using archaic spelling, named his work *Pharoah's Chariot Horses*, and versions of it were attempted by subsequent generations of painters. An earlier rendition reportedly exists, dating back to the 1700s, but without a signature. Herring's masterpiece was the blueprint for tattooers working in the early 1900s, although many adapted it to suit their personal styles and differing pictorial frames, and some reversed the direction of the horses' heads. Originally, they faced west.

Like da Vinci's *The Last Supper* and Guido Reni's *Head of Christ Crowned with Thorns*, Herring's painting recreated a Bible story, that of Moses' parting of the Red Sea. The Old Testament book of Exodus tells of how the Egyptian army, with horses and chariots, chased the "children of Israel" – Israelite slaves departing Egypt – across the dry land miraculously created by Moses, only for God to order Moses to restore the seas in such a way that they would drown every Egyptian man and horse.

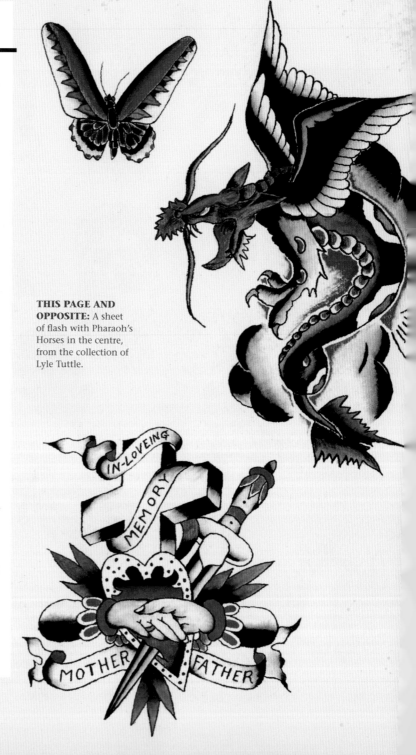

THIS PAGE AND OPPOSITE: A sheet of flash with Pharaoh's Horses in the centre, from the collection of Lyle Tuttle.

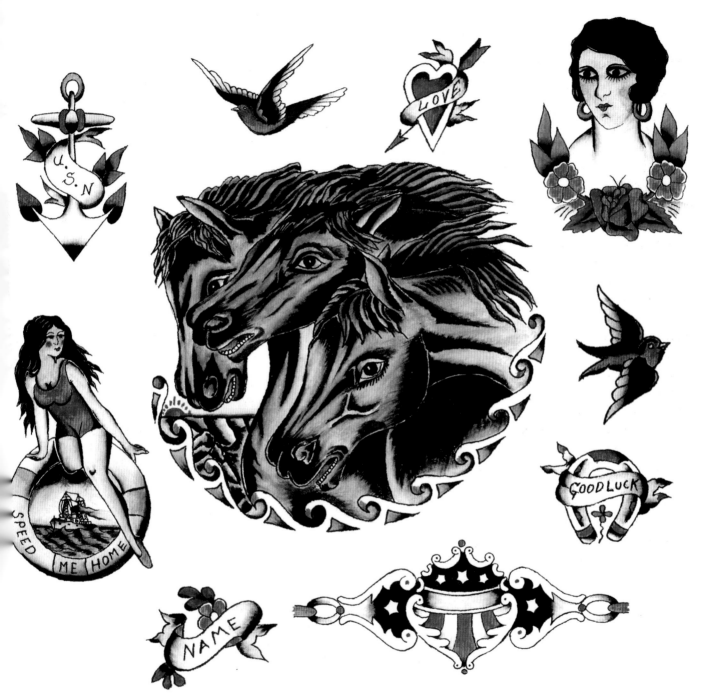

The horses, as depicted by Herring and a legion of tattooers, were majestic white Arabian stallions with windswept manes, charging with all their might towards a disaster that was completely beyond their control, an incontrovertible demonstration of the power of the Almighty. In the finest tattoo versions, the horses looked wonderfully individual yet collectively engaged, fully attuned to each other and the commands of the unseen charioteer.

Circus showman Captain Don Leslie was among the tattooers who sported this design. He received it in the 1950s from Californian artist Lyle Tuttle, who says today: "I did a lot of tattooing on Captain Don. I put a chestpiece on him, the Pharaoh's Horses. Then he went on going out and working on the sideshows and everything, so then I didn't see him for years." Obviously, then, the horses were a success. New York artist Charlie Wagner and carnival exhibit Tommy Lee were others who chose this striking image as a chestpiece and so, it seems, did Captain Elvy, an enigmatic sideshow attraction.

At the Tattoo Archive in Winston Salem, North Carolina, the earliest example of Pharaoh's Horses comes from the flash of Gus Wagner, a leading figure in the early 1900s. The most accomplished tattooers of the vintage era followed on from Gus's lead, including Sailor George Fosdick, Owen Jensen and Percy Waters, a travelling artist whose home base was in Alabama. Waters used advertising and a sales catalogue that prominently featured Pharaoh's Horses (see also pages 50–3).

Then there was Vernon Frank Ingemarson – known as Sailor Vern – who enjoyed a long and lively career on both American coasts tattooing and developing tattoo machines, and who publicized his services with a design that included an American flag and a hovering eagle, with Pharaoh's Horses as its centrepiece.

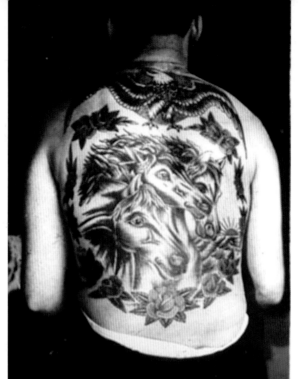

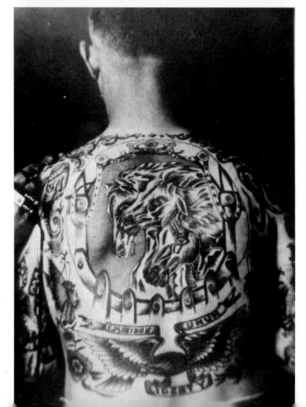

LEFT: A Pharaoh's Horses backpiece from the collection of Gus Wagner (1872–1941).

BELOW LEFT: A backpiece of Pharaoh's Horses, artist unknown.

RIGHT: Floyd Sampson tattooed by Milton Zeis. Among the many tattoos in evidence, the Pharaoh's Horses is placed centrally on Floyd's lower torso.

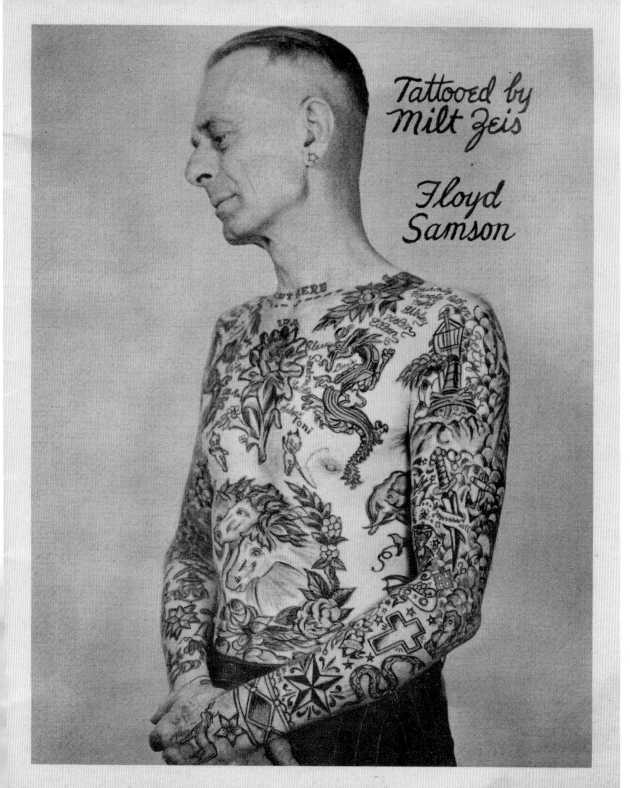

Tattooed by
Milt Zeis

Floyd
Samson

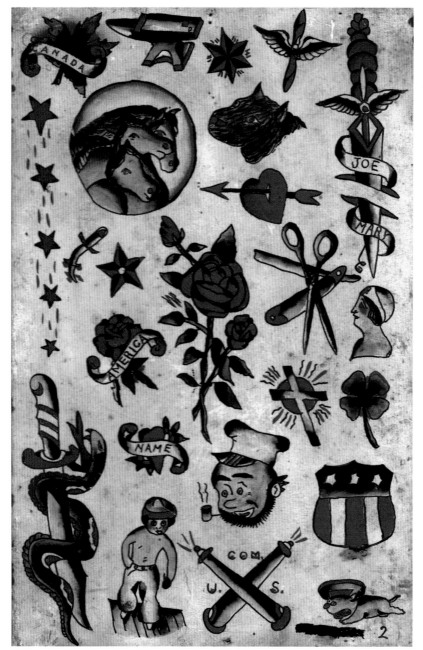

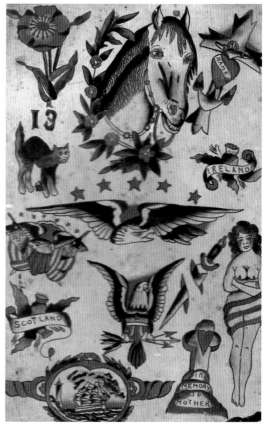

THIS PAGE AND OPPOSITE:
A variety of tattoo flash by Floyd Sampson, including Pharaoh's Horses, left and above.

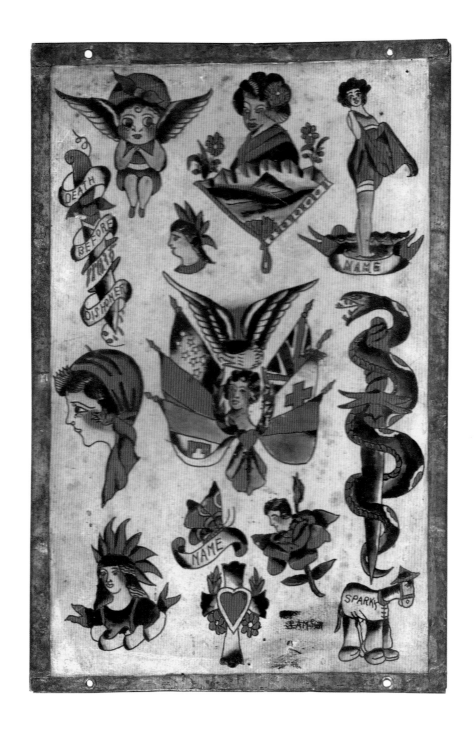

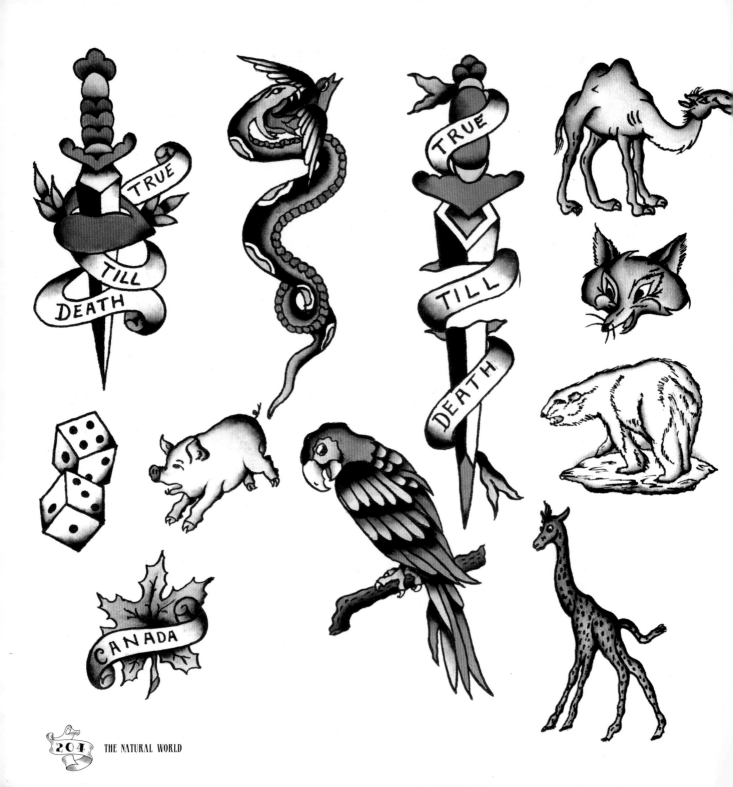

DEVIL DOGS
AND BIG CATS

The serious, detailed and religious nature of Pharaoh's Horses was offset by some remarkably whimsical and humorous animal designs from the likes of Sailor Jerry Collins and Bert Grimm. Mischievously, Grimm had a bit of fun with the wolf, placing this wild dog, a deeply charismatic pack predator, at the centre of a number of cartoon capers. Intoxicated Wolf was one of his more amusing creations. The Strolling Squirrel, with its walking stick, was just as witty. Sailor Jerry's audacious Aloha tattoo, meanwhile, remains an enduring favourite. Few can resist the cheeky monkey in the illustration, bent double and baring its bottom so that the red "o" in Aloha acts as an illustration rather than a letter.

Captain Don Leslie also enjoyed playing with animal imagery. As a circus attraction-turned-tattooer rather than a truly accomplished artist, his flash was generally unsophisticated, but it brimmed with all the innocent fun and colour of the big top. Performing seals and elephants, show horses and friendly-looking daddy lions were recurring themes with Captain Don, although he was also capable of saucy tattoos, like the pair of rabbits doing what rabbits do so often and so shamelessly, and serious portrayals of dogs with muscular bodies and savagely snarling jaws: not your average family pet.

LEFT: Cartoon-style tattoo designs from Doc Forbes, including the one-eyed Popeye the Sailor with his trademark anchor tattoo on his forearm and his corncob pipe. A comic-strip character devised by Elzie Crisler Segar, Popeye made his debut in 1929.

OPPOSITE: Animal tattoo flash from Doc Forbes.

One of the most requested animal tattoos was the English bulldog, which became the mascot of the United States Marine Corps during the First World War. So fierce in combat were the marines that they were nicknamed "devil dogs" by German soldiers unlucky enough to encounter them. The marines were delighted to be recognized in such a way, and adopted the bulldog immediately in their recruitment advertising. The USMC bulldog subsequently became a popular tattoo. It typically portrayed the dog with red angry eyes, baring a row of sharp bottom teeth, and wearing a spiked collar and a helmet featuring the marine logo – an eagle, wings spread, holding a *Semper Fidelis* ribbon in its beak, perched on top of a globe set against an anchor and a rope.

The big cats – bold and brilliant, sleek and fast – were staple designs in any tattoo parlour, and they still are. The public demand for tattoos celebrating these magnificent creatures never wavered, and the tattoo artists worked hard in their determination to capture the strength and deadly beauty of the tiger, the regal dignity and bravery of the lion, and the stealth and intricate markings of the leopard.

RIGHT: A creeping leopard by Bert Grimm.

OPPOSITE: Jaguars with bloody claws by Milton Zeis, dating from the 1940s.

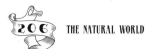

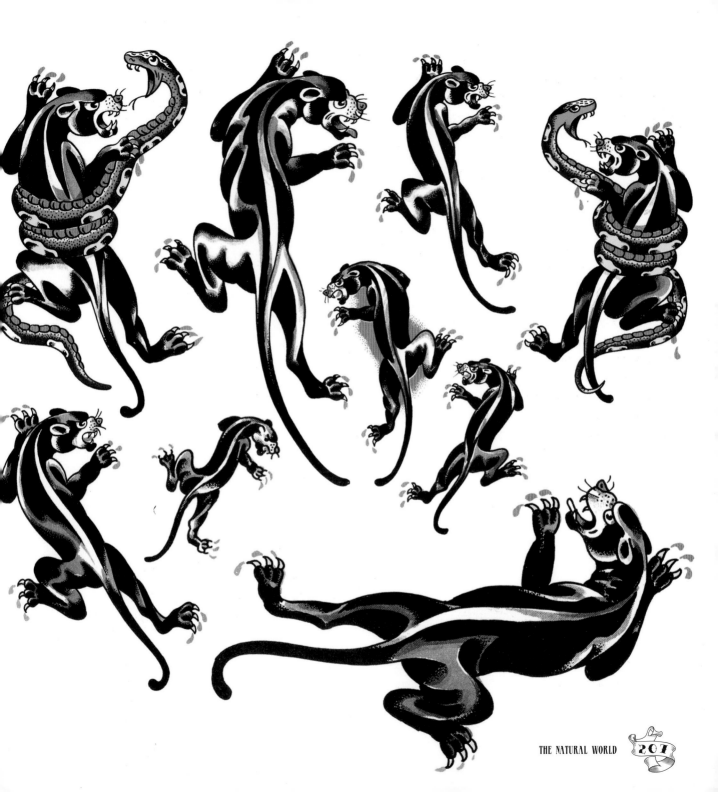

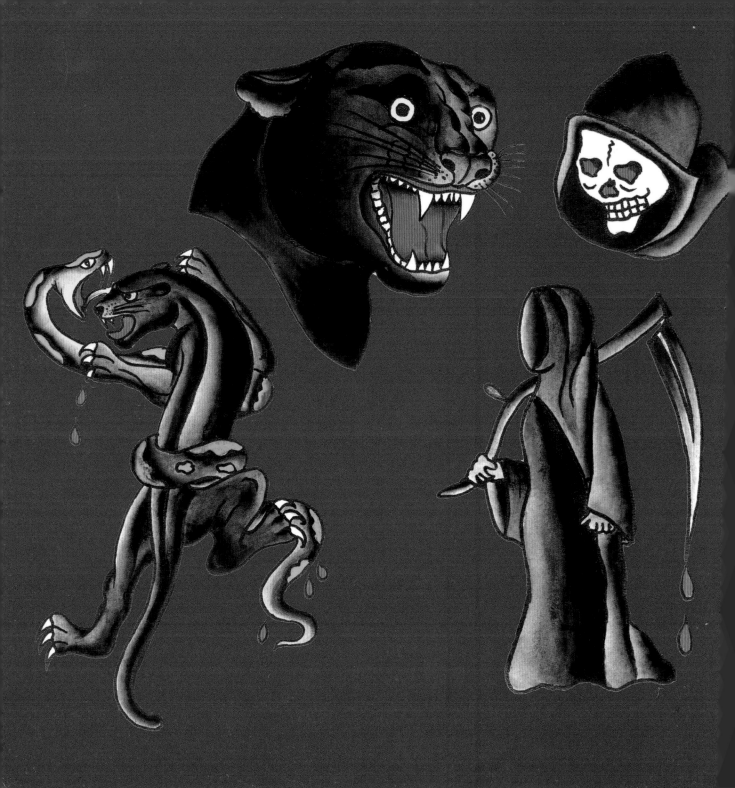

OPPOSITE: Ferocious jaguars, dripping with blood, alongside the Grim Reaper in flash by Doc Forbes.

ABOVE: A fighting tiger and serpent by the British artist George Burchett. Like the tiger and dragon in Chinese culture, these two creatures are opposing but equal rivals.

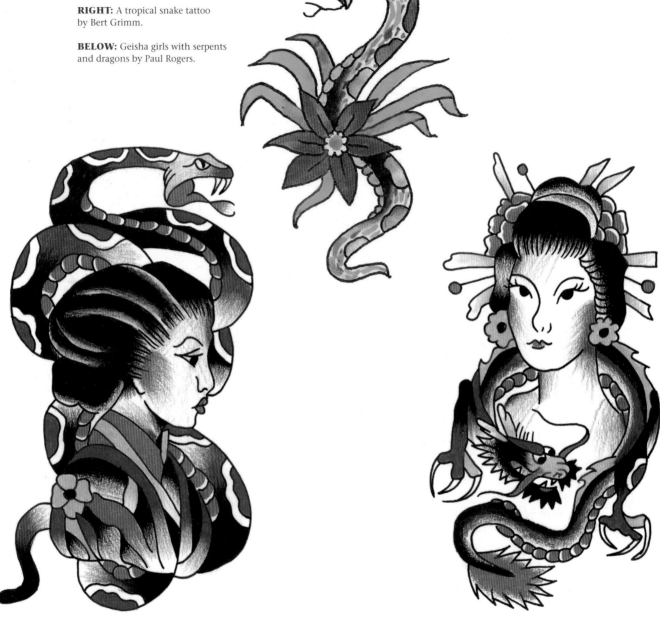

RIGHT: A tropical snake tattoo by Bert Grimm.

BELOW: Geisha girls with serpents and dragons by Paul Rogers.

SNAKES AND INSECTS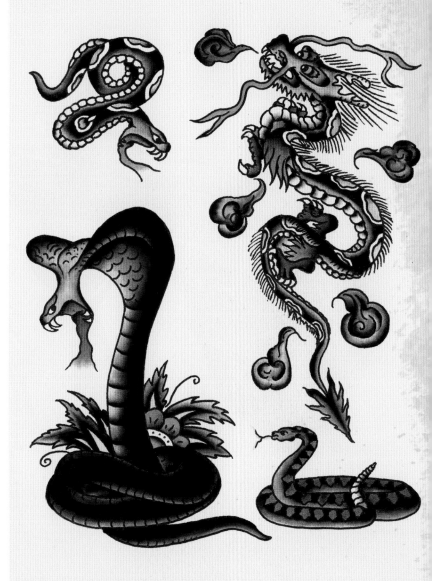

Snakes were another much-requested image, especially the cobra with its dramatic flattened hood and its venomous danger. Some cultures regarded the snake as a symbol of nature or of rebirth and eternal life, but this was hardly the case in Europe and America during the war years. Here, the snake stood for something sneaky, nasty, ill-tempered, frightening and, sometimes, sexual. Appearing on its own or more likely in an ensemble, coiled around a dagger, a sword or a skull, the snake was a threatening presence. Wrapped around a pin-up girl, however, it became a phallic symbol.

The snake was one of the most useful images for artists when, at the time of the Second World War, they were faced with a rush of servicemen asking to have their nude tattoos covered up, on the orders of the US government. Clothes were one solution, along with flowers, feathers and flags. But the addition of a snake, curling itself around the "offensive" body parts, produced an especially racy tattoo. Many tattooers, including Sailor Jerry Collins, employed this strategy when designing pin-ups from scratch.

The insect world was not generally well represented in old-school tattooing. The humble spider and its webs were familiar symbols, and the ladybird made an occasional appearance. But an increasingly popular image as the decades passed was the butterfly, chosen predominantly by women. Some customers found pleasure in the butterfly's display of pattern and colour, while others associated it with personal transformation, balance and elegance. The Butterfly Club existed purely for those hard-core ladies brave enough to have the creature tattooed across the bikini area.

ABOVE: Snakes and dragons by Doc Forbes.

ABOVE: A spider tattoo by Midwestern tattooist JF Barber, circa 1920s.

OPPOSITE: Various insects by Lee Roy Minugh. Using dark, heavy lines, Minugh filled in with the few colours available in the 1950s – yellow, red, blue and green.

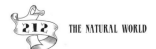

FLOWERS AND BLOSSOMS

BELOW: Jacobus van Dyn and his extraordinary all-over floral face tattoo by British artist George Burchett, circa 1930s.

As well as providing tattooists with the endless inspiration of animals, and the fictional creatures associated with them, the natural world offers another wonderful resource that artists have enjoyed since time immemorial: the flower.

Floral designs were a crucial element in vintage tattoo art. Sometimes they were requested as standalone images, but they were more often used in combination with other symbols and words – the macho, whisky-swigging sailors careering into port in pursuit of a good time and a new tattoo would have been unlikely to ask for a daisy on the bicep or an iris on the upper thigh. On the other hand, they would have liked to see their hula pin-up girls bejewelled with Hawaiian blossom; they would have expected the hearts and banners that carried their loved ones' names to be accompanied by red roses; and they would have wanted their memorial tattoos to incorporate a white lily or some equally respectful bloom.

There were exceptions to the rule, as London tattooist George Burchett would have verified. One of his clients in the 1930s had his entire face tattooed with feminine images – huge flowers, butterflies and hearts. And this particular gentleman, Jacobus van Dyn, was no wimp: he boasted of serving time in all of the most notorious jails on earth. Burchett called van Dyn "the world's worst man", although he admired his nerve.

Flowers, in general, acted as a symbol of nature and the life cycle, although individual flowers held meanings of their own. After the First World War, the poppy became widely known as a tribute to servicemen who died in battle. The rose – by far and away the most popular flower

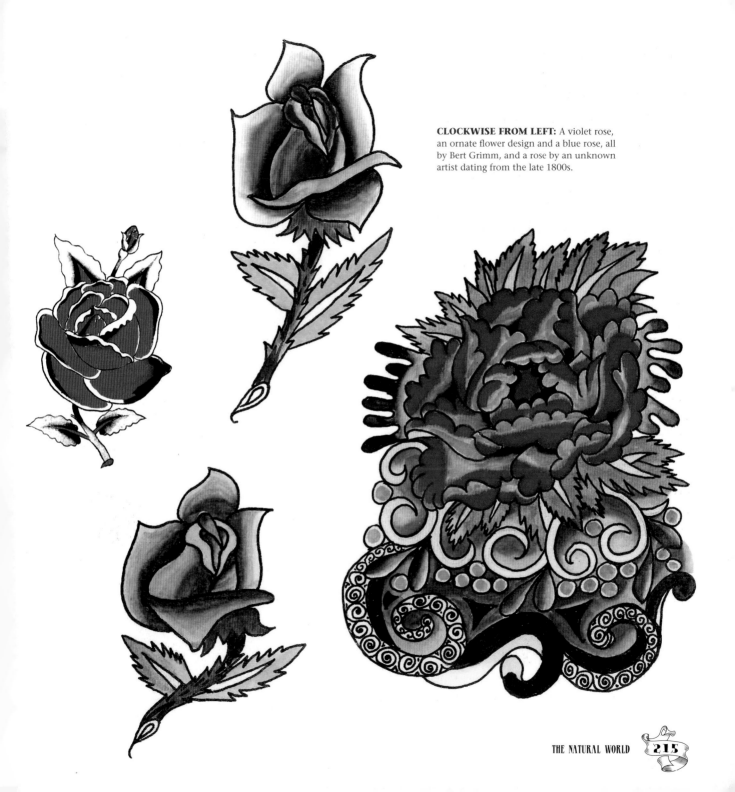

CLOCKWISE FROM LEFT: A violet rose, an ornate flower design and a blue rose, all by Bert Grimm, and a rose by an unknown artist dating from the late 1800s.

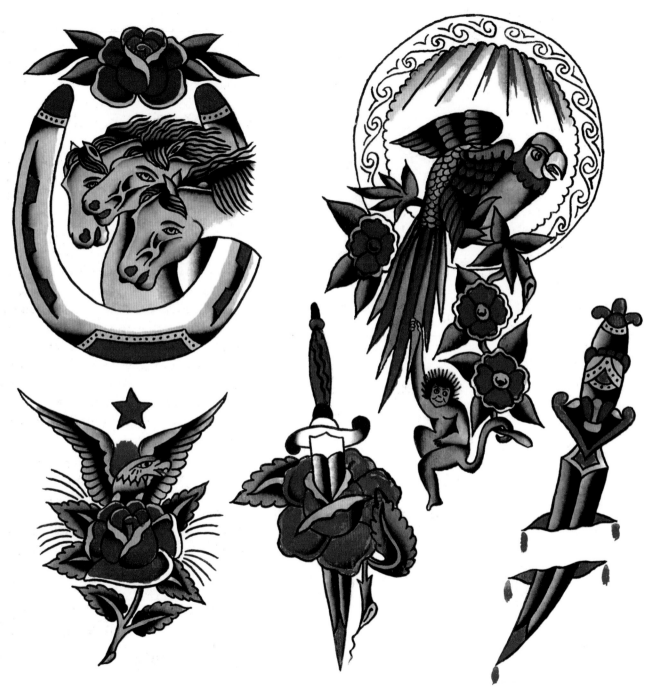

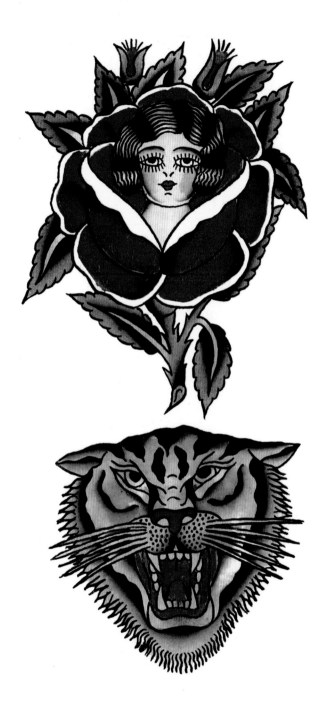

tattoo – was an unmistakable declaration of love and romance. Teamed with a dagger or a skull, sometimes accompanied by the words "Life and Death" or "Love and Death", its meaning spoke for itself. Similarly the rose-with-thorns design warned quite clearly that with love came risk or sacrifice.

The tattooers turned out countless variations of the rose, from the basic outlines offered by Captain Don Leslie to the more generous, shaded blooms of Sailor Jerry and the delicately coloured examples in some of Bert Grimm's flash.

The language of flowers is not an exact science, however, and their symbolic meanings have changed and varied within different cultures and eras. The same is true of the flowers' colours. While red was usually taken to indicate passion or perhaps the blood of Christ, and white suggested purity, Easter or death, nothing was set in stone. Each customer chose according to how the flower looked and what it meant to them personally, and there was an enormous selection to pick from, including some that had crossed over from Eastern tattoo traditions. Typically, these were the cherry blossom, the peony, the chrysanthemum and the lotus flower or water lily.

Flowers were a very handy tool for old-school tattooers because of their infinite variety. They could be used to fill up gaps in a body suit, while vines or leaves could convincingly link one design to the next. Flowers could also be created to camouflage a multitude of sins, the name of an ex-girlfriend, perhaps, or that most unwanted error – the spelling mistake.

LEFT AND OPPOSITE: In Greek mythology red roses were thought to have grown from the blood of Adonis, Aphrodite's lover, thus the traditional association of the red rose with love and beauty. Top left, in flash from the collection of Lyle Tuttle, a full-blown rose contains the object of love in its centre; also pictured are various animal and dagger designs.

INFLUENCES FROM THE ORIENT

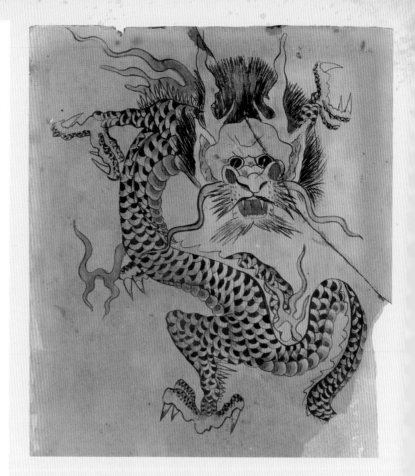

In the UK at the turn of the 1900s, Sutherland MacDonald – one of the two "godfathers of British tattooing", the other being Tom Riley – was building a formidable reputation as an artist, mainly because of his animal tattoos. To create them, he borrowed from Japanese techniques, using an expanded colour palette and working from woodcarvings. As a result, his western-style emblems, his tigers, birds, snakes and lizards, took on an unusual, impressionistic quality gained from an eastern approach to craftsmanship.

Taking another influence from the Orient, MacDonald also turned his hand to dragon tattoos. These, along with other mythical animals and characters, became classics in vintage flash. Like the snake, the dragon had a pretty bad press in western countries. In the Far East, however, where it loomed large in folklore and legend, the dragon represented a sweep of life-enhancing qualities and concepts, many of them connected to nature. The dragon stood for the four elements of fire, water, air and earth and for the four points of the compass. It was gracefully portrayed by tattoo artists and widely recognized as a symbol of good fortune, bringing strength, sagacity and goodwill.

The dragon was chosen as a protective figure in Chinese Buddhism as far back as the ninth century. According to Chinese mythology, it was a magical creature that controlled thunder, lighting and rainfall – a power illustrated by a pearl in its mouth. In many tales, the dragon stood for peace, wealth, fertility and guidance, and in another elevated role, it became a sign of the emperor – and, indeed, the creation of the Chinese nation.

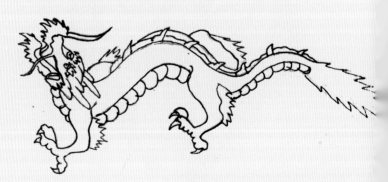

ABOVE: A dragon tattoo stencil by English artist Charlie Davis, circa 1940s.

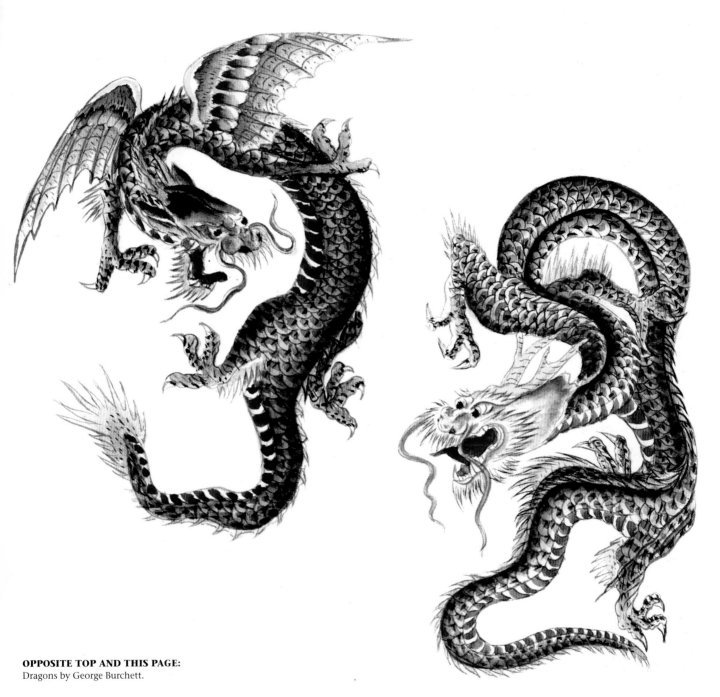

OPPOSITE TOP AND THIS PAGE:
Dragons by George Burchett.

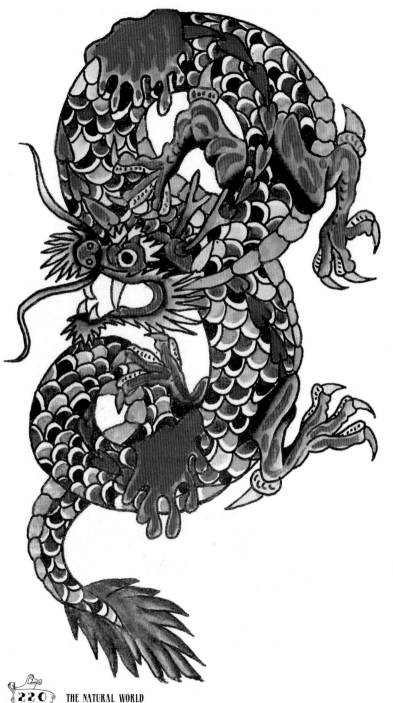

In some stories, the dragon was at the heart of Japanese ancestry; it was immortalized as the holder of some great universal truth, the guardian of immense wisdom represented by pearls or jewels. It also embodied the principle of balance, the yin and the yang, and when pictured with a sword, set up the idea of good battling evil.

In western tattoo culture, few if any of these perceptions of the dragon were of much importance, except perhaps to artists learning from the likes of the revered Japanese master Horiyoshi II or Pinky Yun, a legendary tattooist from Shanghai who moved his business to Hong Kong in 1949 before settling in California in the 1970s.

In Europe and America, the dragon was widely regarded as the bogeyman of the monster world: big, bad and ugly, a supremely malevolent being with wings and a red-eyed glare, breathing fire and putrid fumes over all it surveyed. Traditionally, it posed the ultimate challenge: the most heroic human feat imaginable was to slay a dragon.

Some tattooers caricatured the beast's most ghastly and terrifying features, while others laboured over the dragon's bodywork, creating ingenious shapes and intricate markings. Bert Grimm's many-coloured dragon was riotously detailed. Charlie Wagner was also a great fan of dragons, which were requested by large numbers of sailors because of a certain nautical significance. A regular dragon signalled that the serviceman had been to China on duty, while a golden dragon showed that he'd sailed across the International Date Line.

However it was presented, the dragon was probably the most dramatic character in an array of supernatural tattoo designs that also included devils and angels (often appearing together), demons, fairies, mermaids, gryphons, unicorns, phoenix, centaurs and renditions of Pegasus, the mythological winged horse.

OPPOSITE:
Many-coloured dragons by Bert Grimm.

RIGHT: A Japanese-inspired dragon by George Burchett.

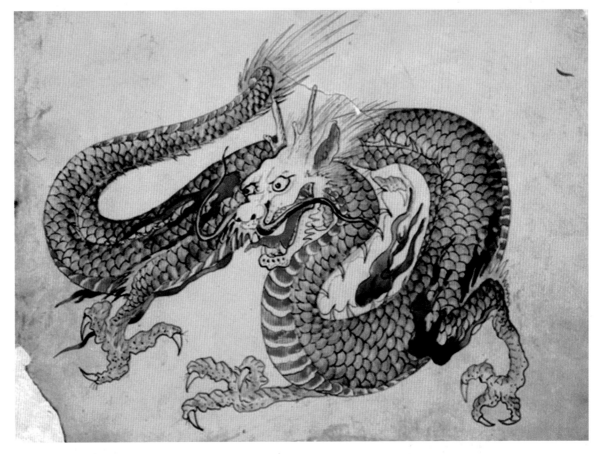

THE JAPANESE EXCHANGE

It's a fascinating phenomenon: more than half a century after the vintage tattooers of Europe and North America were absorbing various influences from Japanese artwork, that exquisitely creative nation is getting visibly excited about the western old-school tradition.

In Japan, tattooing was for years very strictly controlled, with artists training for years, respectfully, under their masters, while being permitted to work only on foreign visitors, never their own people. Underground, tattooed Japanese did exist, but western eyes didn't see that. They saw only the brilliance of the artists who were working legitimately, the extraordinary delicacy and detail, and drama and flow and colouring of the handiwork. It was beautiful.

So what did the West take from Japan? Well, it appropriated the techniques of woodblock artists. It took key symbols, including dragons, lizards, salamanders, chrysanthemums, blossoms and, sometimes, full-bodied geisha girls. It took lettering and panoramic ambition. CW Eldridge, founder of the Tattoo Archive, reveals:

Once books started coming out of Japanese tattooing, the [western] artists would have them in the back of their shops and they'd study them at night and try to crack the code and figure out what these guys were doing, why they looked so cool. The Japanese think of tattooing on such a big scale, full body suits, whereas we think of a tattoo that's three and a half inches in diameter.

Lyle Tuttle adds:

When Japanese people saw me tattooed they said, "Oh, you get tattooed for memories, we get tattooed for a story." Their whole body will be covered with a theme. They picked their favourite story and got it transposed on to their body.

Eldridge credits artists such as Sailor Jerry Collins and his protégé Don Ed Hardy with importantly arriving at a creative blend of styles, explaining:

They were ambitious enough to really mimic the Japanese stuff. In Jerry's case, it would be his Japanese-style body suits, big flowing pieces but with western images in place of Japanese. Jerry sat there in Honolulu between Coleman in Virginia and Japan. He was influenced by Japan, he took Coleman's style, and he made something unique. From Japan, Horiyoshi II made a tremendous impact on tattooers. Horiyoshi III is a big influence these days.

But now, it seems, the West is finally giving something back. As Eldridge says:

The Japanese scene has really changed. They've completely perfected the traditional American tattooing. They've done it so neatly; it's perfect. You can have an American eagle done on your arm. Street shops are quite popular now. Some of them even look like American tattoo shops. They're really like super-sanitary versions of a 1940s American tattoo shop, as only the Japanese can do it."

Lyle Tuttle concurs: "Somebody told me that there was a little article in the *Wall Street Journal* that said tattooing has become so popular that tattoo shops are opening up faster than Mexican restaurants."

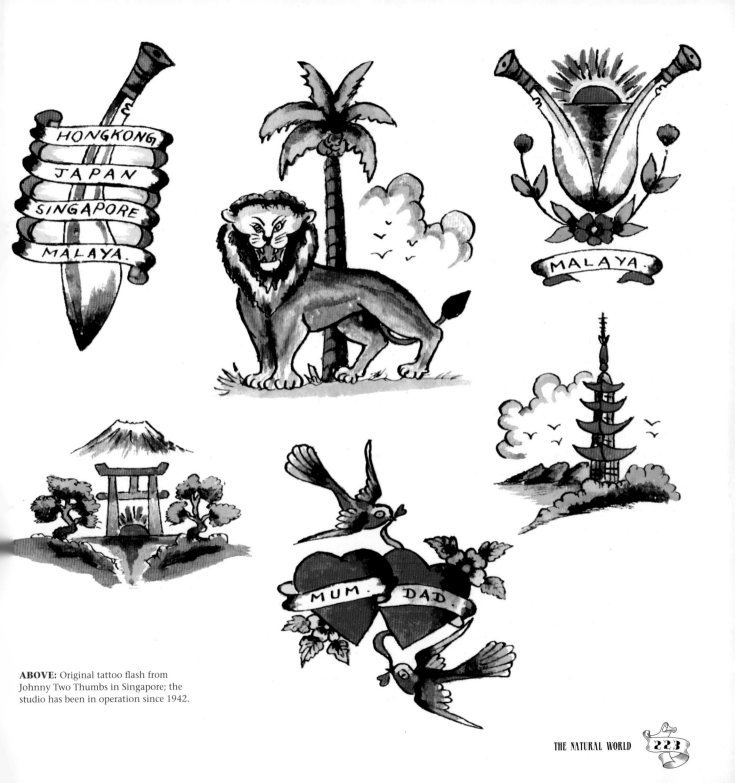

ABOVE: Original tattoo flash from Johnny Two Thumbs in Singapore; the studio has been in operation since 1942.

GEORGE BURCHETT

George Burchett – Britain's "King of Tattooists" – had been fascinated by sailors and tattoos for as long as he could remember. Born George Burchett-Davis in the south-coast town of Brighton, Sussex, in 1872, he spent his childhood listening, awestruck, to sailors' stories of life on the ocean wave, the faraway people and places they'd encountered, the remarkable things that had happened. Most of all, the young George wanted to know about the tattoos. How exactly did you tattoo someone? On finding out, aged 11, he started to experiment on his classmates using a needle and soot, and in the face of his unapologetic refusal to cease and desist, he was unceremoniously thrown out of school.

Some stories suggest that Burchett wangled his way into the Royal Navy as a deckhand at the tender age of 13, although other sources argue that he was 16, and that he received preliminary training in Portsmouth. During his years on board, he learnt the art of tattooing from an older sailor and set up in business inking his shipmates. Burchett saw a lot of the world, and was filled with enthusiasm for much of the tattoo work he encountered, particularly Japanese art. Arriving in Kobe, Japan, in the summer of 1889 on *HMS Victory*, Burchett was about to witness some unforgettable sights. One was the sunset over Kobe Harbour. Another was the "fairyland" of the streets at night, with lanterns swaying and bobbing in the darkness. But the single most exhilarating experience of his stay was to meet and be tattooed by Hori Chyo. In Burchett's opinion, Chyo was a tattoo god, the greatest who ever lived. The master endowed Burchett with a small tattoo, a lizard, on his arm, using thin ivory sticks as needles.

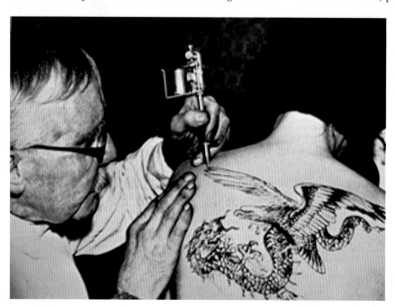

BELOW LEFT: George Burchett at work on one of his famous dragons.

OPPOSITE: A variety of images on a sheet of flash by George Burchett, His wife Edith is pictured bottom centre.

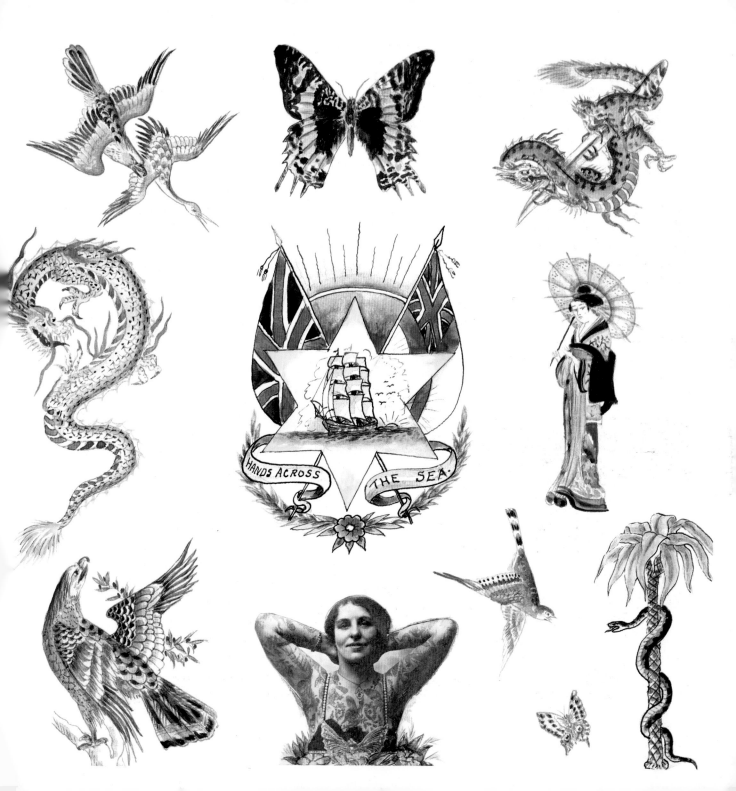

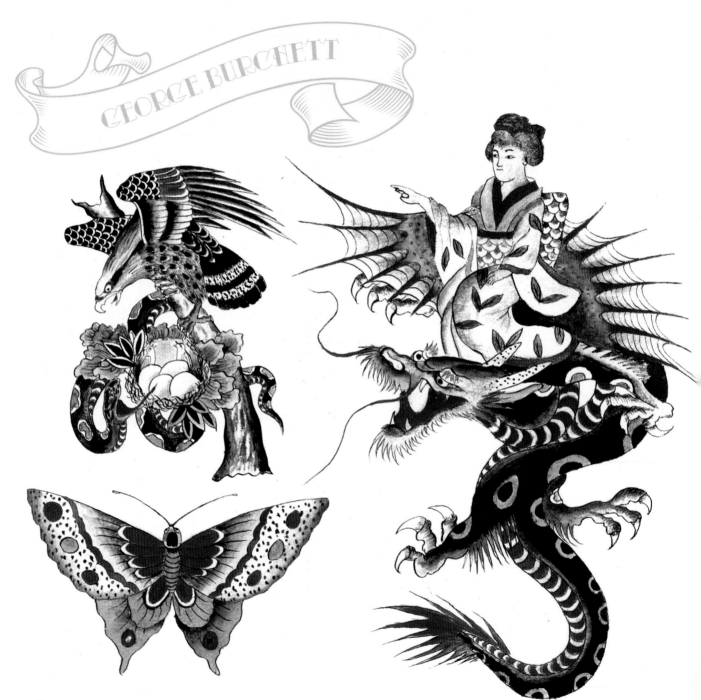

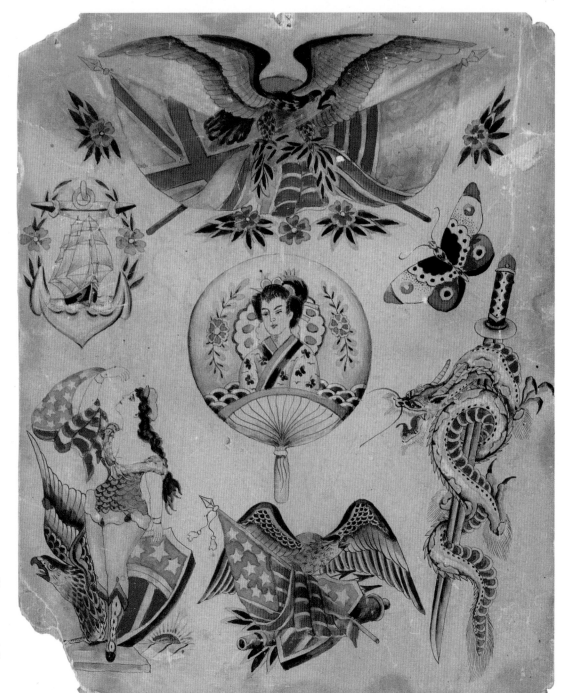

LEFT: Asian-influenced flash from George Burchett, including a geisha riding a dragon.

RIGHT: More classic tattoos from Burchett, including patriotic, nautical and Japanese-influenced work.

When Burchett's ship sailed off for other climes, he took with him the influences of Hori Chyo and the other Japanese artists, hoping to be able to incorporate into his own western style their elegance and exactness, their understated use of shading and the luminous quality of their colouring.

But a sailor's life was hardly packed with such fulfilling adventures. For most of the time, it was hard work, carried out in challenging conditions and in some very tough company. Burchett reportedly went AWOL in the Holy Land, and spent some time as a freelance tattooist. He also took a number of jobs on ships, having dropped the "Davis" part of his surname to avoid detection and arrest for desertion. He was still a young man when he returned home after 12 years. Burchett took tips and advice – some say training – from English tattoo legends Sutherland MacDonald and, particularly, Tom Riley, who were both from army backgrounds. Then, at 28, he opened the first of several tattoo shops in London.

Burchett was hugely successful, building one of the biggest tattoo businesses in the world and a clientele that included King George V (a former naval commander), foreign kings, rich establishment and society figures and, of course, the type of servicemen he'd grown up with. Interestingly, George V was also tattooed by Hori Chyo, before he became king (see also pages 70–1).

Towards the end of his life, George Burchett moved out of London, theoretically to retire, but he kept on working until he died, at the age of 81, on his way to ink a customer.

LEFT: A trio of severed heads by George Burchett.

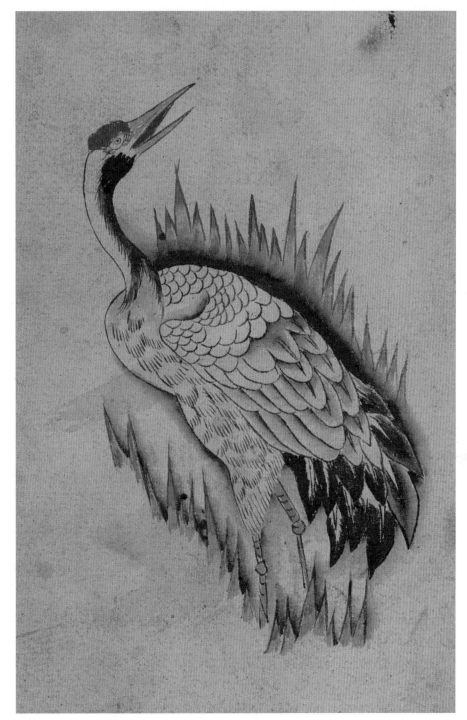

RIGHT: An exquisitely drawn Bird of Paradise tattoo by George Burchett.

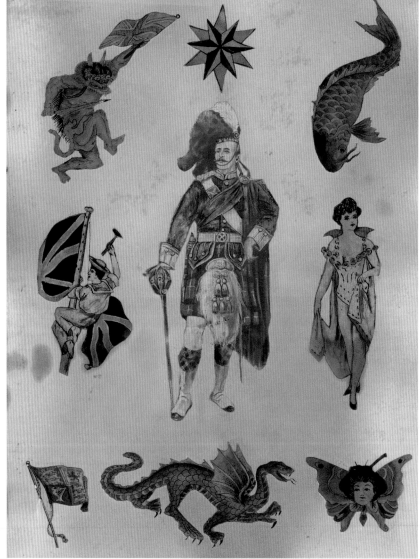

RIGHT: British patriotic designs, along with Japanese influences in the form of a koi fish, a dragon and a butterfly, as well as a nautical star, top centre. All by George Burchett.

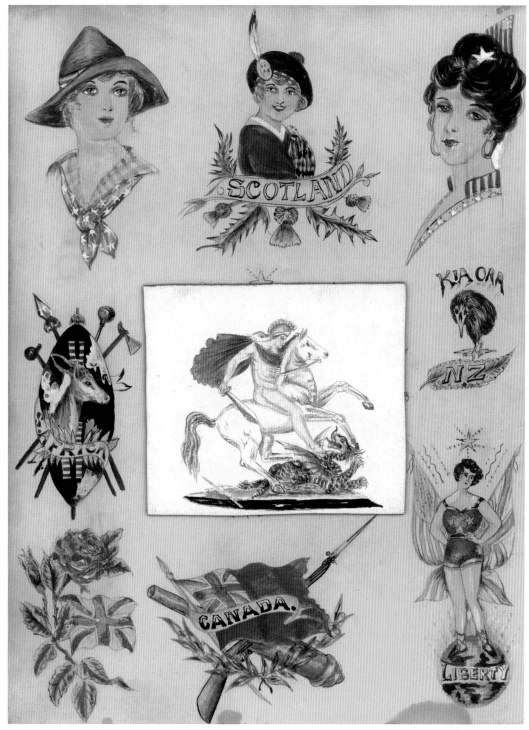

RIGHT: Flash depicting world service tattoos by George Burchett.

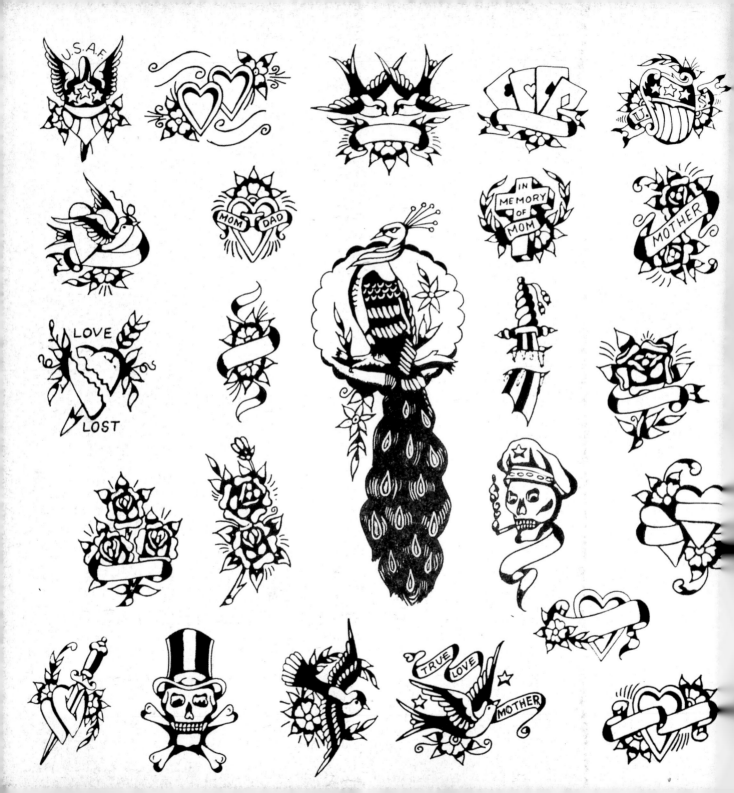

THE
DECLINE OF A
GOLDEN ERA

It was the 1960s that did it, really. Not the 1960s that swung in London, but the latter part of the decade, the years that produced San Francisco's Summer of Love, and psychedelic rock music, hallucinogenic drugs and the credo that "anything goes".

Women had already been liberated sexually by the arrival of the contraceptive pill. Now, they were being encouraged to explore that liberation, and to push through further frontiers. Hippie culture, shaped by a young generation of rock musicians, writers and artists, demanded the breakdown of the old order. And the female figurehead for this revolution was Janis Joplin, an awe-inspiring singer from Port Arthur, Texas.

Joplin came to prominence in the California scene of 1967, fronting her band Big Brother and the Holding Company. But it wasn't just the voice that transfixed her audiences. It was her raucous personality. Cackling, swearing, drinking heartily from a bottle of Southern Comfort and flaunting a lascivious sexuality, Janis Joplin showed young ladies that they no longer had to settle for a subservient role in society. They could join the man's world, on their own terms.

The day that Janis Joplin was tattooed is seen by many as a turning point. It symbolized the end of an era, one in which tattooing was the sole preserve of soldiers, sailors, ruffians, gangs and circus acts, and ushered in the age of rock 'n' roll tattoos, which were increasingly demanded by fans, male and female, across the whole spectrum of class and occupation, and which – to begin with – avoided old-school artwork. The youngsters wanted designs that spoke their own language, that chimed more closely with the style of their counterculture and which, generally, did not celebrate any kind of military activity.

The floodgates opened. Experienced and new tattooists alike adapted their skills for the thousands of long-haired music-lovers wanting contemporary artwork. No one could have known it at the time, but this would ultimately lead to a mainstream acceptance of the tattoo.

Joplin got three tattoos. One was a triple-coloured Florentine bracelet circling her left wrist, another was a heart on her left breast and the third was a small flower on her right ankle. They were inked by Lyle Tuttle at his shop in San Francisco in spring 1970. Delighted, Joplin made a point of showing them off in television interviews broadcast from coast to coast. In May the same year, she threw a tattoo party for actor Michael J Pollard. Lyle Tuttle was invited along to tattoo the guests, and among those who took advantage of the opportunity was Pollard himself, who had a tribute to his wife etched into his arm.

Tuttle has since been described as "the first psychedelic tattoo artist", which does him a great disservice, implying a certain opportunism when in fact he was a dedicated craftsman, inked from top to toe and brought up solidly in the old-school tradition. Much of

RIGHT: A sheet of flash by Milton Zeis, circa 1960s. New-decade images such as the ankh, playboy bunny, marijuana leaf and cartoon characters such as Casper, Road Runner and Wile E Coyote mix with old-school tattoos.

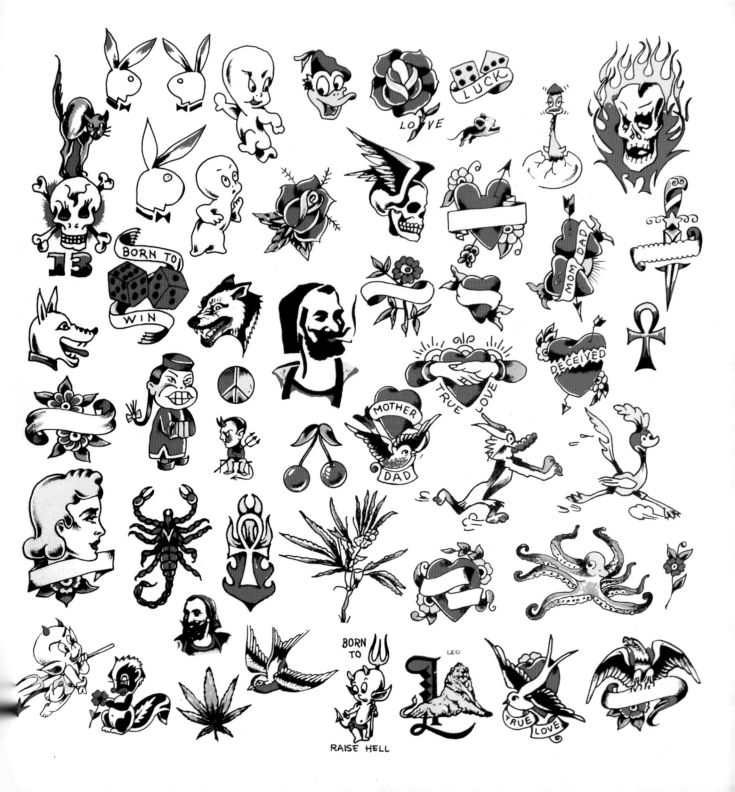

ABOVE: Janis Joplin and Paul Rothschild (producer of her last album *Pearl*), Los Angeles, 1970. The tattoo on her wrist was done by Lyle Tuttle.

his body work, including his backpiece, was carried out by Bert Grimm. A close friend of Captain Don Leslie, the great circus showman, he moved in circles that included such influential artists as Pinky Yun.

But some of the old guard were suspicious, unsettled by Tuttle's ability to move with the times, which certainly were a-changin'. Perhaps not surprisingly, the ultra-conservative Sailor Jerry Collins was said to be among those dismissing Tuttle and the growing band of newcomers involved in rock 'n' roll tattooing, which Collins apparently felt was superficial.

While all this was going on, life was getting more difficult in other ways for the traditional tattooists.

Local authorities all over the United States had been coming down hard on tattoo shops since the 1950s, imposing such stringent health and safety rules that many proprietors preferred to move, work from home or maybe just retire. In some states, there was a total ban. Sideshows, too, were coming under pressure due to a growing national concern about the ethics of exhibiting people for entertainment.

The original old-school pioneers were no longer around. In England, Sutherland MacDonald and Tom Riley had long ago gone to a better place, while George Burchett had passed away in 1953. In America, Riley's New York-based cousin Samuel O'Reilly cashed in his

chips as far back as 1908. The 1940s and 1950s brought a run of deaths from the next generation of American tattooists, notably those of Sailor George Fosdick (1946), Mildred Hull (1947), Percy Waters (1952), Charlie Wagner (1953) and CJ "Pop" Eddy (1957).

The funeral bell tolled relentlessly in the 1970s for another wave of great tattoo artists. Milton Zeis died in 1972, and the next year was particularly depressing, producing a succession of death notices for Sailor Jerry Collins, Cap Coleman, Amund Dietzel and Al Schiefley. Owen Jensen departed in 1976, followed by the Canadian Doc Forbes in 1977.

However, the remaining old-school diehards soldiered on in Europe and North America, keeping the tradition alive in the 1970s amid a hugely expanding tattoo industry, and all the while passing on knowledge to eager young guns they could depend upon to treasure and preserve it. Dutch artist Albert Cornelissen and his son spent years driving round Europe in a mobile tattoo studio, chasing work with air force troops. Peter de Haan – Tattoo Peter – travelled a little but regularly returned to work in Amsterdam, and Ole Hansen continued to ply his trade in Copenhagen. Both died in the 1980s, as did Charlie Geizer, who was the last man with a tattoo shop in Baltimore, after his contemporaries had all bailed out rather than comply with the authorities' strict hygiene rules.

Jack Dracula somehow found time for tattooing while enjoying his many other hobbies, including cooking, wine and archaeology; he also collected antiques and learned to speak Chinese. After leaving his famous shop in Long Beach's Nu-Pike, Bert Grimm carried on working until he died, in Gearhart, Oregon, in 1985. Paul Rogers also kept the flag flying,

tattooing and building machines, up until his death in Jacksonville, Florida, in 1990. Meanwhile, at the time of writing, Pinky Yun was still inking starstruck customers in San Jose, California.

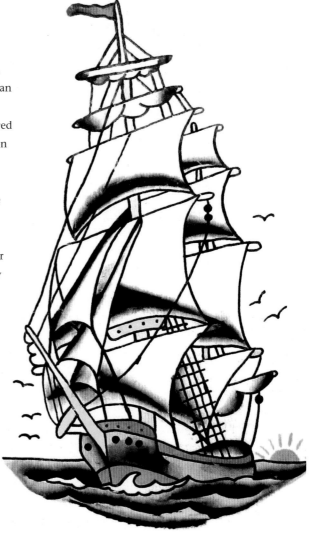

RIGHT: A traditional sailing ship by Jack Dracula, aka Jack Martin, who began working in the 1940s, operated tattoo shops in New Jersey and Philadelphia in the 1950s and 1960s, and by the 1970s became an amateur archaeologist.

OPPOSITE: A death's-head insignia on a motorcycle petrol tank, a modern interpretation of old-school skull tattoos.

THE VINTAGE REVIVAL

They may have been a dying breed, and the popularity of their style of artwork may have been in serious decline during the 1960s and 1970s, but the legacy of the old-school tattooists lived on in the skin of their customers, in their apprentices, in documents, letters, photographs and business cards, and in the flash and equipment that some had had the foresight to bequeath to responsible custodians.

Museums and archives were established to preserve this unique and human aspect of art history, and conventions, exhibitions and lectures were set up to explain and promote it, while the Tattoo Hall of Fame continued to honour the leading exponents.

The circus sideshow was largely a thing of the past, but some individuals bravely forged ahead into the future with all-over body tattoos. Cindy Ray, a young blonde Australian model, took the surprising decision to become a tattooed lady in 1959, at the suggestion of a photographer with whom she had started working. She got herself covered with all kinds of old-time tattoos, including a topless hula girl, and as a result her career as a photographic model prospered in the 1960s. Undeterred by the hostility and mockery her appearance often generated, Ray went on to become an author and an accomplished tattooist, finally being inaugurated into the Hall of Fame in 2005.

Today's tattoo culture, a thoroughly mainstream affair, has now reclaimed the vintage designs of yesteryear and brought them into a whole new world of body modification, corporate advertising and merchandizing, and television. Discovery Channel's *Miami Ink* – and its spin-offs *LA Ink* and *London Ink* – are reality TV series set in tattoo shops. While introducing worldwide audiences to historical aspects of tattooing, some of the artists, notably Miami's Ami James, have spoken about old-school design in some depth.

Traditional images can be seen everywhere, from books and magazines to motorbike engine covers, and from clothing to skin. Amy Winehouse, the talented and controversial British singer, is said to have 13 tattoos, most of them in the old-school style. They include a horseshoe, a bird, a lightning bolt, a feather, a number of pin-up girls and a Betty Boop cartoon on her bottom.

Not everyone takes their enthusiasm to Amy's extreme. Some admirers prefer the temporary adornment of vintage tattoo transfers, which are doing good business online and from fancy-dress shops. Others parade the designs of Sailor Jerry, Don Ed Hardy, Mike "Rollo Banks" Malone and countless imitators on a wide range of fashion garments, such as tattoo-patterned T-shirts.

The resurgence of vintage tattoo art has come about through the efforts of its guardians, the individuals who have cherished and promoted the genre and safeguarded the classic designs they either inherited or collected.

King of the retailers is Don Ed Hardy, who runs a worldwide clothing empire endorsed by some of our

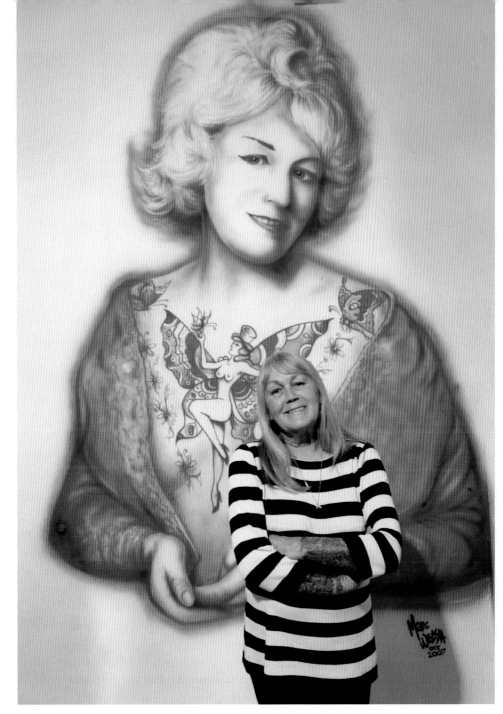

RIGHT: Tattoo legend Bev Nicholas, pictured in 2007 in front of a mural of her, based on a photograph taken during 1960s when she was Cindy Ray "the classy lassie with the tattooed chassis". Described as "the grand old woman of Australian tattooing", the image was featured in an article that appeared in the Australian magazine *The Age*.

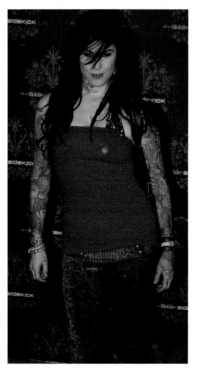
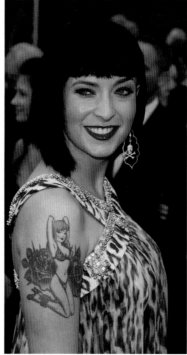
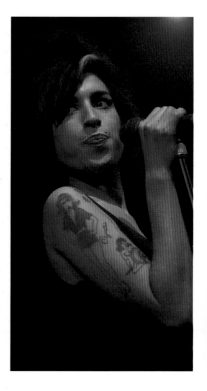

ABOVE RIGHT:
Kat Von D, tattoo
artist from the
reality show *Miami
Ink* and the spin-off
LA Ink.

most celebrated music and movie stars. Hardy's bright and beautiful vintage images (and those of Sailor Jerry, whose merchandizing range is also operated by Hardy's company) are spread stylishly across baseball caps, hoodies, sweaters, jeans, shorts, T-shirts, scarves, belts, shoes, childrenswear and an array of accessories.

Old-school tattooing has long been linked to advertising, with Coca Cola and Marlboro cigarettes among the first major brands to use it in their promotions. The Hardy clothing offshoot, however, has little need of advertising – not when figures such as Mick Jagger, Madonna, Britney Spears, Sylvester Stallone and Miley Cyrus are regularly snapped wearing his clothes; even the website includes a Celebrity Gallery of photographs in which the rich and famous show off the clothing designs.

Other valuable material – tattoo flash, equipment and historical information – is stored in archives and collections for the benefit of present and future generations, rather than being marketed. One such treasure trove is Tattoo Archive, set up by artist CW Eldridge in 1980. The archive has an online presence as well a physical home, operating from the shop of the same name in Winston-Salem, North Carolina. And one of its most exciting resources is the complete legacy of the renowned old-school tattooist Paul Rogers, another native of North Carolina and a former cotton-mill worker.

Rogers, who began his tattoo career in 1928, had known Eldridge for 20 years before he died in 1990, and he made the decision to leave his collection of work effects to Tattoo Archive in his will. Eldridge says:

OPPOSITE:
Old-school pin-up
girl tattoos on
writer Diablo
Cody, Academy
Award-winner for
her screenplay
Juno, and on British
chanteuse Amy
Winehouse.

I think he realized that his family wasn't going to care for it in the way it should be cared for, and it was probably going to get scattered. He had collected so hard for so long he didn't want to see it getting lost. He approached me because he'd seen what I'd been doing.

It did have a little bit of everything – machines, books, business cards, postcards, photographs, drawings, sketches, stencil rubs, stencils, the tubes for the machines, even needles – almost every artefact that's around the tattooer. He still had his paste-up from his last cotton-mill job, which was in about 1932. He'd carried that around with him for 60 some years. We formed a non-profit in his name – the Paul Rogers Tattoo Research Center [PRTRC]. We got into this space here where we were able to expand that research centre and open it up even more to the public.

Eldridge formed the PRTRC with another old friend, Don Ed Hardy, as well as Alan Govenar and Henk Schiffmacher, with the aim of documenting and preserving tattoo history. As a tattooist now mainly specializing in custom artwork, in which he creates personalized designs for customers, Eldridge has a wide knowledge of the vintage era, and an endless fascination for it, as befits a former member of the US Navy. He enlisted as a teenager in the mid-1960s and had his first tattoo inked during a stint in boot camp in San Diego, a place that was packed with sailors. Back in the civilian world, Eldridge was tattooed by Don Ed Hardy in 1974, and four years later started learning the craft as Hardy's student, in a direct lineage from Sailor Jerry. He subsequently travelled to Calgary, Alberta, to work with Paul Jefferies and Jerry Swallow, and returned to San Francisco, where he teamed up with Dean Dennis and Henry Goldfield.

Eldridge founded the Tattoo Archive in 1980 in Berkeley, California, later moving the shop to his home state of North Carolina, although its origins date back much further. He recalls:

The Tattoo Archive started with my collecting in 1965, when I started getting tattooed, and it just grew and grew and grew. Before the Internet, the only way for collectors and fans and artists to correspond was through tattoo club newsletters. I started writing tattoo history articles. I even started my own newsletter that was just history.

Mainly everything that I collect is made of paper. There's a pretty long list of things: books, photographs, postcards and business cards, drawings and illustrations. In our shop here, we also do changing exhibitions, a continuing education thing. We put out press releases and stuff. I do think the interest in old-school tattoo history is growing. I'm quite encouraged by that.

Lyle Tuttle, a star tattooist, rose to fame in 1970 when he inked rock legend Janis Joplin, although he made his name in San Francisco years earlier. Tuttle is also a leading authority on tattoo history and an inveterate collector of tattoo memorabilia. "I would say that my collection is the biggest in the world," he declares. "If I've got two of anything, I'm dangerous, 'cos it's a collection. I got my first tattoo when I was 14 years old, in 1946, and I've been agog with tattoos ever since. It just consumed my life."

That first tattoo, on his inside right forearm, was a classic vintage image, a heart bearing the word "Mother". "It kept me from getting my butt beat," he laughs. "My folks were really congenial. They didn't raise hell about it enough, so with people, when they ask how many tattoos do I have, one of my stock answers is, 'My mom said I could have one, so I only got one – which is all over.'"

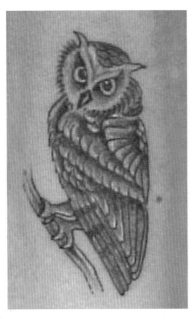

As a young child living in Ukiah, northern California (where he has returned to live, in the old family home), Tuttle was enthralled by the sight of sailors with the famous nautical emblems emblazoned on their arms. He recalls:

I was ten years and two months old when the Japanese bombed Pearl Harbor. A few guys would come back from the service, and I lived 120 miles north of San Francisco in the northern regions of the wine country – you go across Golden Gate Bridge and you keep going till you can't hear nothing – and I'd see a tattoo and it was hot stuff, and so tattoos meant adventure and travel and excitement, and that was my attraction to tattooing.

By the time he was sailing with the marines, in the early 1950s, in the first part of the Korean War, he had himself started tattooing. But his career as a collector dated back to the "Mother" heart tattoo. Tuttle explains:

I have the first business card from the man that tattooed me originally. I loved tattooing and I just collected stuff off the old-timers. I used to have it in suitcases. One of the guys in the shop said, "You've got this second floor of this office building, why don't you set it up?"

This marked the birth of the world-renowned Tattoo Museum in San Francisco, which remained at the same address for just under 30 years until, in 1989, disaster struck:

An earthquake knocked me out of it in 1989 and I lost the building. I didn't lose one artefact in the earthquake. That happened in October, and then I closed the business on 31 December because the building was yellow-tagged. That meant you entered the building under your own risk. It was an un-reinforced brick building. I moved my stuff out.

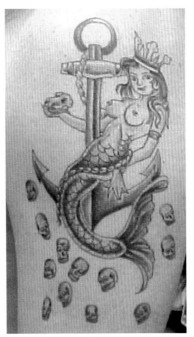

THIS PAGE AND OPPOSITE: Original tattoos by CW Eldridge.

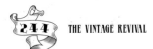

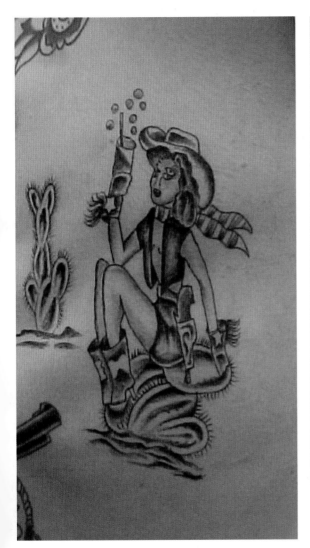

Tuttle decided against opening up another permanent museum, although he contributes substantially to the annual Old-School Tattoo Convention, and lends parts of his collection to travelling shows and major museums staging special tattoo exhibitions. Yet he feels ambivalent about his massive hoard of memorabilia: "I actually hate it in a way, because it encumbers my life." Regaining his passion, he adds:

I have some large collections. I've bought the complete artefacts of retired tattoo artists. Doc Forbes in Canada – I have 150 sheets of his drawings. Ralph Johnson, a retired marine from LA – 450 sheets of his flash… In the 1880s, most tattoo artists were itinerant and didn't have studios. A lot of time they drew on window sheets and they could hang it up, and books were very popular. I have a couple of dozen books of itinerant tattoo artists' flash. They're nothing but sales ads.

In the early 1900s, tattooists came up with various ingenious ways of displaying their work to the public. Some constructed special boxes, and Tuttle owns two important examples of these. He explains:

One is a rolling device that you crank and designs go by you, and it's drawn on cotton. There are 350 designs in that box that you can roll by. Another box was drawn by CB Davis [Charles Burchett-Davis], George Burchett's brother. In that generation, all the boys had the middle name of Burchett, after a Romany gypsy who was honoured by the family. George dropped the Davis. I have this oak box, probably a foot long, six inches wide, that was used for receipts. Crank it and the receipt would come out, and you could keep the copy and give the customer a copy. CB Davis took that, modified it and drew designs on this long roll.

Tuttle also has in his collection around a dozen portable tattoo trunks and cases used by travelling tattoo artists. One, remarkably, incorporates a sink. The family of CB Davis, meanwhile, has sold a number of photographs and designs to the British Tattoo History Museum, which was opened by tattoo expert Lionel Titchener in an Oxford tattoo shop in 1975, and continues to this day. Like Tuttle, the museum is happy to lend items from its collection to leading national museums from time to time.

Both Lyle Tuttle and CW Eldridge have lived through transforming times for tattoo art, which was once the province of servicemen, circus communities, rebels and criminals, and is now a perfectly acceptable mainstream practice, conducted in sanitary conditions in every high street in the West.

"It's a whole new world," agrees Eldridge. "I think in America, one thing that had a big impact was MTV when it started in 1981. It was 24/7 music videos, and there was an amazing number of those videos that had rock stars playing and showing off their tattoos. That had a tremendous impact in changing people's views."

Musicians were particularly fond of vintage-style designs involving skulls, daggers, roses and flames, often demonstrating a certain empathy with the biker gangs of the 1950s, or simply wishing to appear confrontational. Lyle Tuttle is not so sure that the recent, widespread enthusiasm for the tattoo is a good thing. He suggests:

The great unwashed – the general public – has a basic dislike for tattooing. I think they're just deluged with it in all directions nowadays, and that's the acceptability of it. I think the human race has slipped down a few notches.

It's just the idea they don't have a life. Women are getting their whole arms tattooed. It's trendy, and trends pass, and what happens when that trend's passed? Tattoos are constant. People change and times change. So I'm just sure there's going to be a bunch of sick puppies out there one of these days.

Time will tell. In the meantime, however, the revival of traditional tattoo images shows that they have not lost any of their allure as the years have rolled on, for customers and artists alike. What, exactly, is the magic of the vintage era? Eldridge says:

I just love anything nostalgic. In 50 years' time maybe today's tattooing will have that quaint quality. Take classic radio stations. We've been listening to the music that's on those stations for 40 or 50 years, and the songs still sound good. Those tattoo designs from the Second World War still have that quality. It's something about the way they're drawn and shaded and coloured and rendered.

For Tuttle, at least part of the love affair centres on the colourful characters at the heart of the tradition – extraordinary showmen like Captain Don Leslie and the tattooed carnival ladies who had always intrigued him. Crucially, Tuttle says, "They were individuals, individualists. I met Captain Don in 1955 and we became fast friends right off the bat."

The great tattooists were street-wise; they could think on their feet, summing up a situation quickly and taking tactical action. As evidence of this, Tuttle describes an abiding memory he has of the esteemed Bert Grimm:

One of the things that sticks in my mind was that I was standing in the shop one day and a ravenous drunk came in. And Bert put up his hand and said, "I know you're a reasonable man. I'm talking to this guy here with some important business, and if you will just let us finish our business and come back in ten minutes, I'll address your problem." The guy just sort of spun around and stumbled out the front door and never came back.

Another special quality of the old-school community was a deep sense of honour and responsibility that cared for the unique bond between artist and customer. Tuttle insists:

You've gotta have a conscience. You can do things to people that's going to affect their whole life. Like, nowadays, people are getting tattooed on the side of the neck, there's more facial tattooing going on than went on in yesteryear, and I'm out of the old school. If you had tattoos on your hands, it would complicate your employment. I don't tattoo above the collar line or on hands because I'm doing something to you that's going to last you for the rest of your life. I just wouldn't do it.

He sums up that, at heart:

Tattooers are ultra, ultra dedicated people. A lot have been married more than once 'cos they spend so much time in the studio. You're compelled. You wanna be there. The tattoo artist just works, works, works. He's down the shop all the time. The woman thinks it's almost like the competition of another woman or something. There's an adoration your clients feel that's second to none. A tattoo artist is the closest thing that the general public will ever get to having a witch doctor.

RIGHT: Lyle Tuttle, posing for a portrait on 14 June 2003, in Toronto, Canada. After receiving his first tattoo at 14 in 1946, Tuttle has filled his entire body with the art that has made his career. He has tattooed everybody from Janis Joplin to Peter Fonda.

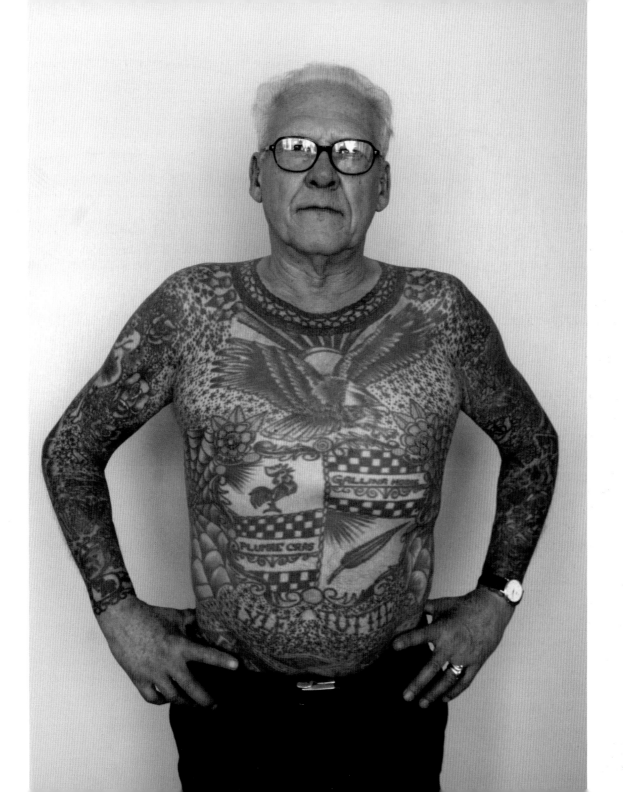

INDEX

Figures in italics indicate captions to
illustrations.

A

Albert Victor, Prince, Duke of Clarence
 and Avondale 70
Alberts, Lewis 11, *21*, 49, 72, 85
Arbus, Diane 13

B

Bailey, James Anthony 43, 47, 49, 177
Banks, Joseph 38, 66
Barber, J F *212*
Barnum, Phineas T 11, 43, 44, 47, 49,
 176
Barrs, 'Sailor' Charlie *62*, 72, 77, 83,
 174, 177
Bell, Ian 13
Berg, Tom 81, 83, *113*
Bergey, Earle K 110
Bligh, William 69
Boehme, FA *99*
Bogart, Humphrey 165
Bolles, Enoch 110
Bonnie and Clyde (Bonnie Parker and
 Clyde Barrow) 20, 130
Broadbent, Betty *48*, 49
Brown, Earl *178*

Buchan, Alexander 66
Buffalo Bill (William Frederick Cody)
 130
Bunnell, George B 47
Burchett, Edith *7*, *224*
Burchett, George *7*, 11, 12, 43, *43*, 66,
 67, *71*, 98, *169*, *183*, *209*, *214*, *219*,
 221, 224–31, 236, 247
Burchett-Davis, Charles 247

C

Cabri, Jean Baptiste 43, 44
Carey, Harry 49
Charlotte, Queen 40
Churchill, Sir Winston 62
Chyo, Hori 70, *71*, 224, 228
Cody, Diablo *243*
Coleman, Cap 14, 15, *21*, 77, *77*, 78,
 78, 93, 222, 237
Collins, Norman Keith ('Sailor Jerry')
 11, 72, 85, *87*, 93, 119, 120, 122, *123*,
 129, 139, 142, 165, 205, 211, 222,
 236, 237, 240, 242, 243
Constantine, Prince (Alexandrinos
 Constentenus) 11, 44, *44*
Cook, Captain James 10, 38, *38*, *39*,
 40, 66, 69
Cornelissen, Albert 13, 90, 93, 237
Cyrus, Miley 242

D

Dampier, William 38, *41*, 69
Danzl, Danny *59*
Darpel, Joe 12, *16*, 22, *22*, 25,
 26, 72, 77, *106*, *107*, 155, *159*,
 166, 177
Darpel, Mabel 12, *16*, 22, *22*, 72,
 77
Darwin, Charles 69
Davis, Charlie *218*
de Burgh, Emma 49, 175, *177*
de Burgh, Frank 49, 175
de Haan, Peter 93, 237
Dennis, Dean 243
Dietzel, Amund 12, 98, 99, *99*,
 237
Dillon, Sandy 83
Dracula, Jack (Jack Martin) 13, *162*,
 165, 237, *237*
Dutch, Detroit 50

E

Eddy, Clement John 83, 237
Edward VII, King (as Prince of Wales) 70
Eldridge, CW 130, 133, 222, 242–3,
 244, *246*, 247, 248
Elvgren, Gillette 110
Elvy, Captain 81, *81*, 200

F

Floyd, 'Pretty Boy' 20, 130
Fonda, Peter *248*
Forbes, Doc 13, 120, 129, *137*, *140*, *145*,
 146, *147*, *148*, *152*, *186*, *189*, *205*,
 209, *211*, 237, 247
Fosdick, 'Sailor' George 72, 80–81, *80*,
 81, *113*, 200, 237
Fourneaux, Captain *40*
Frederick IX, King of Denmark 90
Frobisher, Sir Martin 69

G

Geizer, Charlie 72, 80, 83, 177, *177*,
 237
George III, King 40
George V, King (and as Duke of York)
 70, *71*, 228
Gibbons, Artoria 175–7
Gibbons, Charles W 'Red' 175, 176, 177
Giolo, the Famous Painted Prince
 (Prince Jeoly) 10, 38, *41*, 69
Goldfield, Henry 243
Govenar, Alan 243
Grable, Betty 110
Great Omi (Horace Ridler) 11, 43, *43*
Grimm, Bert *9*, 11, 12, 13, 15, 20, 22,
 58, *62*, 72, 80, 81, *82*, 83, *83*, *84*, 85,

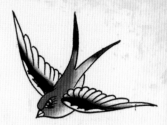

93, 119, *119*, *123*, 130–35, 136,
139, 146, *155*, *156*, *161*, *170*, *182*,
193, 205, *206*, *210*, *215*, 217, 221,
221, 236, 237, 248
Grimshaw, Bill 77, 78, 98, *142*

H

Hamilton, Pearl 50, 193, *193*
Hamilton, Ted 193, *193*
Hansen, Ole 90, *90*, *92*, 120, 129,
172, 237
Hardy, Don Ed 87, 99, 139, 142,
222, 240, 242, 243
Hartley, Joseph 15
Hasberg, Adolph 83, *113*
Herring, John Frederick, Sr. 198, 200
Hildebrandt, Martin 47
Hildebrandt, Nora 11, 47
Hix, John *48*, 49
Hodge, Trevor 13, *56*, *121*, *148*
Hoffman, Herbert 13, *88*
Horiyoshi II 220, 222
Horiyoshi III 222
Howard, Annie 49
Howard, Frank 49
Hull, Mildred 49, 166, 170, 237

I

Ingemarson, Vernon Frank 200

J

Jack, Captain *114*, *116*
Jagger, Mick 242
James, Ami 240
Jeffries, Paul 243
Jensen, 'Dainty Dotty' 83
Jensen, Owen 11, 14, 83, *108*, 200,
237
Johnny Two Thumbs *223*
Johnson, Ralph 247
Joplin, Janis 11, 234, *236*, 243, *248*

K

Kemp, Al *100*
Kemp, Shelly 50
King Brothers (Floyd and Howard)
22, 49

L

Larson, 'Sailor' Walter 72, 81
Lee, Tommy 166, *175*, 200
Leonardo da Vinci 49, 172,
198
Leopold, Leo 146
Leslie, Captain Don 14, 22,
28–37, *43*, 136, 146, 200,
205, 217, 236, 248
Lieber, 'Brooklyn' Joe *54*, 72,
129
Lone Wolf *150*

M

MacDonald, Sutherland 12, 43, 66,
70, 218, 228, 236
Madonna 242
Malone, Mike 'Rollo Banks' 87, 120,
139, 142, 240
Michelangelo 175
Mills, Bertram 43
Minugh, Lee Roy 14, 83, *212*

N

Nicholas, Bev *241*
Nolan, Don 9, 14, 127, *128*,
190

O

O'Connell, James F. 11, 20, *20*,
44, *44*
Omai 10, 38, 40, *40*, 66, 69, 70
Omette (Gladys Ridler) 43
O'Reilly, Samuel 9, 11, *22*, 23, 44–5,
46, 47, 49, 62, 72, 85, 172, 175,
236–7
Ötzi the Iceman 8, 10

P

Page, Bettie *128*, 129
Page, JJ *21*
Parkinson, Sydney 66, 69
Péquart, Marthe 8
Péquart, Saint-Just 8
Petty, George 110
Pollard, Michael J 234

Q

Quintana, George 110

R

Raphael 175
Ray, Cindy 240, *241*
Rea, John T *21*, *22*, 78
Redcloud, Jack 177
Reni, Guido 70, 177, *177*, 198
Reynolds, Sir Joshua 40
Richter, Karlmann 13
Ridler, Gladys *see* Omette
Ridler, Horace *see* Great Omi
Riley, Tom 11, 12, 23, 43, 66, 70,
218, 228, 236
Ringling Brothers 28, 43, 49, 176
Roberts, Frederick, 1st Earl 69
Robinson, A G *152*, *169*, *184*
Rogers, Helen *22*, 78
Rogers, Paul 14, *21*, 22, *22*, 72, 77,
78, *93*, *210*, 237, 242–3
Rothschild, Paul *236*
Rowe, Tex *93*, *94*
Rutherford, John 10, 43, 44

S

Sailor Gus 72, 81
Sampson, Floyd 15, *200*, *202*
Savage, John *41*
Schiefly, Al 194, 237
Schiffmacher, Henk 243
Segar, Elzie Crisler *205*
Shanghai Kate 87
Shaw, Bob 13, 15, *102*, *125*, 133,
133, *190*
Sitting Bull, Chief 47
Skuse, Les 15, *61*, *118*, *178*, 194
Smith, John 69
Snow, Charlie 146
Sparrow, Phil 99
Spears, Britney 242
Stallone, Sylvester 242
Swallow, Jerry 243

T

Tato Jack 90
Tattoo Johnny *73*

Thomas, Tatts *61*
Thompson, Burt 177
Titchener, Lionel 247
Todd, Colonel William *190*
Tryon, Jack 15, *21*, 22, 49, 85
Tuttle, Lyle 28, 30, *65*, 133, *137*,
140, *145*, *171*, *186*, 200, *217*, 222,
234, 236, *236*, 243, 244, 247–8,
248

V

van Dyn, Jacobus 214, *214*
Van Hart, Joe *48*, 49
Vargas, Alberto 110
Von D, Kat *242*

W

Wagner, Charles 11, *21*, 44–5, *45*,
46, 47, *48*, 49, 50, 72, 85, 93, *96*,
126–7, 170, 177, 200, 221, 237
Wagner, Gus *112*, 200, *200*
Wallace Brothers 81
Washington, George 176
Waters, Percy 15, 50–53, 200, 237
West, Sailor *138*
Western, Charlie 81, 85
Wicks, Bobby 'Texas' 177
Williams, Clyde 50
Winehouse, Amy 240, *243*
Woodward, Irene *46*, 47

Y

Yun, Pinky 120, 129, 220, 236

Z

Zeis, Milton 15, 193, 194–7, *200*,
206, *233*, *234*, 237

READING

Bodies of Subversion: A Secret History of Women and Tattoo, Margo Mifflin, Juno Publishing, 2001.

Don Ed Hardy: Permanent Curios, Smart Art Press, 1997.

Don Ed Hardy: Tattooing the Invisible Man – Bodies of Work 1955–1999, Smart Art Press, 2000.

Electric Tattooing by Men 1900–2004, Madame Chinchilla, Triangle Tattoo Museum, 2004.

Electric Tattooing by Women 1900–2003, Madame Chinchilla, Triangle Tattoo Museum, 2003.

Franklin Paul Rogers: The Father of American Tattooing, Don Lucas, Meyerbooks 1990.

Memoirs of a Tattooist, George Burchett, Oldbourne Book Co, 1956.

New York City Tattoo: The Oral History of an Urban Art, Michael McCabe, Hardy Marks Publications, 1997.

Sailor Jerry Collins: American Tattoo Master, Jerry Collins and Don Ed Hardy, Hardy Marks Publications, 1994.

Stoney Knows How: Life as a Sideshow Tattoo Artist, Alan Govenar, Schiffer Publishing, 2003.

Tattoo: Secrets of a Strange Art, Albert Parry, Dover Publications, 2006.

Tattoo Book of Days: Past Present and Future, Lyle Tuttle, Proteus PR, 1996.

Tattooing New York City: Style and Continuity in a Changing Art Form, Michael McCabe, Schiffer, 2001.

1000 Tattoos, Henk Schiffmacher, Taschen, 1996.

RESOURCES

Baltimore Tattoo Museum
1534 Eastern Avenue
Baltimore MD 21231 USA
+1 410 522 5800
www.baltimoretattoomuseum.net

The British Tattoo History Museum
389 Cowley Road
Oxford OX4 2BS UK
+44 (0) 1865 716877
www.tattoo.co.uk/bthm.htm

Lyle Tuttle's Virtual Tattoo Museum
http://lyletuttle.com

Sailor Jerry
16–118 South 13th Street
Philadelphia PA 19107 USA
+1 215 532 6380
www.sailorjerry.com/contac.php

Sea Tramp Tattoo Company
207 SE Grand Avenue
Portland OR 97214 USA
+1 503 231 9784
www.worldwidetattoodesigns.com

Tattoo Archive
618 West 4th Street
Winston Salem, NC 27101 USA
tattoo@tattooarchive.com
www.tattooarchive.com
For the work of C W Eldridge and many others.

Tattoo Charlie's
7640 Dixie Highway
Louisville, KY 40258 USA
+1 502 995 5635
www.tattoocharlies.com
Includes Charlie's Tattoo Museum, which
showcases his collection tattoo memorabilia.

Tattoo City
Ed Hardy's shop
700 Lombard Street
San Francisco, CA 94133 USA
+1 415 345-9437
www.tattoocitysf.com
www.hardylife.com/

Tattoo Memories
http://tattoo-memories.com/photos.html
Prints on offer from Lee Roy Minugh's son.

Tattoo Museum
Achterburgwal 130
Amsterdam, Noord-Holland 1012 DT
Netherlands
info@tattoomuseum.com
For international memorabilia and history.

Triangle Tattoo and Museum
www.triangletattoo.com
Especially good for US patriotic tattoos and the work of
Captain Don Leslie. See the Flash from the Past section.

Tom Dolan
http://tomdolan.pconline.com/tattoo/tattoo1.htm
For vintage flash from 1930–1950.

ACKNOWLEDGEMENTS

AUTHOR'S AKNOWLEDGEMENTS

My warmest thanks are due to tattoo artists Lyle Tuttle and CW Eldridge for sparing the time to give interviews for this book. Especial thanks go to Mr Eldridge, founder of the Tattoo Archive, for making available a wealth of information about old-school tattoo art and its exponents.

A number of books and magazines have been helpful in my research. They are: The Bible, *Buried Alive: A Biography of Janis Joplin* by Myra Friedman, *Pearl: The Obsessions and Passions of Janis Joplin* by Ellis Amburn, *Prick* magazine, *Time* magazine, *Wisconsin Magazine of History*, *Milwaukee Journal Sentinel* and *The Japan Times Online*.

I have been very fortunate that so much detail is available online in websites too numerous to list, but I would like to mention the following sites which have been particularly illuminating:

www.tattooarchive.com, www.lyletuttle.com, www.sailorjerry.com, www.donedhardy.com, www.worldwidetattoodesigns.com, www. oldschooltattooexpo.com, www.tattoojohnny.com, www.tattoosymbol.com, www.vanishingtattoo. com, www.tattoojoy.com, www.tattoos.com, www. triangletattoo.com, www.tattoos-by-design.co.uk, www.tattoo.co.uk, www.tattoo-memories.com, www. bmezine.com, www.nymag.com, www.prickmag.net, www.skinink.com, www.time.com, www.thewavemag. com, www.tattooartistmagazine.com, www.zimbio. com, www.wikipedia.org, www.hells-angels.com, www. shanghaikates.com, www.beachcalifornia.com, www. coneyisland.com, www.pjgandassociates.com, www. artcyclopedia.com, www.artfact.com, www.ibiblio. org, www.dreadloki.com, www.bettiepage.com, www. bettyboop.com, www.ne.jp/asahi/tattoo/horiyoshi3, www.ill-use.com, www.swaves.com, www.tattoocitysf. com, www.fancydress.com, www.avaloncycleworks. com, www.tlcdiscovery.com and www.pbs.org.

A great big hello goes out to Patricia Mitchell, Maria Jefferis, Kerry Lake and Sarah Hiller for their support and encouragement, with a special hug for Doreen Clerk. Finally, I must record my endless appreciation of a wonderful husband and daughter, Nigel and Eve O'Brien, who have, as usual, given love and help way beyond the call of duty.

Carol Clerk, April 2008

PICTURE CREDITS

The publishers would like to thank the following sources for their kind permission to reproduce the pictures in this book. Key, t: top, b: bottom, l: left, r: right.

Alamy Images: /MN Images: 238; **cookephoto.com:** /Clark J. Pierson: 236; **Corbis:** /Bettmann: 40, 48tl, /Bo Bridges: 242l, /Christel Gerstenberg: 38, /Hulton-Deutsch Collection: 47, /Lucas Jackson/Reuters: 242c, /Keystone: 48c, /The Mariners' Museum: 173, /Swim Ink 2/LLC: 129b; **fairfaxphotos.com:** /Simon Schluter: 241; **Getty Images:** 129br, 249, /Time & Life Pictures: 39, 56r, 120l; **Courtesy of Lyle Tuttle:** 4 (clover), 4 (swallow), 4 (two hearts), 4 (circus tent), 4 (butterfly), 5tr, 6, 11, 12t, 13 (roses), 14(clown), 18, 19, 28, 29, 30/31, 32, 33, 34, 34c, 36, 37, 42, 43, 44, 62, 64/5, 66, 67, 76/7, 78, 97, 137, 140, 141, 142/3, 144, 146, 147, 148 t, 148 , 152, 153, 168, 169, 171, 183, 184, 185, 186, 186/7, 187, 188, 189r, 198/9, 204, 204/5, 208, 209, 211, 216/7, 218tr, 219l, 219r, 225, 226, 227, 228, 229, 230, 231, 251, 253, 255; **The National Gallery:** 177; **Private Collection:** 23t, 70; **Rex Features:** /Huw John: 242r; **State Library of New South Wales:** 41; **Tattoo Archive:** 4 (bird & flower), 4 (dragon), 12b, 13 (ship), 14 (sailor girl), 15 (girl with pink ribbons), 15 (Lady Luck), 16, 20, 21l, 21r, 22, 23b, 30, 46, 50t, 51, 54, 58, 79, 80, 81, 98, 99, 107, 108, 113l, 113r, 120r, 125, 126, 127l, 130, 133, 148bl, 158, 162-3, 164, 165, 172, 174, 175, 176l, 176tr, 193r, 200t, 200b, 212, 214, 221, 224, 237, 244tl, 244bl, 245l, 245r, 246 ; **Tattoo Charlies:** 4 (smoking skull), 4 (snake), 12 (rose), 13 (cat), 14 (geisha with snake), 15: (horses), 24/25, 26/27, 56l, 57, 60, 93, 94, 95, 100/1, 104, 105, 106, 112, 121, 138, 149, 159, 166/7, 191, 192, 202r, 202tr, 203, 210l, 210r; **Courtesy of Tom Dolan:** 4 (snake & dagger), 8, 13 (nurse), 96, 124, 131, 132, 134, 135, 154, 179, 180, 82/3, 84/5, 102/3, 156/7; **Triangle Tattoo and Museum:** 2, 9, 13 (Last Port), 14 (butterfly), 14 (eagle), 15 (geisha), 15: (jaguar & snake), 45, 50br, 52bl, 52r, 53, 59, 61, 68, 69tl, 69b, 72, 73, 74tl, 74bl, 74c, 75t, 75br, 75bl, 86, 87, 88t, 88bl, 88br, 89tl, 89tr, 89b, 90, 91, 92, 110, 111l, 111r, 114, 115, 116, 117, 118t, 118l, 118r, 127r, 128, 150, 178, 190, 194t, 194bl, 194br, 195, 196, 197, 201, 207, 213, 215l, 218b, 223, 232, 235; **worldwidetattoodesigns.com:** 4 (geisha), 4 (peacock), 4 (woman in headscarf), 4 (ship), 5l, 63tl, 63tc, 63tr, 63bl, 63bc, 63br, 119, 122, 123l, 123t, 123r, 160l, 160r, 161l, 161r, 170, 182, 189l, 193b, 206, 210t, 215t, 215r, 215bl, 220l, 220b.

Every effort has been made to acknowledge correctly and contact the source and/or copyright holder of each picture. Carlton Books Limited apologizes for any unintentional errors or omissions which will be corrected in future editions of this book.

The picture research department would like to express extra special thanks to: Lyle and Suzanne Tuttle, Chuck and Harriet Eldridge at Tattoo Archive, Buddy Wheeler at Tattoo Charlies, Mr G and Madame Chinchilla at Triangle Tattoo and Museum and Jeff Johnson at Sea Tramp Tattoo Company (worldwidetattoodesigns.com).